VOGUE
portfolio series

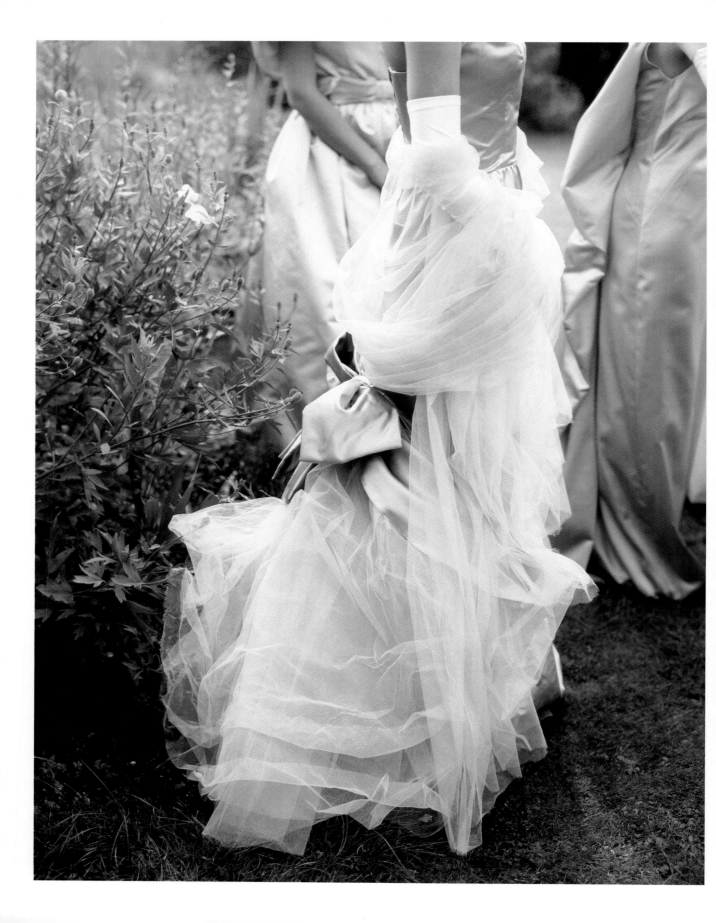

VOGUE
the gown

Jo Ellison

foreword by Alexandra Shulman

conran
OCTOPUS

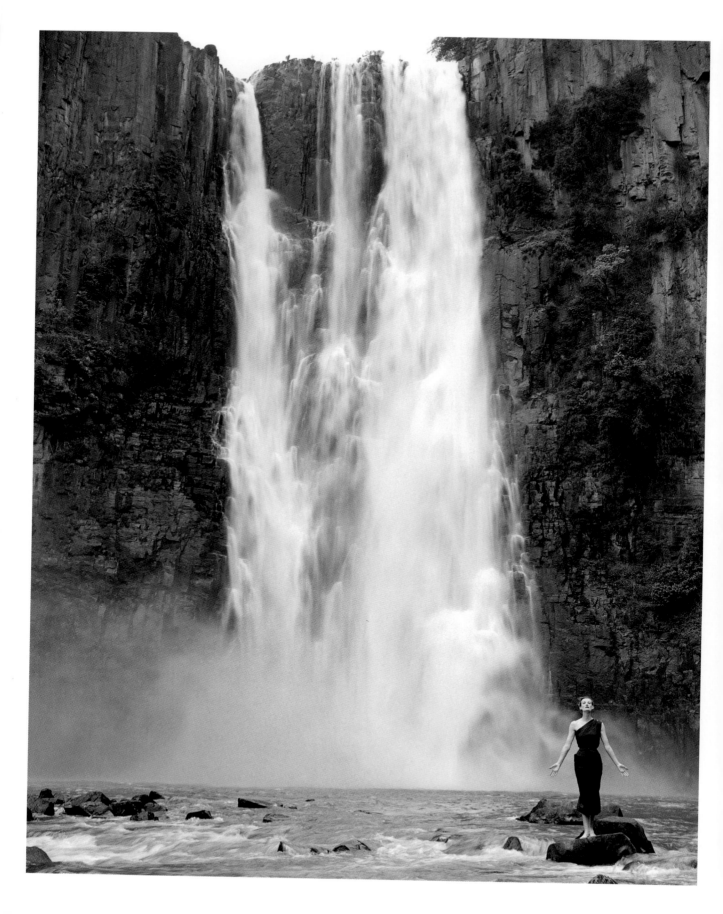

contents

foreword

by Alexandra Shulman

Where would *Vogue* be without the gown? So much more than an item of clothing, it embodies so many of the qualities of the magazine. *Vogue*, launched originally in 1892 to cover the lifestyle and fashions of New York high society, is now a chronicler of contemporary fashion throughout the world. In the UK since 1916, images of the most desirable clothes available have occupied *Vogue*'s pages, and what is more desirable than a gown? Gowns are exceptional and often excessive. They have little to do with daily life and are part of a world of imagination and indulgence. The same is true of *Vogue*.

Despite the changes in the lifestyles of modern women, and the vastly different repertoire of clothing available nowadays compared to those first days of *Vogue*, gowns are more popular than ever. The rise of the red carpet celebrity, the big business of philanthropic fundraising, and, extraordinary as it might seem, the ever-growing desire for traditional celebrations such as weddings and anniversaries have, if anything, given gowns a new lease of life. When we search for a gown to wear we wish to find something that is transformative and that will make our own experience of any of these occasions memorable.

In this sumptuous book Jo Ellison demonstrates the wealth of *Vogue* images that display the gown in all its variety and splendour. She shows how the years pass, but the gown often remains remarkably similar. Compare, for example, the reverential 1938 Horst picture of Madame Grès' white jersey column (see page 13) with Terry Richardson's jazzy picture of Karlie Kloss 70 years later in Donna Karan's version of similar draping (see page 31). Or look at Norman Parkinson's classic 1950 image of a beautiful girl in repose surrounded by her ballgown of tulle and satin (see page 67), later reflected in Mario Testino's pictures for the Christmas issue of 2009, with model Lara Stone featured in Dior Haute Couture (see page 117) – a gown showing hardly any trace of time.

Of course, a magazine is more than images and in these pages Ellison provides rich context and information so that each can be viewed, not only as a glorious picture, but as part of a bigger story. We learn, for example, that the model in Clifford Coffin's Stonehenge shoot (see page 170) was Cherry Marshall, who was a dispatch rider during World War II, and that Jacquetta Wheeler covered in slices of Gucci pink satin was photographed by Tim Walker for a British *Vogue* pantomime, and that Cate Blanchett graced the cover of British *Vogue* in June 2005, photographed by Regan Cameron in Alexander McQueen, just after accepting an Oscar.

In an age where fast fashion dominates our high streets, luxury items can be ordered at the click of a mouse, designers are persuaded to produce a multitude of collections every season and the same clothes can be bought in the same stores in every corner of the world, *Vogue The Gown* reminds us of the genuine beauty and lasting pleasure that fashion can also bring.

→ These *Vogue* covers, dating from 1918 to nearly the present day, chart not so much the evolution of the gown, which has remained mutely resistant to radical change over the decades – plunging, swirling and billowing with the exact same grandiosity and casual disdain for purpose – but that of the wearer. First rendered as illustration, the *Vogue* cover girl was originally a shy creature, much given to daydreaming and whimsical escapism. The Forties and Fifties saw her more strident of silhouette, but frequently in shadow, before she emerged in the Sixties level-eyed and confident – and showing a bit of leg. Today's cover stars leave us in no doubt as to their feminine power.

When RnB singer Rihanna (top left) took to the cover in 2011, she was platinum-haired, freshly inked and defiantly imperious in her pristine Armani Privé. They may be wearing evening gowns, but these girls mean business.

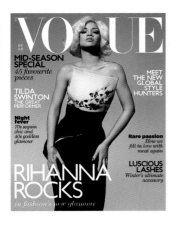

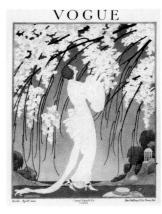

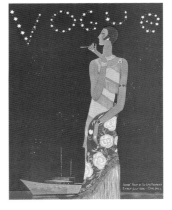

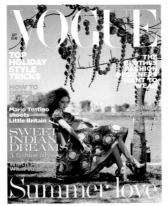

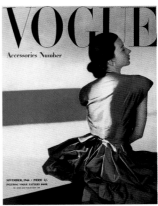

introduction

What is a gown? In a world of T-shirts and jeans, the word seems almost antiquarian: a mysterious relic from a bygone age in which women were dressed by candlelight and wore dancing slippers on their feet. But what place does a gown have in our society now? And why do we remain so endlessly enraptured by them?

To be clear – a gown is no mere dress. A dress is...well, a dress, while a gown bestows upon its wearer a certain transformative magic, lending her a specific grandeur, sophistication and romance. In a gown, one becomes dazzling, amusing, charming, elegant. Above all, one becomes beautiful.

Gowns, then, are the ultimate expression of the fashion fantasy: a world in which women can be fairytale heroines, Grecian goddesses, star-struck ingénues and supermodels. No wonder designers like to design them, stylists to style them and photographers to shoot them. In the theatre of fashion, the gown sets the stage for countless dramas and intrigues – the ultimate tool of escapism. A gown must be invigorated with a back story, enlivened by detail and brought to life by a beautiful woman: there is nothing so forlorn as an unworn dress on a hanger (which is possibly why so many fashion exhibitions, with their spectral mannequins, can seem so haunted by the ghosts of parties past). 'I imagined a dancer who had been dancing non-stop for eight days and eight nights, the dress stretched in movement...pulled here and there,' said the protean provocateur John Galliano to *Vogue* when asked, in 2004, about the creative decisions that inspired one of his more balletic creations. 'I always want to create a passion, a personality... to cut some emotion into it.'

Gowns may be a surprising outlet for emotional expression, but they capture a whole range of moods – mystery, darkness, tragedy, triumphalism, seduction, indulgence, malevolence, magnificence. They offer us an easy shorthand for every nuance of the human condition. And you simply can't do that with a pair of trousers.

Perhaps nowhere has a single item of clothing been deployed so powerfully than in the summer of 1947. London was a denuded shell of its former self, its spacious Georgian streets reduced to rubble and its landmarks pocked by the persistent bombardment of the Blitz. Yet, even as the world blinked its way to post-war recovery, *Vogue* offered a unique palliative to readers: the glimpse of a 'fairytale dreamed upon a June evening'. In an article entitled simply 'Renaissance', the magazine sought to reconcile the brutality of war with the delicate language of renewal, repair and regeneration. And what did the magazine use as its image of hope? A solitary female figure standing clear-eyed and sure-focused, sheathed in a sumptuous full-length

→ **Clifford Coffin, June 1947**
In this unseen image from the famous Coffin sitting 'Renaissance', the photographer shoots Wenda Rogerson in daylight, exposed against the bare bones of a Georgian building left ravaged by the war. Ultimately, the image chosen for publication was far less strident, and depicts Rogerson in candlelight at the foot of a great stairwell. But the fragile symbolism of the Ravhis pink faille gown is no less powerful in either frame.

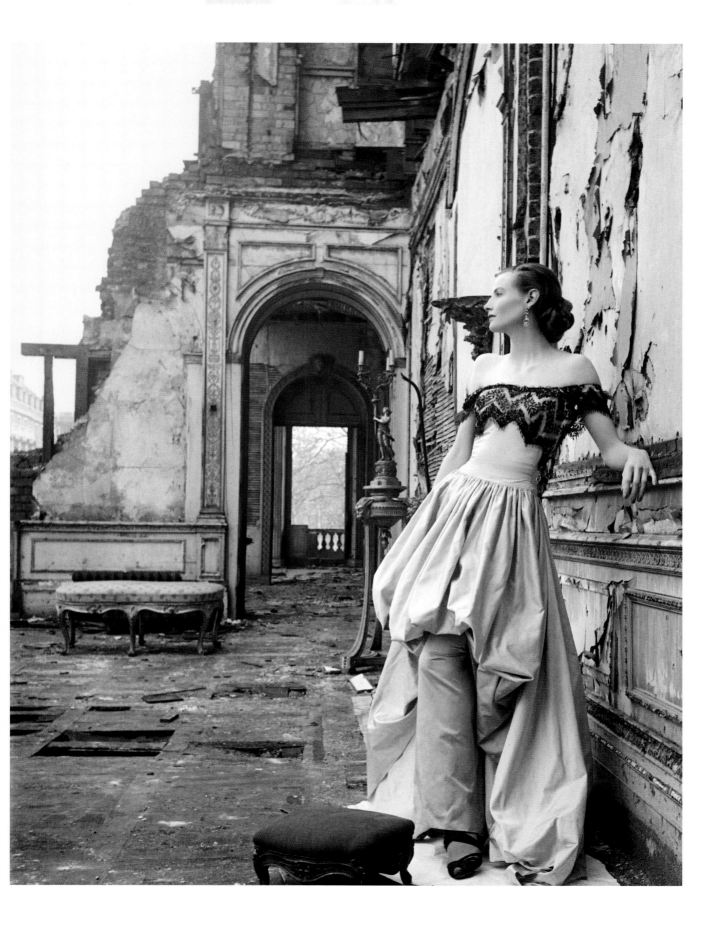

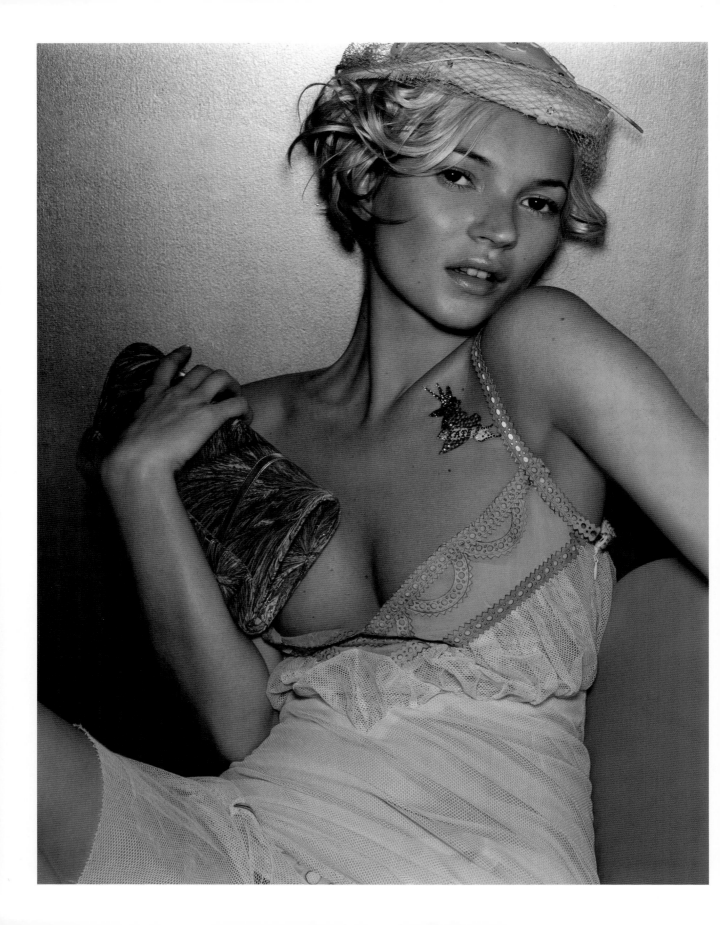

gown: 'She stood in candlelight, like a model for a Portrait of a Lady in a dress by an unknown painter. The dim cobweb of the staircase floated behind her, and her gown was pink and blossomy as a rose. Oblivious of the crumbling plaster under her feet, she listened grave-faced and serene – perhaps to catch the first sounds of the house as it shimmered into life around her.'

It seems a bold stance, to suggest that an extravagant frock might be an appropriate metaphor for rehabilitation. Or reassurance. But *Vogue* persisted: 'Ruins rise, and beauty has its second spring: the future holds equal hope and hazard, and the grace of a ball dress, bright against the rubble and brave in the encompassing dark, is a symbol of our gradual return to a certain serenity of life.'

Things change, lives change, styles come and go. But the gown survives. Since *Vogue* was first published, women have won the vote, worn the trousers, battled into boardrooms and been elected into office, yet the gown has remained an unchanging presence on its pages – even while the occasions on which we might wear one have radically diminished. Maybe we just like to look at them: in the same way that as children, we pored over illustrations of fairytale frocks, now, as adults, we gaze at a gown and it unlocks in us that most primal instinct to admire beauty. And something about a gown's unashamed opulence still ignites in us the promise of a Cinderella moment. Writing in *Vogue* at the couture shows in 2003, novelist Geoff Dyer observed a young model at a fitting: 'She turned and gazed at herself in the mirror. I say "gazed at herself", but this form of words fails to do justice to whatever it was she beheld in the glass. She had glimpsed what she would become: the incarnation of something more than herself.'

A great gown is exactly that: something more than oneself. And, although few will ever wear such creations as the pink faille dress by Ravhis, immortalized by the photographer Clifford Coffin in 1947, or the champagne-coloured ostrich-feathered slip by Yves Saint Laurent that tickled Linda Evangelista (Patrick Demarchelier, 1987), or the off-white tulle confection by Dior that enveloped Kate Moss on the cover of *Vogue* (Nick Knight, December 2008), the fairytale endures.

With this in mind, the following gowns have been sorted according to their mood. Rather than present a chronological account of their appearance in *Vogue*, it seemed more apposite to take the themes that might connect them. The trends in dressmaking have followed clear revolutions: silhouettes shrink to the slimmest of lines only to explode into great clouds the following year; hemlines rise and fall like the tide, and waistlines scuttle up, down and around the female frame with exasperating impatience. What is *dernier cri* for a moment will disappear for years before making a reappearance decades later, reinterpreted for a new age and a new reader. Here we can see a neoclassical gown by Madame Grès in the Thirties, reinvigorated by Seventies disco divas under Donna Karan, and made fit for Olympian bodies beautiful by Azzedine Alaïa in the Eighties; a Twenties flapper dress by Chanel is reclaimed by a Sixties swinger and then, later, by a Nineties waif. The gown has shape-shifted through the century, picking up and discarding details en route, but its essential power remains unchanged.

Here, then, are images to nurture the imagination and salve the soul. Gowns that have made history, gowns that have transformed the industry, gowns that have captured a moment and forever frozen it in the public mind, gowns that have promised of faraway places and adventures, and gowns that have elevated mere ordinary mortals and turned them into myth. Gowns, above all, that remind us of 'a certain serenity of life'.

← **Mario Testino, March 2001**
Kate Moss embodies the 'new girlie style' in a seductive citrus slip dress with suede details, by Givenchy. The look recalls the spirit of the Twenties, all mini-hemlines, sheer fabrics and Riviera-honeyed limbs. But Kate Moss is a thoroughly modern flapper – sparkling with diamanté and Noughties sass.

classical

Sometimes, the simplest silhouettes are the most beguiling, and few gowns have proved as enduring as the classically inspired robe. After all, who doesn't want to look like a goddess? As simple in appearance as the contour-skimming togas of ancient myth, the gown is deceptive in appearance: such artless sophistication requires masterful skill, and the art of draping has become a career's obsession for couturiers refining and perfecting those all-important folds.

The dress found its sincerest devotees in the Thirties when the fashion for all things Italian (and the popular democratization of fabrics like jersey and artificial silk) offered designers such as Elsa Schiaparelli, Madame Grès and Madeleine Vionnet new opportunities for experimentation with drape and fall. Appearing to hang in liquid folds, the gowns found favour with *Vogue* photographers such as Horst P Horst, George Hoyningen-Huene and Edward Steichen, who, inspired by the Surrealists, used them to define a newly refined yet subtly erotic shape.

'Boldness and even a certain degree of heroism is needed for a woman to face the world despoiled of the old magic which has helped her sex for so long,' explained a *Vogue* editorial in 1932. 'To trust the strength of her own charms, unadorned by any veil, is an act of faith in herself that brings to mind the old verse of Aeschylus describing Helen of Troy. He pictures her as serene as the restful sea, with a beauty so great that it overshadowed the richest garments.'

Such serenity has continued to resonate throughout *Vogue*, where the strictures of a Grecian gown have served as a sartorial palette cleanser each season, as well as flattering and ennobling our fashion sensibilities. In the Seventies, classical gowns were given new dynamism and purpose. Norman Parkinson returned frequently to the goddess theme, placing otherworldly-looking women such as Jerry Hall or Iman, in grandiose amphitheatres or before great modern architectural edifices to create a spirited Aphrodite for the modern age. At the same time designers such as Halston and Donna Karan created kinetic dresses in form-flattering silk-jersey to be worn by the adored divas of the dance floor, with streaming hair and winged feet.

In the Eighties, the supermodels Naomi Campbell, Cindy Crawford and Helena Christensen were reimagined by Herb Ritts and Helmut Lang as sexually explosive Helens of Troy, body-beautiful, ethereal and fabulously untouchable in Versace, Calvin Klein or Azzedine Alaïa. More recently, designers such as Tom Ford, Dolce & Gabbana and Rodarte have looked to the Ancients to showcase exquisite technical skill.

As Patrick Kinmonth wrote in *Vogue* in 1980: 'Legendary beauty sits apart. Time, enemy of loveliness of the flesh, unfocuses the marble figures of antiquity...and allows imagination's alchemy to invent perfection.' We mortals can only wonder.

→ **Horst P Horst, April 1938**
A neoclassical setting imbues this Immortal dress in white jersey, with 'surprisingly long sleeves', by Alix (later Madame Grès) with added gravitas. The picture's implacable star is Ludmila 'Lud' Fedoseyeva, who, after an inauspicious start, became one of the photographer's favourite models: she first met him while mistakenly delivering a parcel to his studio and then furiously throwing the errant package at his feet. Her passionate spirit captivated the photographer, and she became one of the great fashion faces of the era.

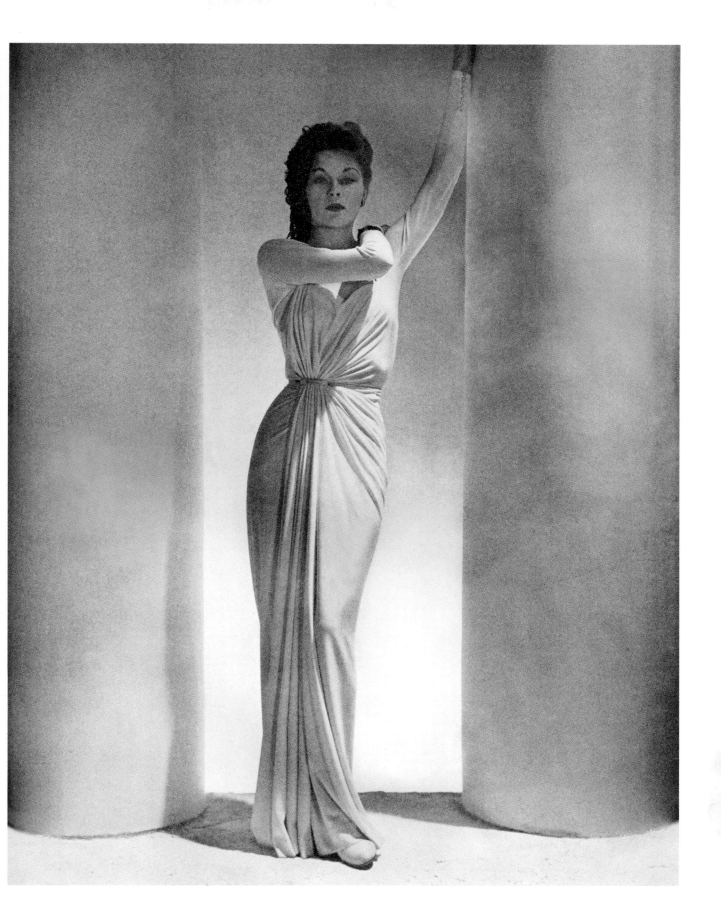

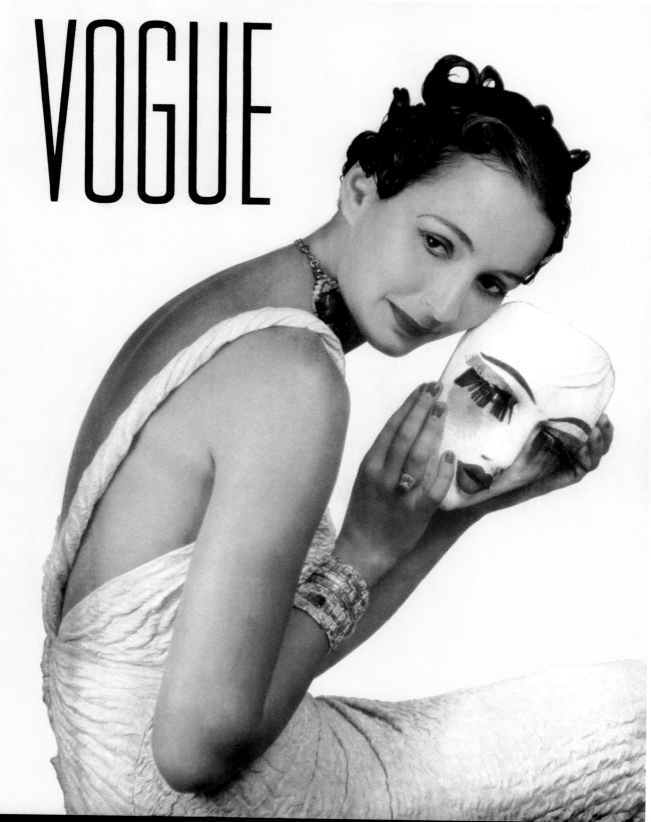

VOGUE

DECEMBER 25, 1935 (26) · VANITY NUMBER · ONE SHILLING THE CONDÉ NAST PUBLICATIONS LTD.

← **Edward Steichen, December 1935**
In the mid-Thirties, Edna Woolman Chase ruled a chiefdom of English, French and American *Vogues*, alongside her British editor Elizabeth Penrose. One of the first colour photographs to grace the cover of *Vogue* (the first, three years prior, was also taken by Steichen), this cover is praised in the accompanying editorial for capturing 'the duplicity of all charming women' through the conceit of a Schiaparelli-designed mask.

↓ **Herb Ritts, December 1988**
The late American photographer had an extraordinary ability to invest the models of the Eighties with the 'superhuman' powers of popular mythology. In his photographic essay 'Modern Legends', cover star Stephanie Seymour is a modern Aphrodite, in white chiffon by Giorgio di Sant' Angelo and silver swirl earrings.

↓ **Mikael Jansson, July 1993**
In 'White Heat' – an essay on cool modernity in Morocco – Czech model Tereza Maxová teaches us how to 'lessen the pressure, lighten up'. A Helmut Lang T-shirt dress announces that 'backs are back', along with the ancient theme of noble sophistication.

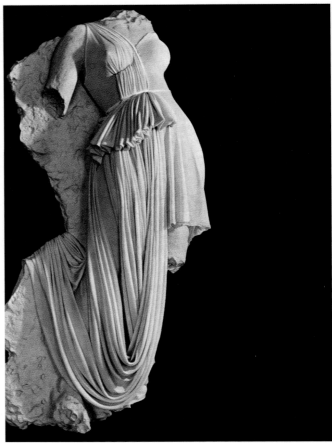

↑ **William Klein, April 1965**
This ravishing pleated dress by Madame Grès is 'light as air, pale as porcelain, made for dancing'. Yet, at the hands of the American-born French film-maker and photographer, our model-muse is here frozen in time, as fixed, immobile and immaculate as a motif on a Grecian urn.

↑ **Photographer unknown, August 1939**
Is it a gown or an artwork? For the New York World's Fair, Alix (Madame Grès) designed and draped a plaster figure as a promotion of trends for the forthcoming season. 'Your figure lays the foundation of your chic…' forewarned *Vogue* in reference to the new voluptuous curves that were set to eclipse the stick-straight silhouette of previous years. 'Tiny waists, rounded hips and curving bosoms,' it continued. 'We're not afraid of drapery.'

→ **Horst P Horst, September 1937**
For all his instinctive passion for the avant-garde, Horst's fashion photographs are an object lesson in classicism. Here, his attentions are focused on Madeleine Vionnet's gown of chiffon-fine lamé: 'Suspended at the necklace, it falls, a torrent of molten gold, in pleats which record every motion of the body.'

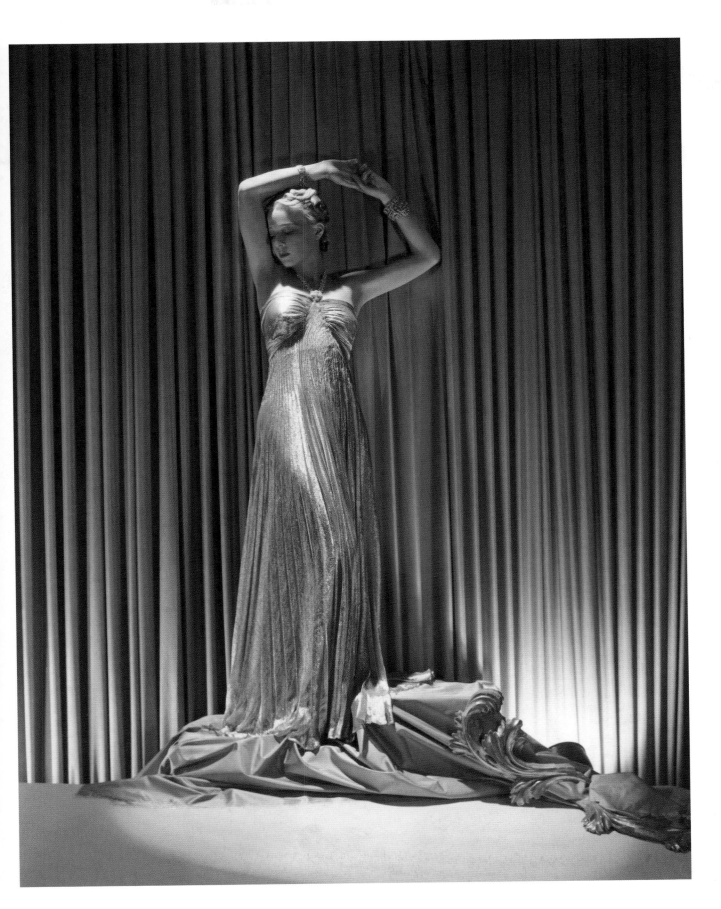

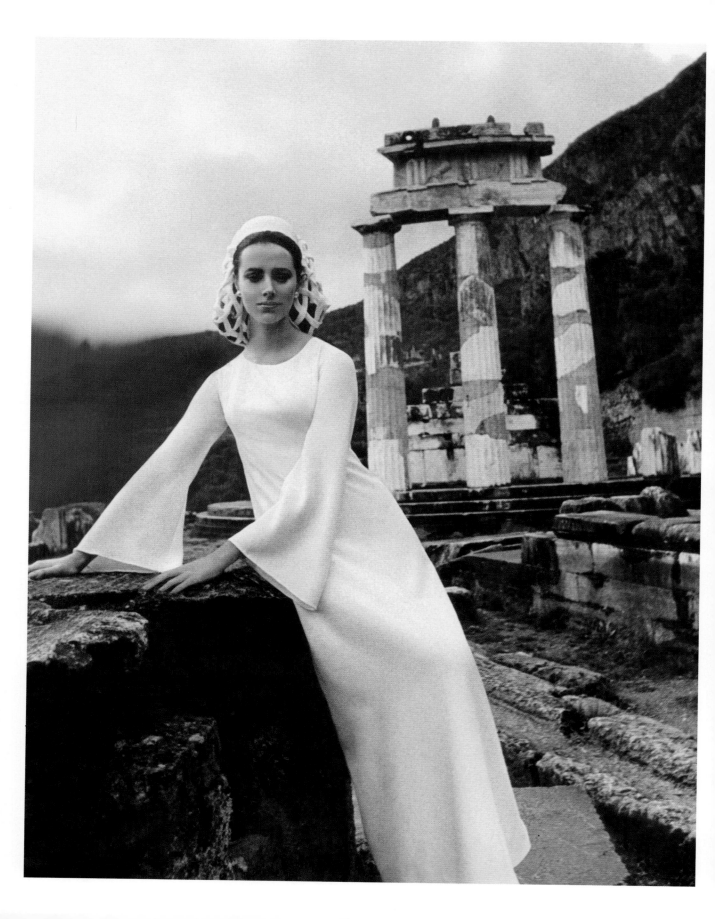

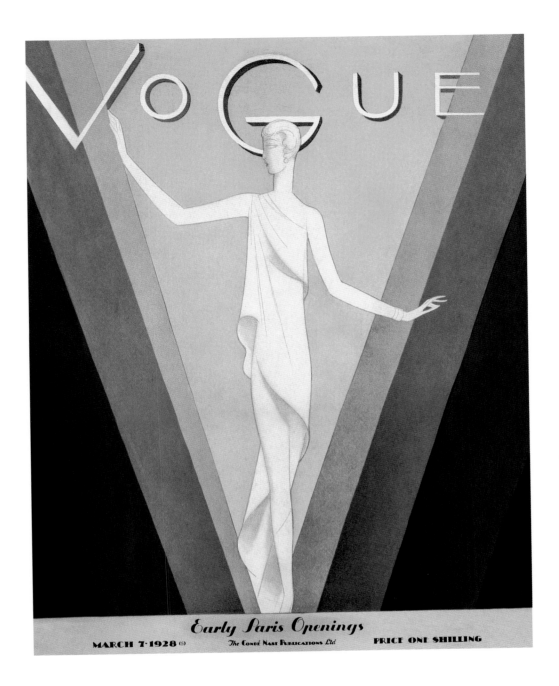

VOGUE

Early Paris Openings

MARCH 7·1928 (5) The Condé Nast Publications Ltd PRICE ONE SHILLING

← Richard Dormer, February 1965
This 'classically simple' wedding dress is shot, Grecian-style, at the Treasury of the Athenians in Delphi. A marble-white crepe gown with fluted sleeves, by Susan Small, makes for a surprisingly demure bridal ensemble, though the lattice-web headdress of woven crepe adds to the intrigue.

↑ Eduardo Benito, March 1928
One of the most prolific fashion illustrators, the Spanish-born artist and graduate of the Ècole des Beaux-Arts in Paris arrived at *Vogue* in 1920. A devotee of the Cubist and Constructivist movements, Benito created sculptural-looking female figures that are timeless, chic and yet emphatically independent.
The issue coincided with the year of Amelia Earhart's first successful transatlantic flight, in an era awash with new feminist heroines.

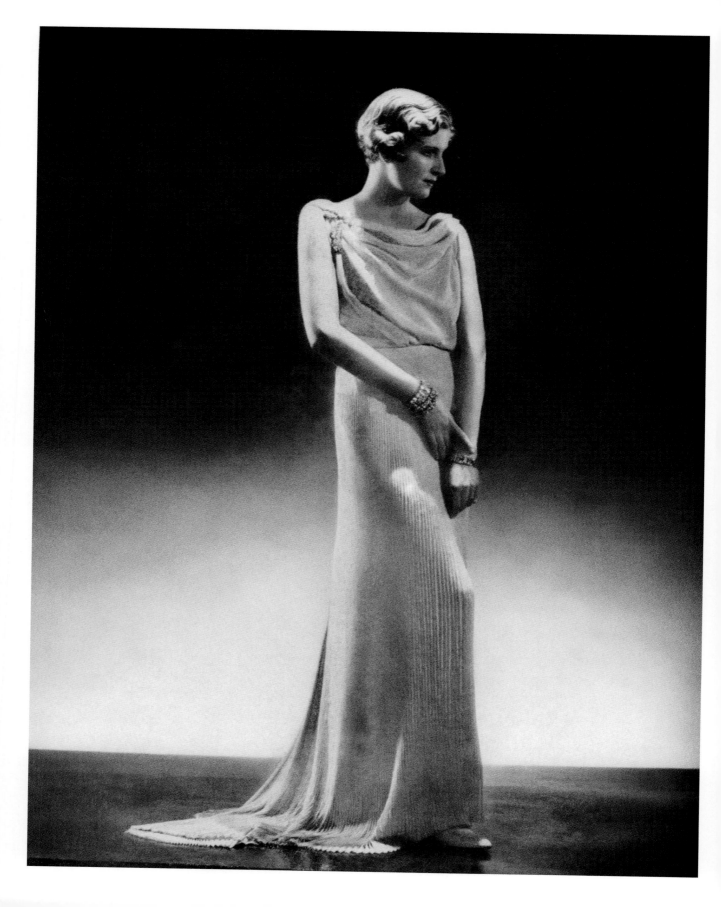

George Hoyningen-Huene, May 1932
'Before these pictures of a young mortal, how can one help thinking of her immortal sisters, the wingless victories that dance through the centuries on the frieze of Greek temple far away on the wind-blown Acropolis?' So demands *Vogue*, as Hoyningen-Huene breathes magic into a bas-relief (below). Whether in movement or in repose (as seen in the Madeleine Vionnet gown, opposite), the photographer's mastery is found in the art of dissembling, so that the body and gown are one and 'the tunics of a Greek nymph…play their own role in defining proportions, giving character to an attitude, accentuating a gesture'.

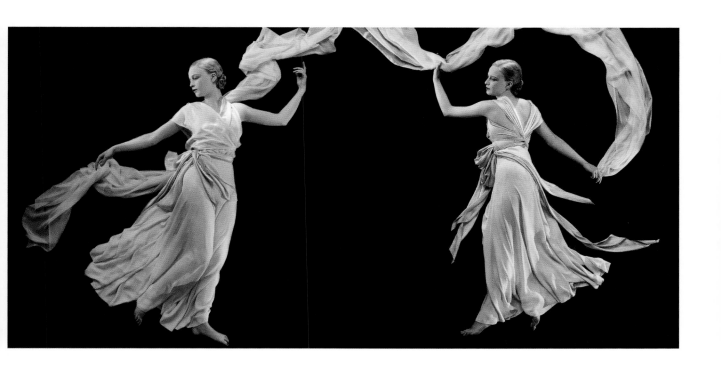

← Lee Broomfield, August 2004

Jennifer Lang creates a barely-there gown of shredded tassels and knitted loops that recalls a latter-day Queen of Sheba and which is here worn with the same noble confidence and regal bearing.

↓ Patrick Demarchelier, October, 2006

No mistaking the divine curves and magnetism of this modern goddess. Scarlett Johansson combines conscience and couture for *Vogue*, promoting both ethical fashion and this strapless silk organdie dress by Armani Privé.

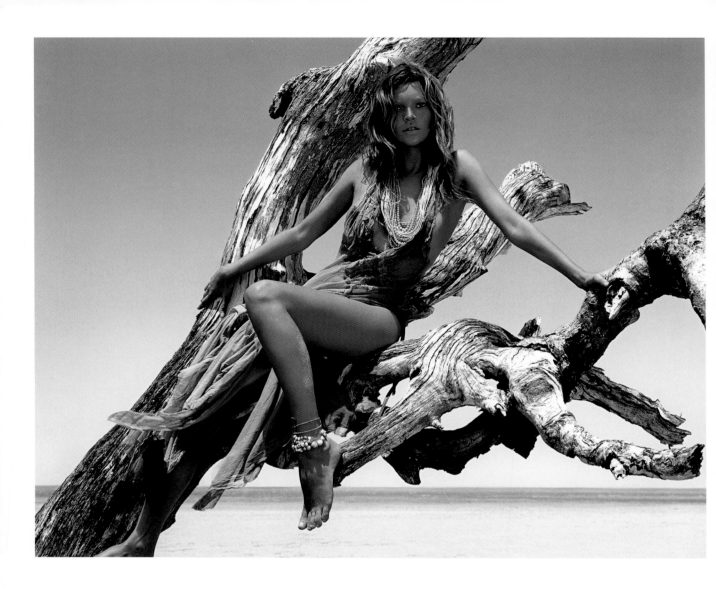

↑ **Mert Alas and Marcus Piggott, June 2002**
Under the white heat of the Kenyan sun, Kate Moss perches upon sun-bleached driftwood. She is as a hypnotically beautiful siren; her salvaged jewels and embroidered sea-green gown by Preen only better serving to entice love-drunk suitors to their fate.

→ **Tim Walker, May 2011**
We are in the dunes of Kolmanskop, in a former mining town slowly being reclaimed by the sands of the Namib Desert, and haunted by the ghosts of a lost civilization. The model, Agyness Deyn, is warrior-like in softly draped silk by Donna Karan – her Amazonian image helped, in no small part, by the prowling cheetahs at her feet.

→→ **Nick Knight, September 2012**
Vogue's contribution to the 2012 Olympic Games was not athletic, but it was no less a feat of stamina, enterprise and endurance. For 'The Midas Touch', *Vogue* gathered together 12 British models, photographer Nick Knight and British design houses to present a set of images that was also used as a backdrop at the Olympiad's closing ceremony.

Naomi Campbell is here immortalized in a creation by Sarah Burton at Alexander McQueen: 'bedecked in golden metalwork and complete with Indian jewellery and gold-dusted tulle cape and train'. Driven by her own Olympian ambitions, the model is characteristically confident: 'If I were an athlete, I would be a sprinter. It looks so elegant – and I can definitely hold my own.'

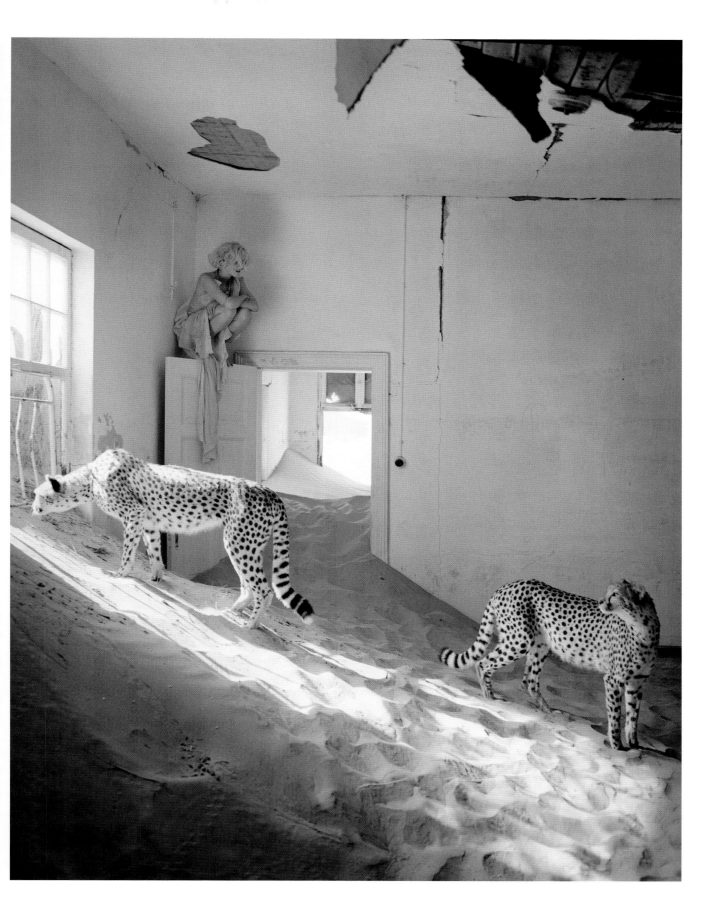

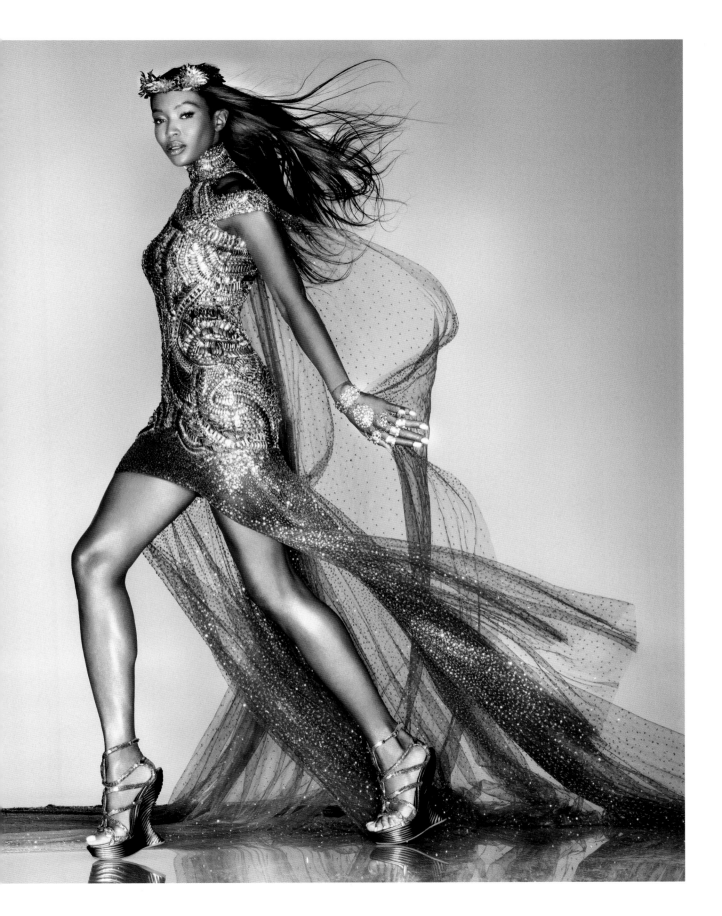

↓ **George Hoyningen-Huene,
November 1932**

It was the beginning of a new decade
and the fashion world was enthralled by
the 'new flow of Vionnet's draperies'.
The architect of the bias cut, and a
passionate admirer of the fluidity
in Grecian design, French designer
Madeleine Vionnet famously decreed that
'when a woman smiles, her dress should
smile too'. Sadly, we cannot appreciate
the subtle gradations in 'vari-coloured
pastels', nor the gauzy chiffon panels that
this gown featured, but we can agree
absolutely in *Vogue*'s assertion that this
is 'all in all – a delicious frock'.

→ **Clifford Coffin, October 1948**

In post-war Britain there was perhaps
little need, or desire, to conjure the
tragic heroines of mythology. But here, a
renewed enthusiasm for elegance finds
Vogue amid the majestic red-marble
pillars of the Grand Trianon at Versailles,
marvelling at the 'Grecian simplicity'
of Marcelle Chaumont's pleated
'soft-as-chiffon gold lamé, held by gold
braid at a high Greek waistline'.

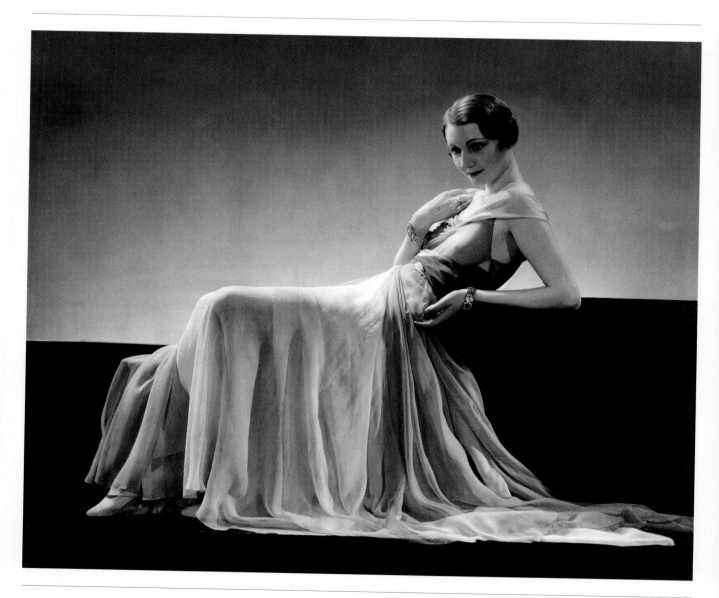

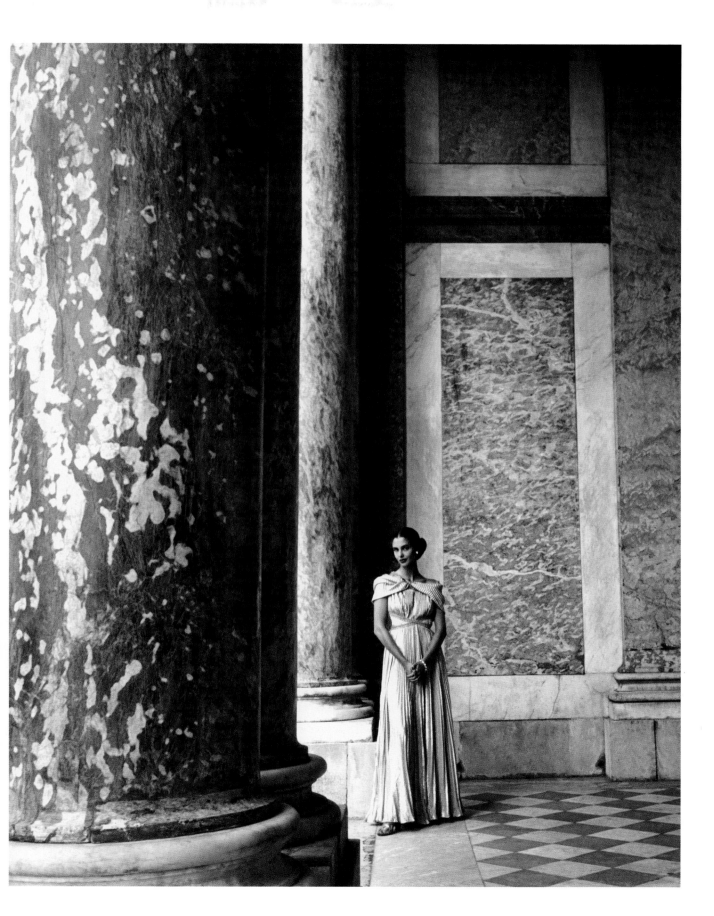

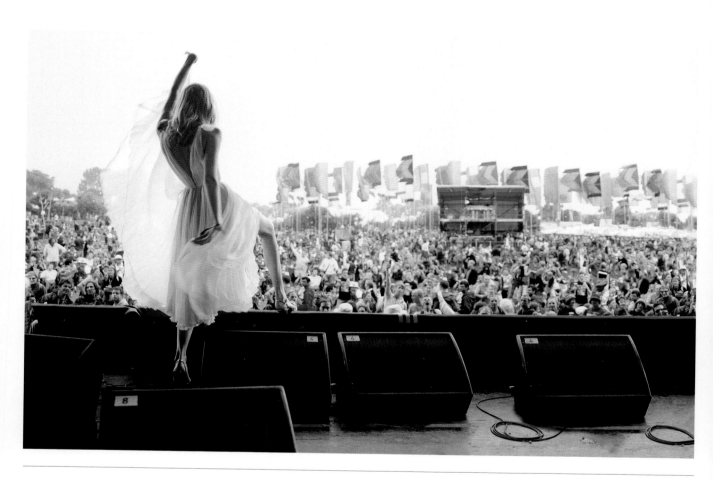

↑ **Corinne Day, October 2005**
Glastonbury – where the gods of rock
entertain their devotees from faraway
stages and mortals revel in the mud.
The 2005 festival will be memorable
for the rain that fell down ceaselessly
over the *Vogue* crew sent to capture
this uniquely British event. But when
Gemma Ward took to the stage, in a
pleated chiffon dress by Alexander
McQueen, the gods had mercy and,
for a moment, the sun shone…

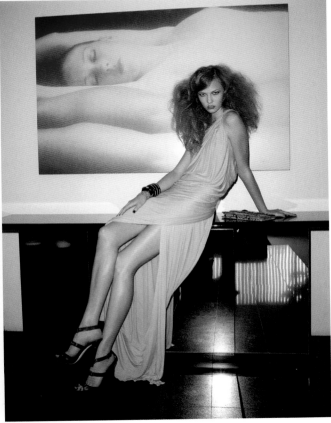

↑ **Mario Testino, December 2007**
The Russian model Sasha Pivovarova
stars in a magical winter story that
references everything from Shakespeare
to Lewis Carroll, and from punk to the
shape-shifting beasts of fairytale.
Here, she is a Givenchy nymph, ethereal
in pale pink accordion pleats as 'fragile
as fondant icing'.

↑ **Terry Richardson, November 2008**
A seductive, jersey gown is high up
on *Vogue*'s 'hostess hotlist' in this
quintessentially slinky eveningwear
shoot by the American photographer
Terry Richardson. Karlie Kloss is our
guide to the bacchanal: just add
Donna Karan's 'peachy perfect gown,
and acres of leg'.

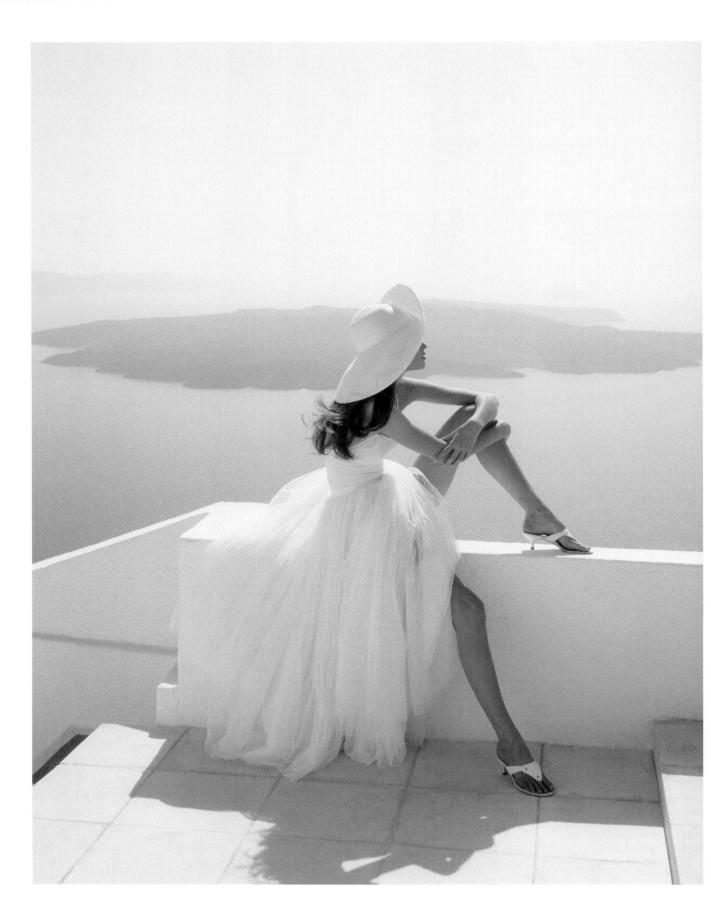

← **Mario Testino, January 1993**
Santorini, Greece, with its sparkling whitewashed walls, makes the perfect lookout onto the crystalline waters of the Aegean. All set the scene for Isaac Mizrahi's tulle confection, part of a 'well-behaved' collection deemed suitable for relaxed holiday-wear.

↓ **Nick Knight, May 2007**
This time England's shingled shoreline of Kent forms a backdrop for this billowing, sail-like silk crepe gown by Narciso Rodriguez. Lily Cole, flame-haired and baby-faced, makes for a very modern Venus, the goddess's signature scallop shell here replaced by a giant plastic corsage.

→ → **Mario Testino, March, 2011**
The clear crystalline waters of the Indian Ocean offset an indigo taffeta gown, by Etro, in this location shoot by a master of the fashion narrative. 'Spicy hues on cottons, silks, simple summer tops and long, sweeping skirts are a sunny outlook,' says *Vogue* of the new season, which delivers a vivid punch of colour with it. Is our young goddess, here, awaiting the return of a hero, or ensnaring a hopeless mortal devotee? Either way, we are entranced.

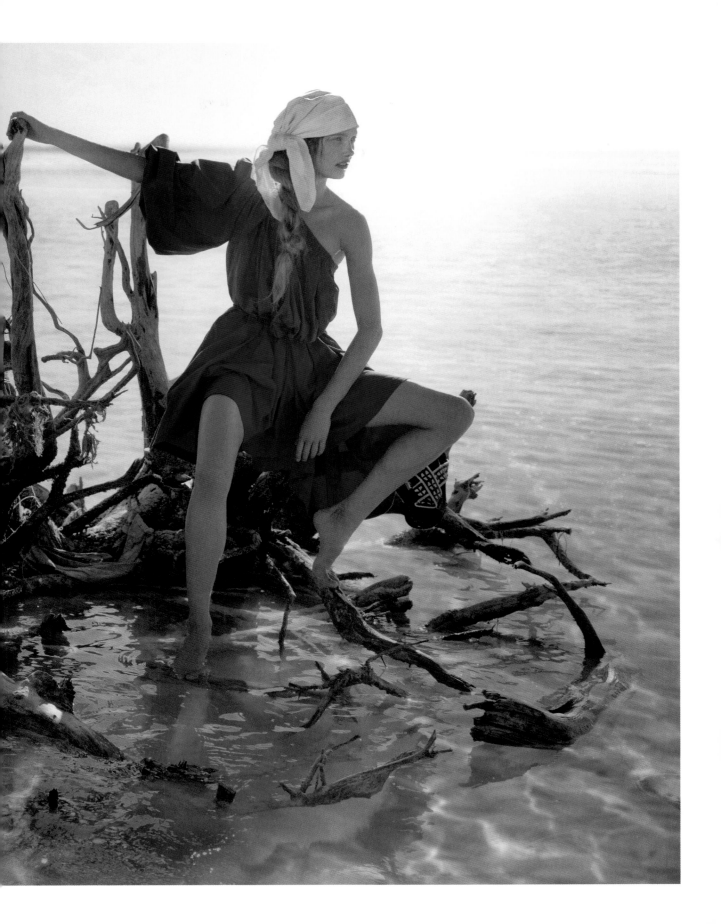

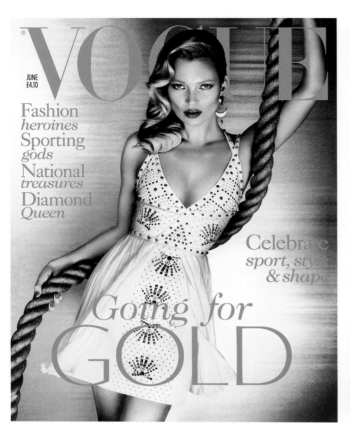

↑ **Mert Alas and Marcus Piggott, June 2012**

Kate Moss fronts a special issue of *Vogue* to celebrate the 2012 Olympiad. 'Going for Gold' proclaims the magazine's cover line. And what better way to mark an issue dedicated to sport, style and shape than this studded leather and silk dress by Versace? Gladiatrix chic never looked so good.

↑ **Lee Miller, April 1941**

'London Can Make It' announced *Vogue* as beleaguered Londoners battled fabric rations and limited means. The fashion seasons continued to shift with placid inevitability, nonetheless, and in this issue soft sleeves, accented waists and contrast colours were held up as the latest innovations. Here Ravhis' 'graceful sloping-shouldered gown' and Joe Strassner's 'statuesque white crepe' are accessorized with battle armour and Grecian bands. 'Ravhis nips waists with inserts of elastic-shirred fabric', while Strassner's gown makes good example of the new 'small draped crossover sleeve for evening'.

→ **Clifford Coffin, July 1946**

In this rare colour plate, a simple white gown by the future Queen Elizabeth's favourite couturier, Hardy Amies, perfectly demonstrates the 'limpid drapery of classical Greece'. The look is described as being 'Zephyr cool for evening', but it is the haunting melancholy in the model's eyes that most bewitch here.

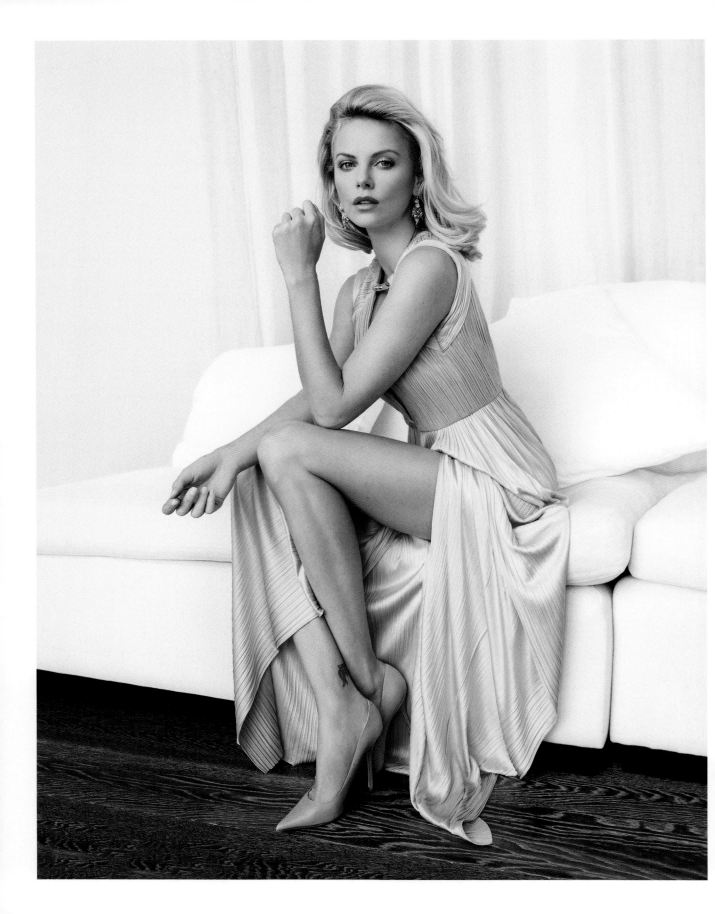

← Patrick Demarchelier, May 2012

A Hollywood goddess at the height of her powers…and armed with an Academy Award. In fact, as the South African-born actress Charlize Theron insisted in her interview, she wasn't at all what the industry wanted when she first set out on her career: 'I was too tall, too big, too late for the supermodel look of the Eighties.' *Vogue* justly applauded her for her earthy attitude and salty humour, but nothing can mask her otherworldly beauty before the lens. Here she wears baby-blue pleated Versace and an expression worthy of Helen of Troy.

↓ Horst P Horst, November 1937

During her short career as a couturier, Jeanne Lanvin transformed attitudes to womenswear. A great exponent of fluid design, her genius is fully expressed here, in a lamé gown, shirred to the hipbone and pooling to the floor like molten gold.

↓ André Durst, June 1938

A woman in white is the focus of this typically stark composition by Durst. The image has a Hollywood-like dramatic tension, and our model's froideur recalls something of the silver-screen star Greta Garbo – all the better to showcase the crepe gown by Jeanne Lanvin, 'draped with all the cunning of a sculptor, tailored severely, contrasted with black and frosted with silver'.

Classical 39

↑ Patrick Demarchelier, January 1985
Here a white pleated Hellenic dress by Mary McFadden helps demonstrate 'the new beauty of fashion', in which the model's hair is moulded maquette-like to the scalp and her body is daubed with paint. As *Vogue* wrote of the new mood: 'The body is wrapped in asymmetric simplicities, crypto Egypto, the jewels have weight, the paint, Nuba inspired, is daubed and plastered.' Clashing cultural influences abounded in the mid-Eighties but, despite the cacophony of ideas, the end results are surprisingly simple.

→ Herb Ritts, October 1989
'The laughing leaves of the trees divide / And screen from seeing and leave in sight / The god pursuing, the maiden hid.' Algernon Charles Swinburne's verse accompanies this fashionable metamorphosis, and an evening gown appears almost as bark. Has *Vogue* declared itself a 'friend of the Earth', calling time on the heady excesses of the Eighties? Not likely, when the gown in question is a chameleon bronze sheath by Romeo Gigli.

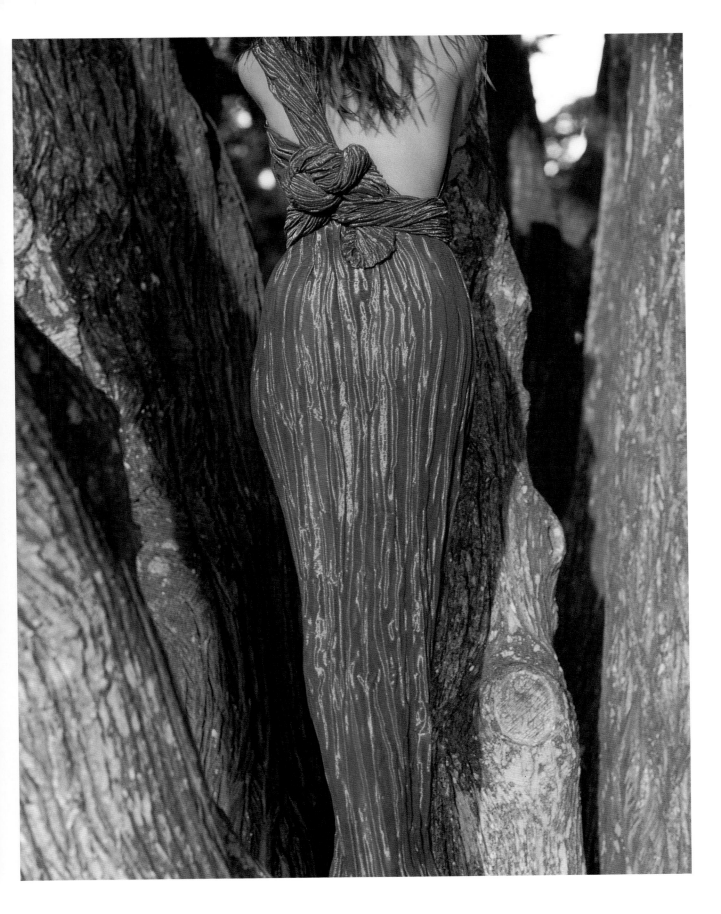

↓ **Justin de Villeneuve and Klaus Voormann, November 1969**

Like a winged Victory, Twiggy takes flight in 'an enchanted dress, flying from the neck and sleeves', by Ossie Clark, and with a diamanté and gold eagle at her throat. Part of a 'Surreal Adventure' concocted by the model's manager and boyfriend, de Villeneuve, and the idiosyncratic German musician and artist Voormann, this classical excursion is a distinctly Sixties trip.

→ **John Cowan, May 1967**

Another winged fantasy, this time barefoot in the sands of Abu Dhabi. The tiny emirate and former pearl-diving capital had struck upon the oil that was to transform the Gulf only two years previously, and the Arabian sands are as yet unsettled by the massive influx of settlers to come. For now, the mood is free and full of opportunity. The gown? 'Polyester crepe with crystal clear buttons', by Eve Stillman.

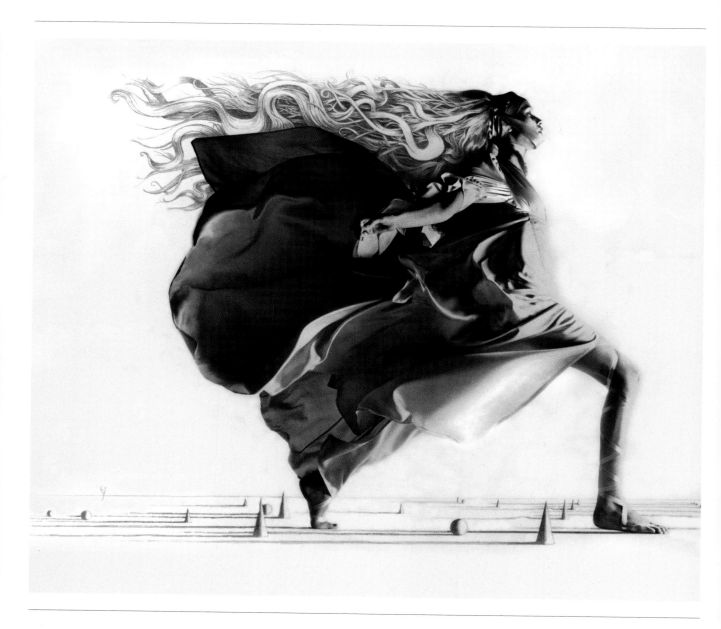

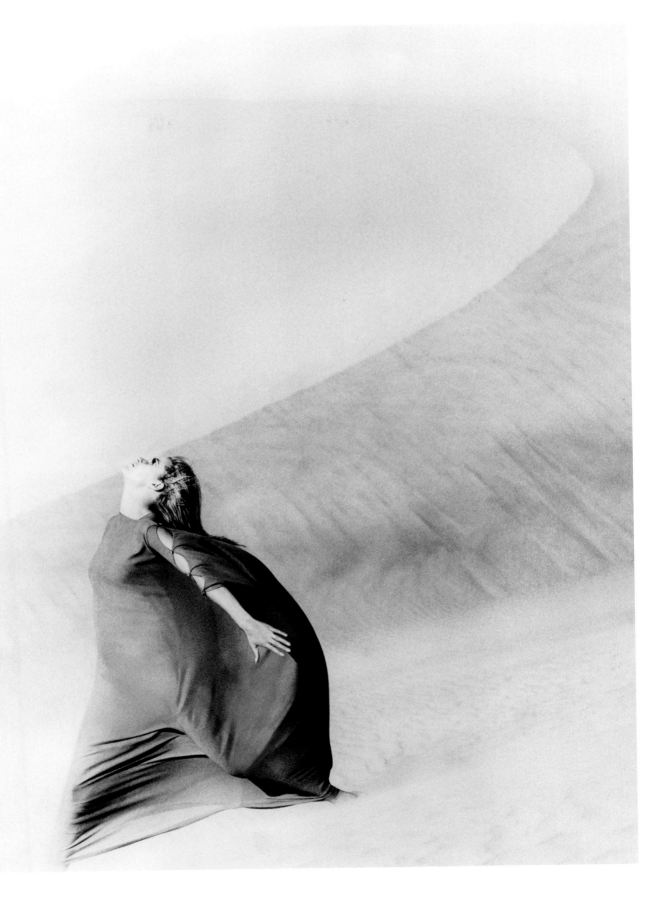

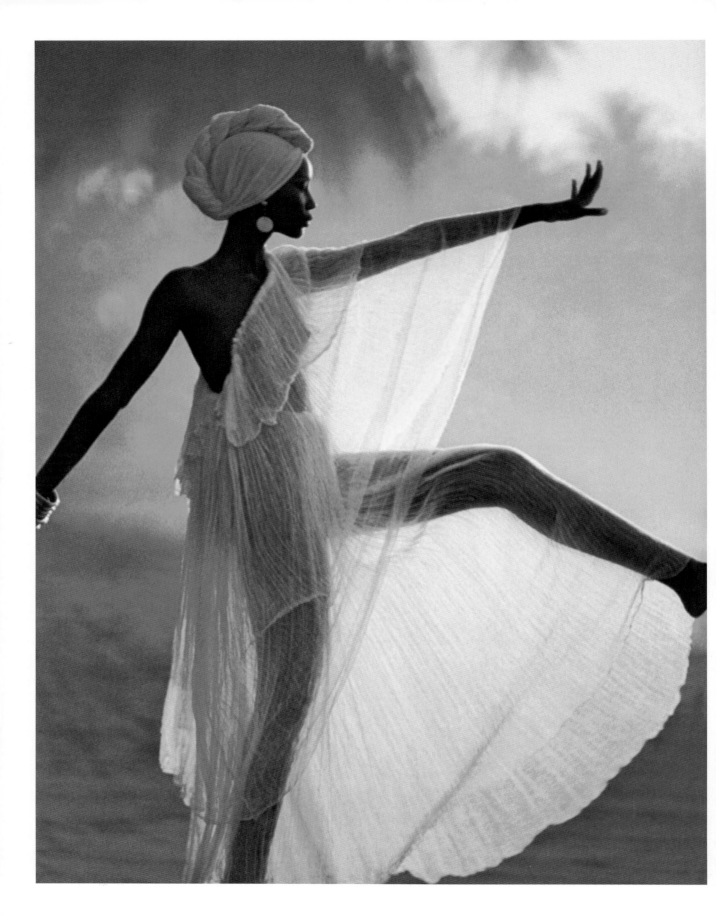

← Norman Parkinson, May 1976

The *Vogue* photographer's summer retreat in Tobago, West Indies, formed the backdrop for many of his fashion shoots. In 1976 he took the then unknown Iman Mohamed Abdulmajid (latterly Mrs Bowie) to the island, to shoot the lissom Somalian beauty in summer fashion. In gauzy cheesecloth (priced £1 a metre from Liberty's Oriental Department) and gold-disc earrings by Saint Laurent Rive Gauche, she became a model sensation shortly thereafter, a favoured muse of both Parkinson and the designer Yves Saint Laurent, who was later to describe her as his 'dream woman'.

↓ David Bailey, February 1976

'When did you last see the colours of sunshine?' *Vogue* asks readers beleaguered by the chill winds and bitter frosts of February. The magazine delivers only the promise of sun, via a 'flight south to Djerba', and this picture of Marie Helvin – loosely draped in a creamy sand jersey dress, by Yuki, and a matching turban.

↓ Eduardo Benito, September 1926

The illustrator here delivers a rainbow of colour to mark the beginning of autumn. But will this modern Pandora be tempted to open her treasured casket? We trust that *Vogue*'s offering of new seasonal delights proved sufficiently distracting…

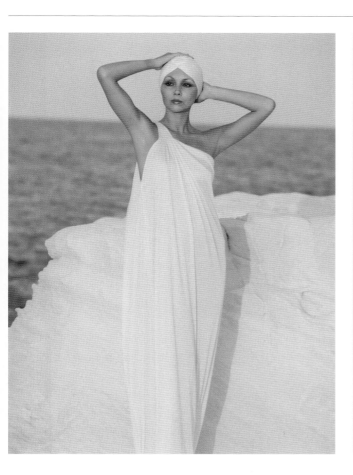

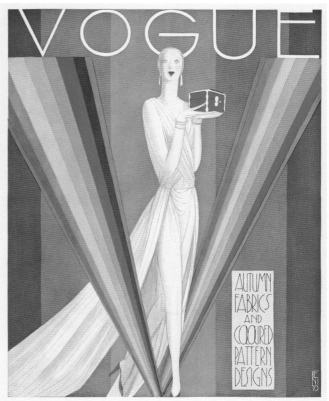

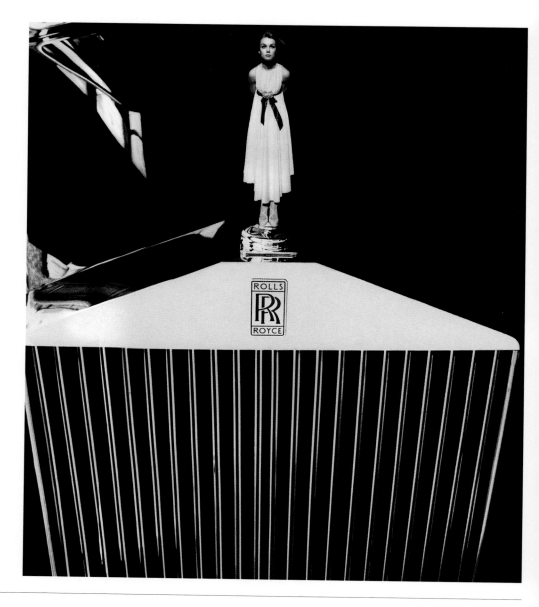

↑ Helmut Newton, April 1966

Forget Pegasus. Today's wings are brought to you courtesy of a Rolls-Royce Silver Cloud Mark III – 'gliding, faultless, timeless and powerful'. Jean Shrimpton is *Vogue*'s own Spirit of Ecstasy (or hood ornament, depending on your fancy), 'flying free' in a chalk-white gown by John Bates and slingback shoes by Christian Dior.

→ Herb Ritts, June 1989

Vogue celebrates a 'forceful, new womanhood' in a typically Amazonian shoot by Ritts. 'Strong, lean and vigorous, the current ideal body is light years away from the delicate notion of delicate femininity,' writes *Vogue* of the new weight-trained, muscle-built body aesthetic, hewn by the novel practice of Pilates ('pronounced Pi-lah-tes'). A shiny viscose off-the-shoulder dress, by Michel Klein, is the best way to show off one's 'strong, flexible and long musculature', while the body is beautified with lashings of Lancôme's Sculpturale, 'to smooth, hydrate and contour'.

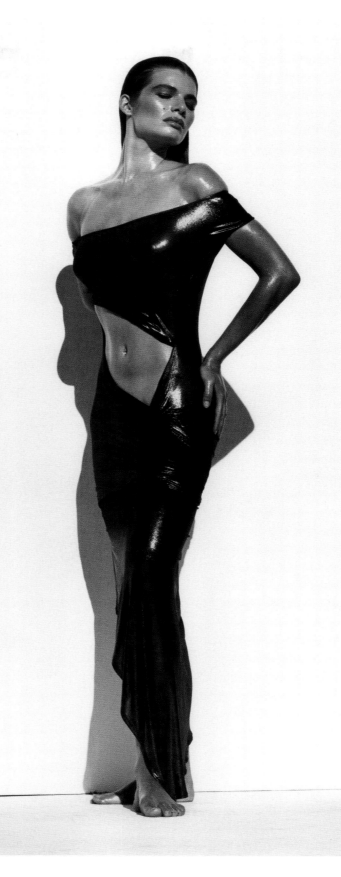

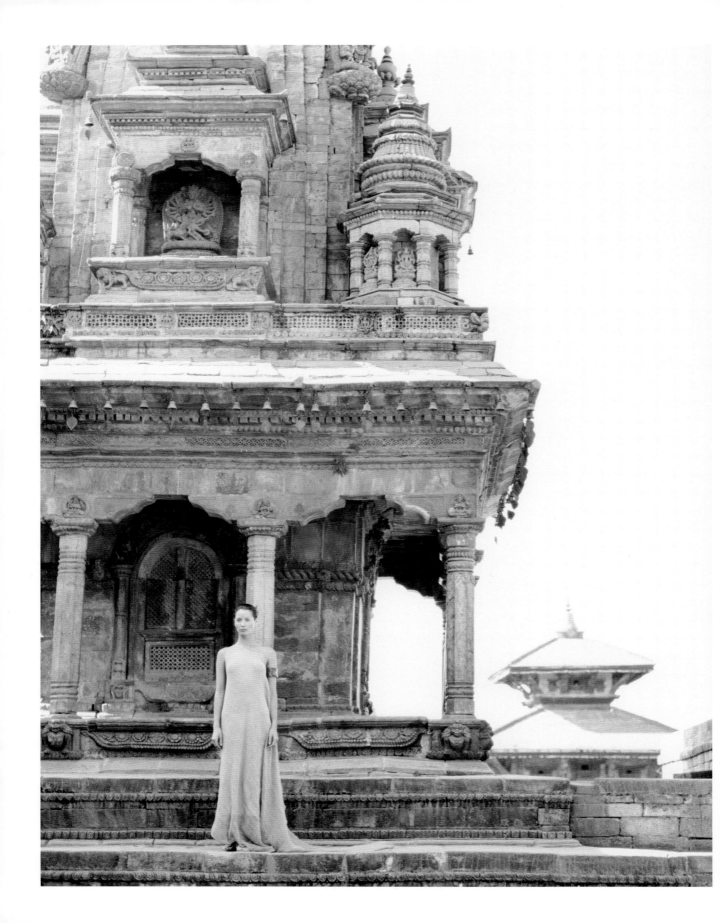

← **Arthur Elgort, March 1994**

Standing in the ancient temple of Singha Durbar in Kathmandu, Nepal Christy Turlington is divine in a metallic chiffon sari dress by Donna Karan. It is all part of a mid-Nineties simplification in style: 'Following a Buddhist philosophy of purity and sparse elegance, these clothes are designed to please the eye and cool the karma.' When modelled by the goddess of clean living, Christy Turlington (herself a yoga devotee, the creator of ayurvedic cosmetics and a philanthropy queen), the look is positively transcendent.

↓ **André Durst, January 1937**

'The Grecian influence still casts its shadow in some of the most distinguished evening dresses,' says *Vogue* of Elsa Schiaparelli's navy-blue corded crepe gown with 'statuesque moulding', whose wearer is here captured rapt before a suitably classical tableau.

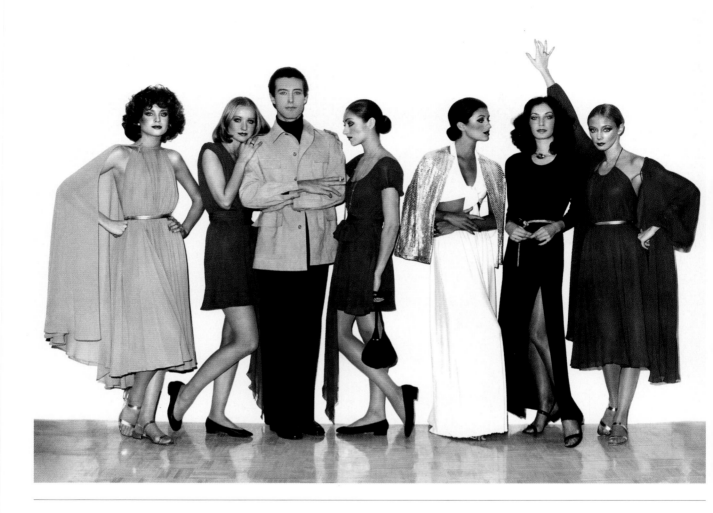

↑ Eric Boman, March 1975

Roy Halston Frowick, otherwise known
as New York Seventies superdesigner
Halston, is flanked by disco divas in his
'skimp dress and other spring stories'.
The length is up to you, Georgette rules,
in a rainbow of slinky alternatives, and
accessories are kept to minimum – just
don't forget to bring your dancing shoes.

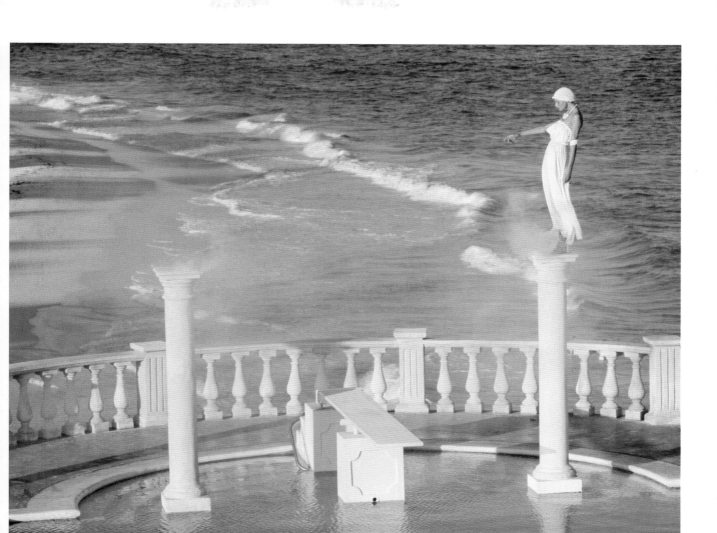

↑ **Norman Parkinson, July 1973**
Apollonia van Ravenstein rules the
oceans from upon her pedestal at
the Crane Beach Hotel in Barbados,
dressed in ivory Ban-Lon jersey, by
Jane Cattlin. *Vogue* describes the
island as 'happiness-on-sea', with
'mile upon mile of curving coral sands
and postcard-blue seas and the year-
round unfailing and reliably tanning sun'.
An image of near-mythological status
itself, it encapsulates both a new age
of exotic glamour in *Vogue* and the
magnificent working partnership
enjoyed by 'Parks' and his impossibly
glamorous Dutch muse.

↓ **Eduardo Benito, August 1930**
With her basket of seasonal bounty (of *Vogue* patterns), Benito's scarlet draped goddess is like a modern Pomona – accompanied by a young fawn and garlanded in gemstones.

↓ **Mario Testino, March 2011**
Model Karmen Pedaru is swathed in saffron-coloured silks in this kaftan-inspired evening dress by Costume National. Shot in Zanzibar, on a beach far, far removed from modern civilization, the image speaks of an ancient beauty, as rare and unspoiled as the sands beneath her feet.

→ **Norbert Schoerner, July 2006**
The marvellously named Andi Muise delivers her siren call across the sparkling Aegean Sea in pleated Hermès in that label's quintessential orange. 'Wickedly sexy and heartbreakingly cool', *Vogue*'s apparition in Chanel sunglasses proves an 'irresistible lure'.

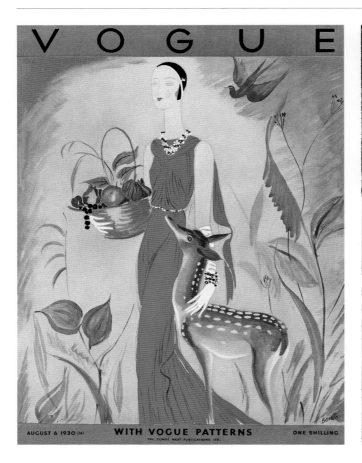

VOGUE

AUGUST 6 1930 (16) **WITH VOGUE PATTERNS** ONE SHILLING
THE CONDÉ NAST PUBLICATIONS LTD.

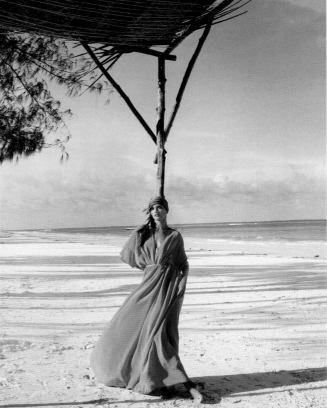

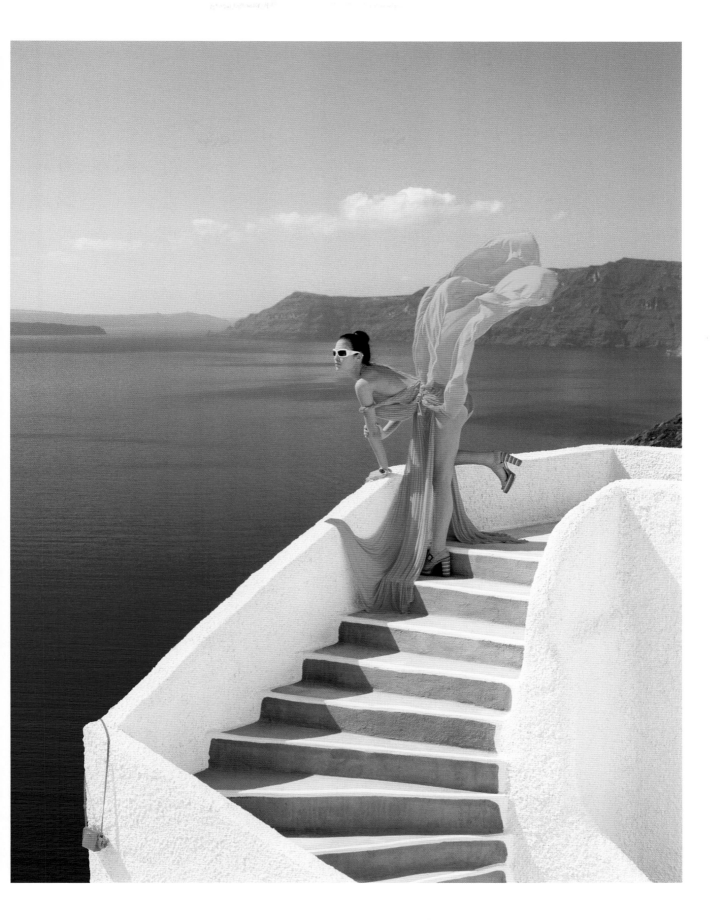

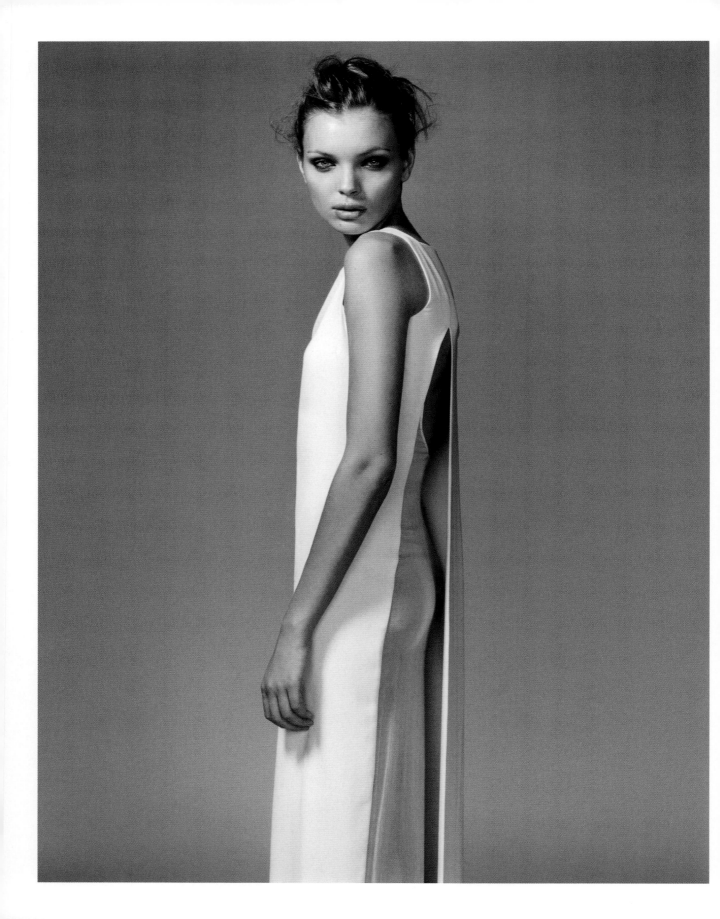

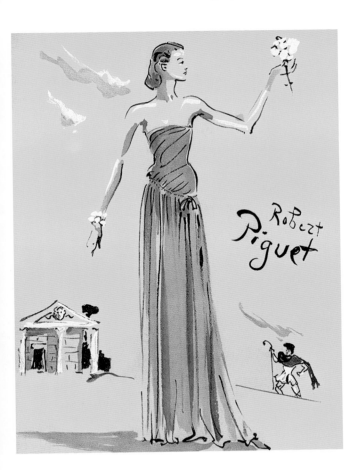

← Robert Erdmann, March 1997
Gianfranco Ferré's simple long white dress is slashed from the shoulder blade for greater fluidity and ease of movement. No statement jewels here, and certainly no smiling – this is Nineties femininity pared down to a sensuous extreme.

↑ Christian Bérard, September 1937
For this September issue, the illustrator conjures a couturier's parade, drawing on that season's continuing devotion to all things classical. Robert Piguet's sea-green silk-jersey evening sheath comes with accompanying temple and hero. The dress, however, needs no more decoration than the simplest of beads and a floral corsage.

↑ Patrick Demarchelier, July 1986
Christy Turlington's facial symmetry would have greatly satisfied admirers of the Phidian rules of beauty, and she found her perfect match in Donna Karan, a designer expert in cool, contemporary classicism. The combination is put to dazzling effect here, on a July cover from the mid-Eighties.

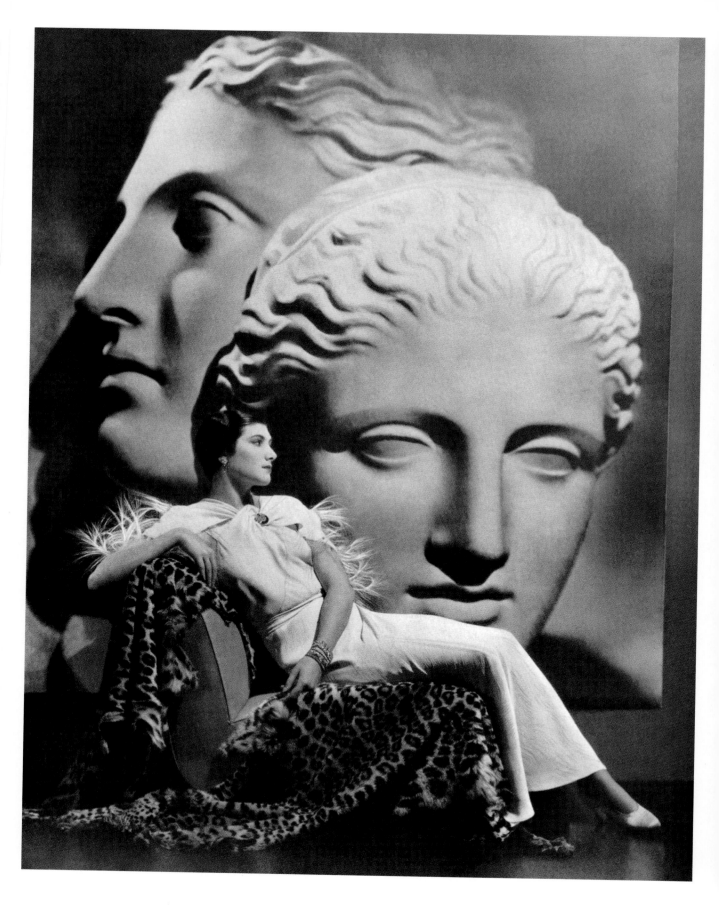

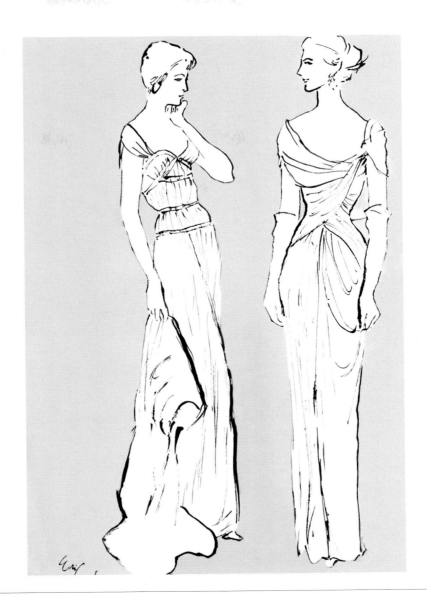

← George Hoyningen-Huene, June 1934

Jeanne Paquin's heavy broche crepe gown, with shoulder pieces edged with feathers and a train on the skirt, serves to remind readers of 'The Prestige of White'. The giant classical heads and leopard-skin throw, however, are only optional extras.

↑ Carl Erickson, September 1955

The celebrated American illustrator has been tasked with capturing the 'heartening sense of confident fashion advance' in the latest collections. Eveningwear is high-busted and slim, 'especially welcome after years of heavy-weight near-crinolines', although Vogue decries the 'swing back to straplessness', seen elsewhere. Thank heavens, then, for these serene silk-jersey gowns by Mattli (left) and Ronald Paterson (right), in equally timeless shades of grey.

fantasy

'Who can describe a robe made by the fairies? It was white as snow, and as dazzling; round the hem hung a fringe of diamonds, sparkling like dewdrops in the sunshine. The lace about the throat and arms could only have been spun by fairy spiders. Surely it was a dream!' — Anon., *The Little Glass Slipper*

Asked to imagine the dress of their dreams, most women will defer to Cinderella. Centuries may have passed since the French folk tale first became popular but the specifications have barely changed: the fantasy gown must be lush and extravagant; it must swish across the floor with a whispering sweep; it must feature clouds of taffeta, streamers of tulle, ribbons of silk and sparkling jewels; it must make one feel like the scion of a minor European royal family. And, in almost every eventuality, it should be pink.

Vogue has always seen itself as fashion's fairy-godmother – blessed with the power to fulfil all our wishes, no matter how outlandish. At *Vogue*'s command, perfect white wedding dresses are conjured for coupon-poor war brides, sultry evening satins are made to seduce in, and make-believe ball gowns spun out of thin air. Like Cinderella's enchanted retinue, *Vogue*'s supporting cast of photographers, designers and stylists, make-up artists and hairstylists all have their role to play.

British designers have always demonstrated an especial weakness for such nostalgic flights of fancy. London couturiers Victor Stiebel and Norman Hartnell created the blueprints for sweetly romantic eveningwear that was innocent, charming and devastatingly pretty. John Galliano has long plundered the historical archives to create ever-more breathtaking designs.

Dame Vivienne Westwood, too, has made a trademark of fine crinolines that are part pirate queen, part Elizabethan lady, and fully bewitching to behold.

Many of the following gowns are couture – dresses drawn from the wildest reaches of a designer's imagination, and painstakingly hand-sewn, stitched, embroidered and appliquéd by an atelier of dressmakers, whose modesty and expertise might have inspired the Grimm Brothers' *The Elves and the Shoemaker*. Such gowns recall a sumptuous history of womenswear weaving a golden thread of continuity, from the court of Elizabeth I, through the salons of Marie Antoinette, and into the great design houses of today. As Yves Saint Laurent observed, haute couture is an exquisite legacy of 'secrets whispered down from generation to generation'.

The notion of dressing like a princess is one *Vogue* has actively encouraged. Over the years, the magazine has been a portal into the world of the Windsors, and its photographers – Cecil Beaton, Lord Snowdon, David Bailey and Mario Testino among them – have captured the most candid moments, from Royal weddings, birthdays and coronations, with a sense of unbridled celebration and a stirring of sentiment befitting the best fairytales. (*Vogue* certainly does *not* invite republican dissent.)

The wedding is the closest most women will get to their own Cinderella moment, so appropriately the magazine remains transfixed by the transformation of a bride en route to the altar: 'We're a romantic bunch at heart,' wrote the editor in 2011. In the union of girl and gown, there can be no happier ending.

→ **Peter Lindbergh, August 1988**
Queen Guinevere reincarnated: Linda Evangelista wears Murray Arbeid's strapless dress with a black velvet top and net skirt over pink satin, and a coronet of beaten metal by Slim Barrett.

This mythical creature may not wear the 'grass-green silk' described by Alfred, Lord Tennyson, but few would argue about her loveliness. As the poet writes: 'A man had given all other bliss, / And all his worldly worth for this, / To waste

his whole heart in one kiss / Upon her perfect lips' ('Sir Launcelot and Queen Guinevere: A Fragment').

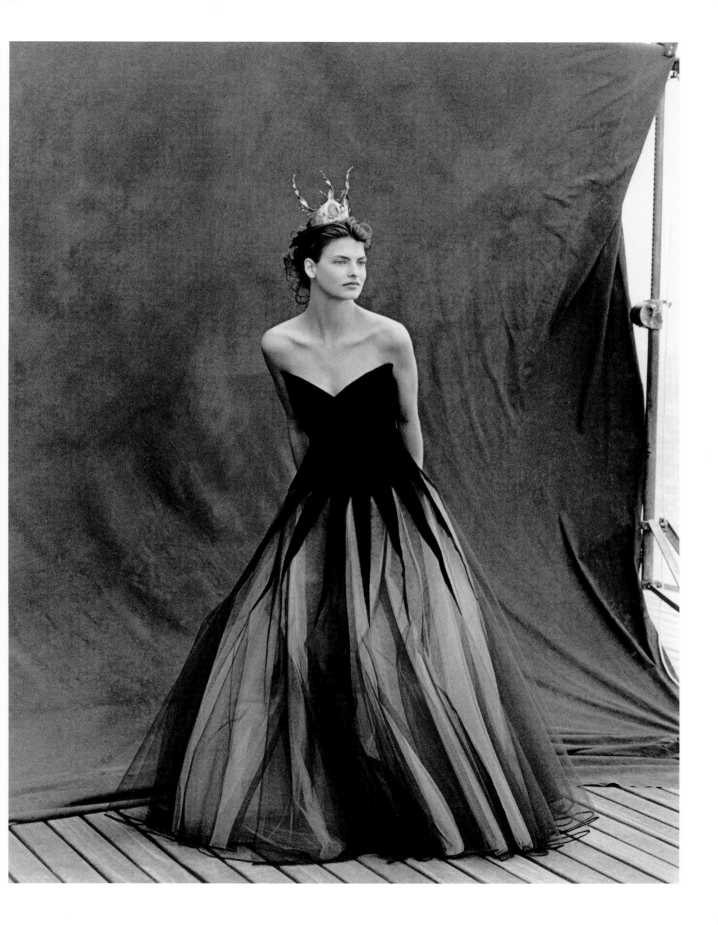

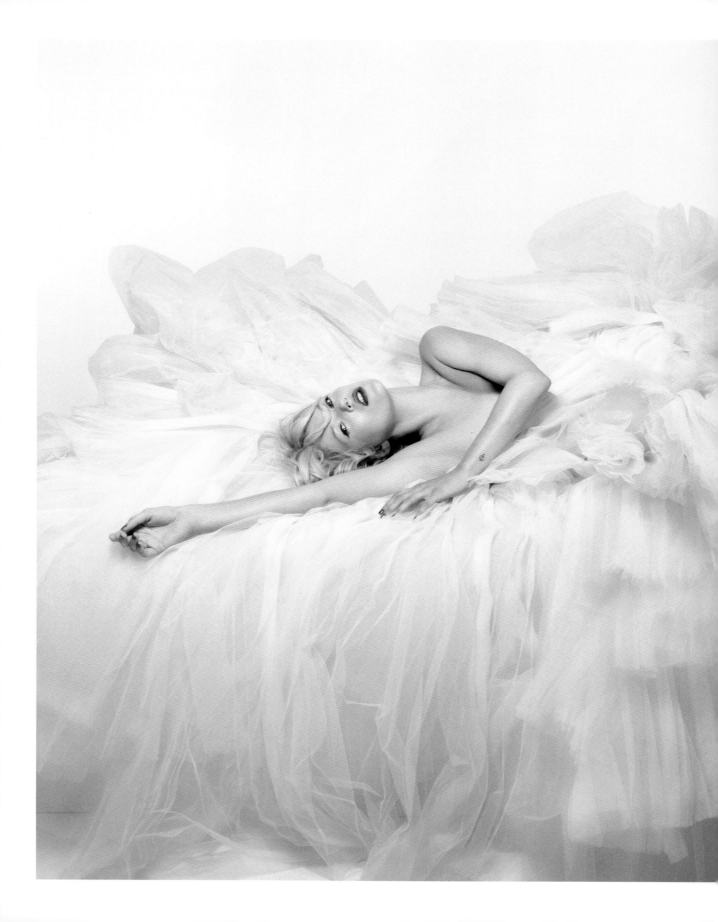

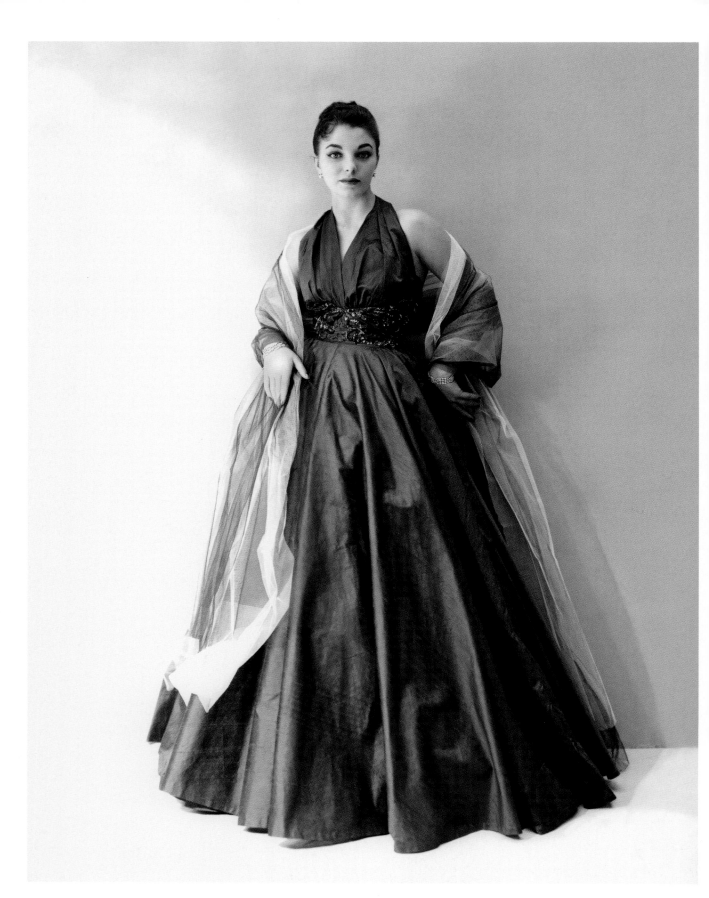

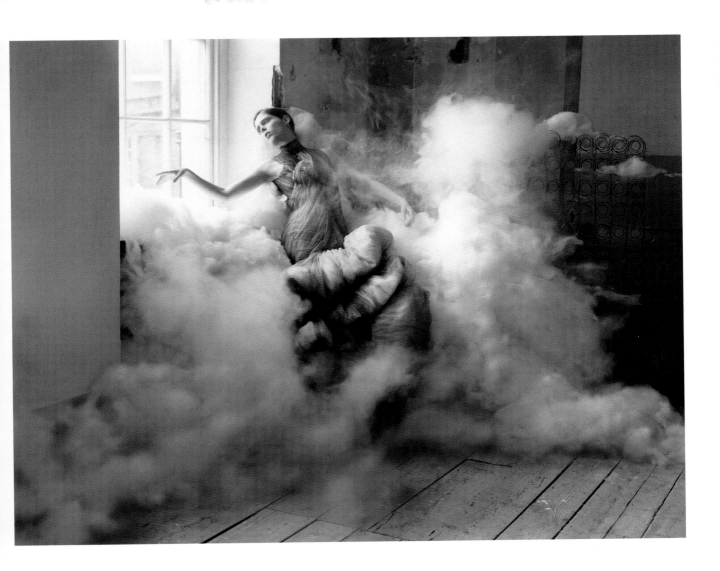

← ← Nick Knight, December 2008
Kate Moss hovers mid-air in this
commemorative issue celebrating
a 'Fantastic Fashion Fantasy'. The
photographer, Nick Knight, is no
master of levitation; instead, digital
wizardry creates the illusory effect
of suspension, aided in no small
part by this cloud-like tulle gown, by
John Galliano for Dior Haute Couture.

← Don Honeyman, December 1951
An 18-year-old Joan Collins makes
her *Vogue* debut, decades before her
rebirth as *Dynasty*'s rhinestone-clad
villainess and considerably smaller of
shoulder. But there is no mistaking those
kohl-ringed green eyes or heart-shaped
face. The RADA graduate, about to make
her third film opposite Celia Johnson,
shows off the 'Christmas Party Look',
in a full, swirling dress of midnight-blue
paper shantung, shot with charcoal and
sewn with blue paillettes.

↑ Tim Walker, February 2007
Is Coco Rocha emerging or vanishing
from that shroud of smoke? Alexander
McQueen's tulle wrap dress, with tiered
puffed hem, is given a new dimension
as fashion takes a surreal turn in the
hands of Tim Walker and his long-term
set designer, Shona Heath. Everything
here is smoke and mirrors.

↓ Clifford Coffin, June 1947
Sometimes the most powerful fantasies are those that speak to our deepest hopes and wishes, and in the ruins of a Blitz-ravaged city, *Vogue* offers exactly that: the fantasy of normalcy. Coffin's candlelit portrait of Wenda Rogerson (later Mrs Norman Parkinson) remains one of *Vogue*'s most enduring and powerful images. 'Elegance...despite destruction such as then was never dreamed of, has once again emerged triumphant from the debris,' announced the magazine in an article entitled 'Renaissance', going on to praise the tentative optimism embodied in this pink faille dress with sequined black lace, by Ravhis. 'The grace of the ball dress, bright against the rubble and brave in the encompassing dark, is a symbol of our gradual return to a certain serenity of life.'

↓ Corinne Day, April 2002
Acclaimed for reinterpreting the rarefied world of fashion through the prism of 'grunge', here Corinne Day takes Christian Lacroix's exquisitely shredded voile bustier sheath dress to a squalid London bedsit. The deferential allusion to Coffin (left) is immediately obvious, but her innovative take on haute couture's otherworldly luxury also emphasizes its precarious survival in the modern world.

→ Tim Walker, July 2005
Tim Walker's Indian fashion odyssey seems at times more dreamscape than reality: his rosebud-mouthed muse, Lily Cole, is like an exotic bird as she perches, in Stella McCartney, on a stairwell of a ruined Rajasthan palace. Her plunging train pools on the floor below in a splash of vivid cool: 'fit for marriage to a maharajah'.

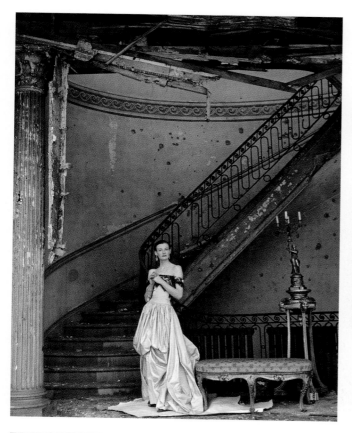

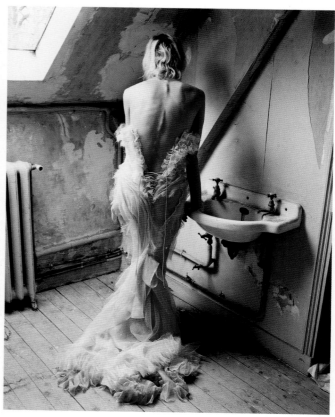

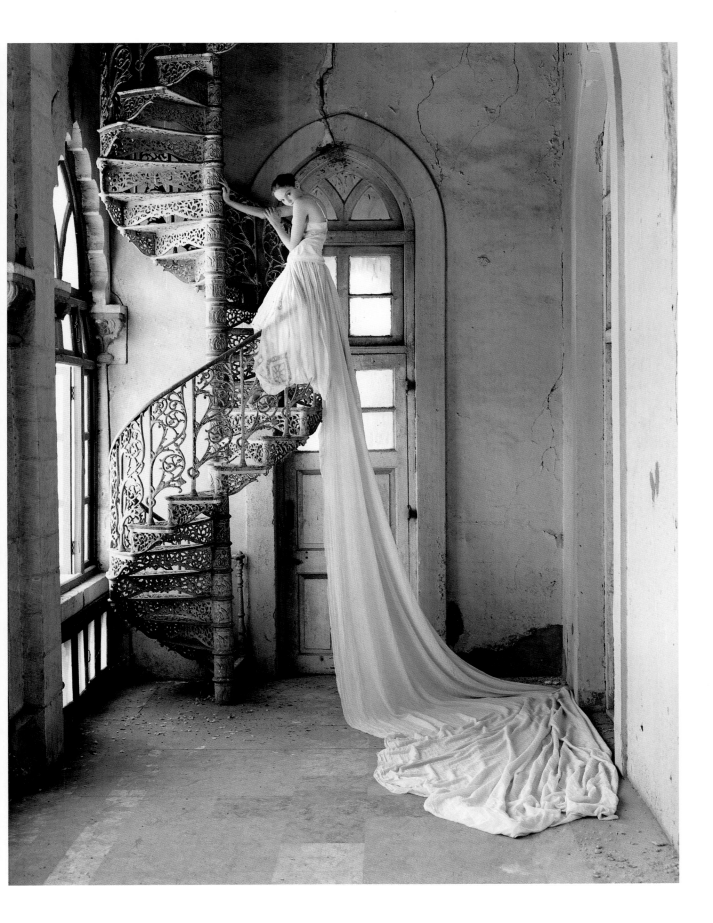

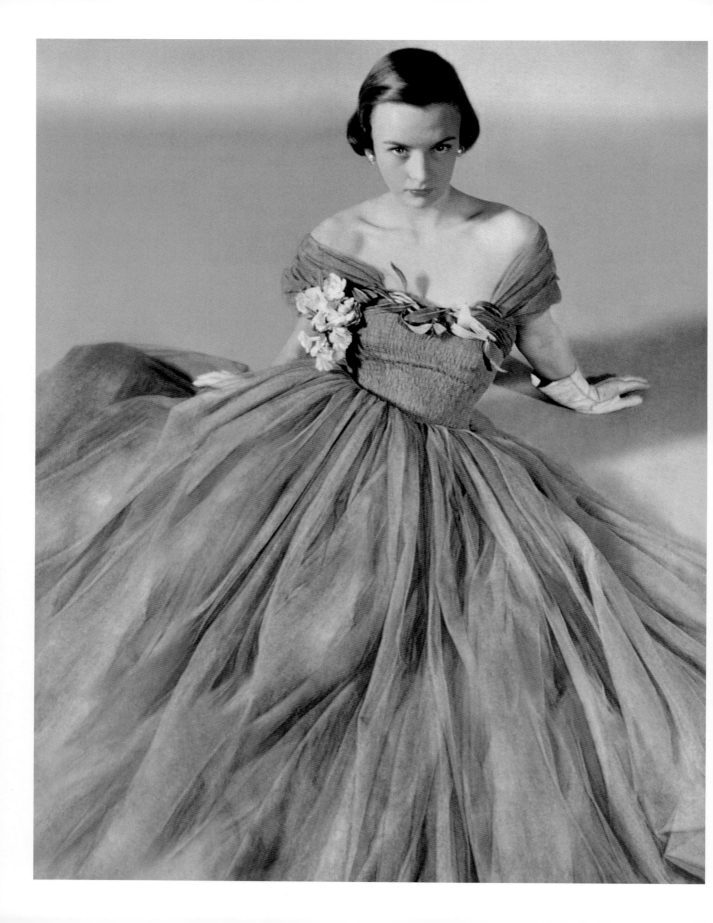

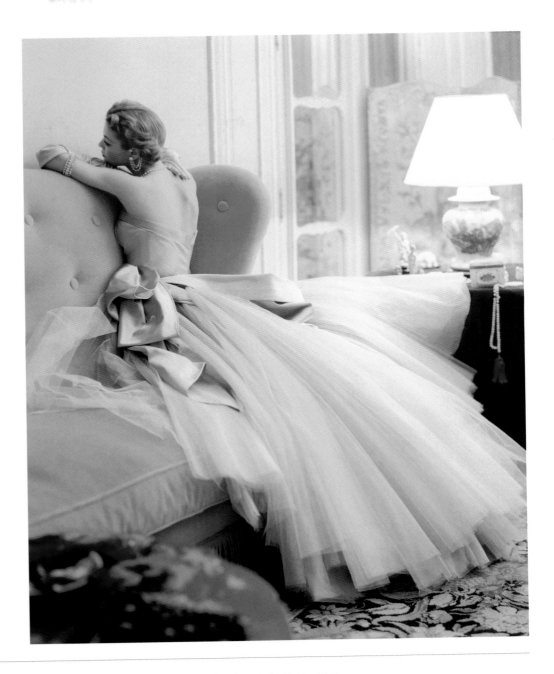

← Hans Wild, April 1949

'A dream dress for a debutante' – or, indeed, any girl with a weakness for shirring or streamers of tulle. Victor Stiebel's formal dress follows the London collections' penchant for rich fabrics in neutral colours, although this gown, with its off-the-shoulder insouciance, is far from sober. As *Vogue* observes: 'There is always news in the neckline.'

↑ Norman Parkinson, May 1950

Perhaps the best example of dress as fantasy, the arrangement and composition of this spectacular taffeta and satin dress, by Jean Dessès is simply sublime. Panels of tulle cascade to the floor, while the gown's subtle shades of beige, grey and mauve 'barely tint the air'. The model, Jeannie Patchett, starred in numerous fashion shoots and was immortalized in *Vogue* that same year, photographed by Erwin Blumenfeld, in the much-imitated 'doe-eye cover'. Here, we are granted only a passing acquaintance with her, a beautiful dreamer, poised in reverie as she gazes over the back of a chaise.

↓ Carl Erickson, July 1933

Vogue heralds the arrival of midsummer with flowers, a gossamer-light white gown and eulogy for the holiday spirit: 'To sit outside on the *terrasses* sipping things, looking at people, and wondering why one always wants frocks worn by other women, rather than those (often lovelier) worn by oneself.' Guidance as to the seasonal palette is brief: 'the first, second and third idea will probably be white.' Those still seeking inspiration should look no further than the fashion illustrator, 'Eric', who conjures this exquisitely balmy image of evening glamour *en plein air*.

→ Cecil Beaton, unpublished 1946

In this unpublished image taken from a sitting at the end of World War II, the young princesses are shown to have slipped into womanhood. Now 20 years old, Princess Elizabeth is the more formal of the pair, poised on the cusp of adulthood in a pre-war crinoline of her mother's, by Norman Hartnell, while her younger sister, Princess Margaret, still only 16, wears gauzy chiffon, cropped to the shoulder. Behind them, the tableau of a frozen lake and a lonely bird seems at odds with their youthful spirit. Do these young princesses, with their spring-like vivacity, represent the projected health of Britain's future after a few bruising years? Almost certainly. Writing in *Vogue*, two years later, Arthur Bryant marvels at the immense popularity of the Windsors: 'Nearly the whole of the old world has repudiated the conception of kingship. But instead of growing weaker, the monarchy has grown stronger.' The reason? 'They stand for honesty, kindliness and decent honourable living.'

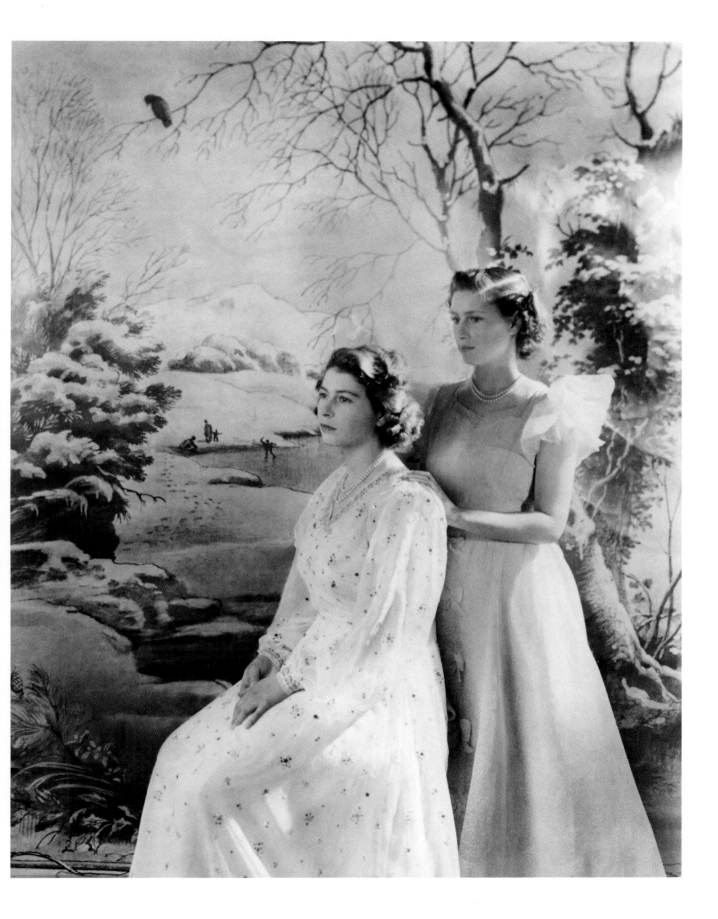

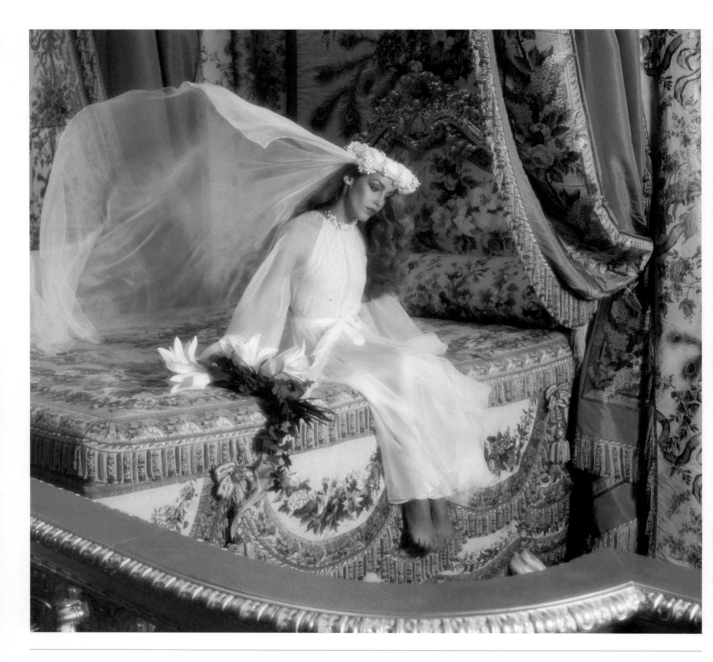

↑ **Norman Parkinson, September 1975**
There are no greater fantasies than those dreamed up by the affianced, and *Vogue*, too, becomes quite giddy at the merest whiff of a bridal bouquet. Here the mood is pure melodrama: Jerry Hall wears Yves Saint Laurent's white silk-chiffon wedding dress, with handkerchief points and sashed waist, to re-enact Marie Antoinette's uneasy preparations for her nuptials at Versailles…Is our downcast bride-to-be having doubts, we wonder? At least, her flowing chiffon veil should aid a last-minute flight from the altar.

→ **Adolph de Meyer, April 1921**
In this issue, *Vogue* presents a portfolio of brides, each cherishing a 'million romantic memories'. But first some rules: 'It becomes one's actual duty to have a beautiful wedding gown, a moral obligation to have one's attendants delightfully arrayed. The style must be becoming, the colour scheme distinctive, and it would be better if the costumes of the bride and her attendants had some relation to each other.'

For this classical look, an unidentified gown is made of soft ivory velvet brocade, with a broad bertha of rare Venetian lace, which falls to a draped skirt and ends in a long train. A misty length of white tulle is secured on the head with a single band of pearls. 'As with many brides this season, this one exercises her own choice and wears a long pair of ivory kid gloves wrinkled along the forearm,' sighs *Vogue* admiringly.

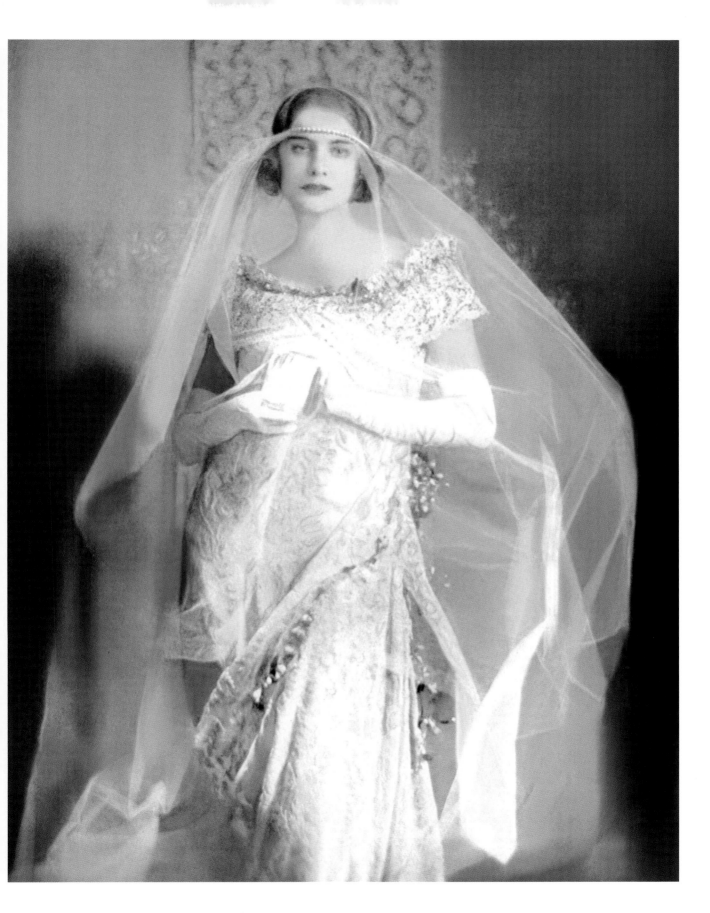

↓ **Alasdair McLellan, November 2012**
Jennifer Lawrence, Oscar winner, star of bloodlust fantasy *The Hunger Games*, and contemporary dream girl, wears a sheer lace dress with appliqué flowers by Dolce & Gabbana. Despite her curves and smouldering sensuality, the Kentucky-raised actress is more tomboy than temptress, and is only just learning to inhabit the floor-sweeping red-carpet gowns required for the myriad award ceremonies she attends. Her sartorial education has already taken a couple of missteps: she exposed more thigh than ideal after a slight wardrobe malfunction at the SAG Awards in 2013, and she tripped on the hem of her Dior Haute Couture gown while going to collect her Academy Award the same year. Luckily, there were only a few tens of million people watching…

→ **Cecil Beaton, December 1941**
Miss Rosamond Fellowes became Mrs James Gladstone at a time of strictly policed wartime rations – no wedding bells, no fresh flowers and precious little cake. Nevertheless, a white wedding was not beyond the realm of possibility: 'Choose lace – antique or new. What could be lovelier? – and your coupon card will still be intact.' The bride's Pre-Raphaelite gown, designed by Bianca Mosca, is made entirely of lace and threaded with pale blue-grey ribbons, her antique veil once belonged to her relative the Duchess of Marlborough, and the belt is fastened with the bridegroom's regimental badge.

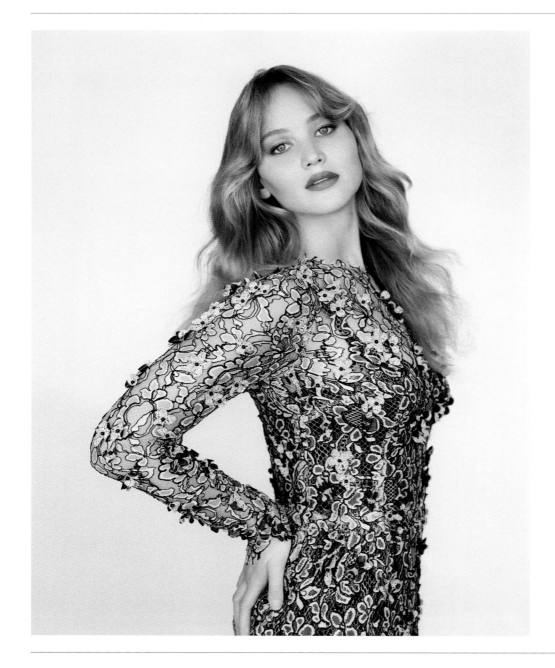

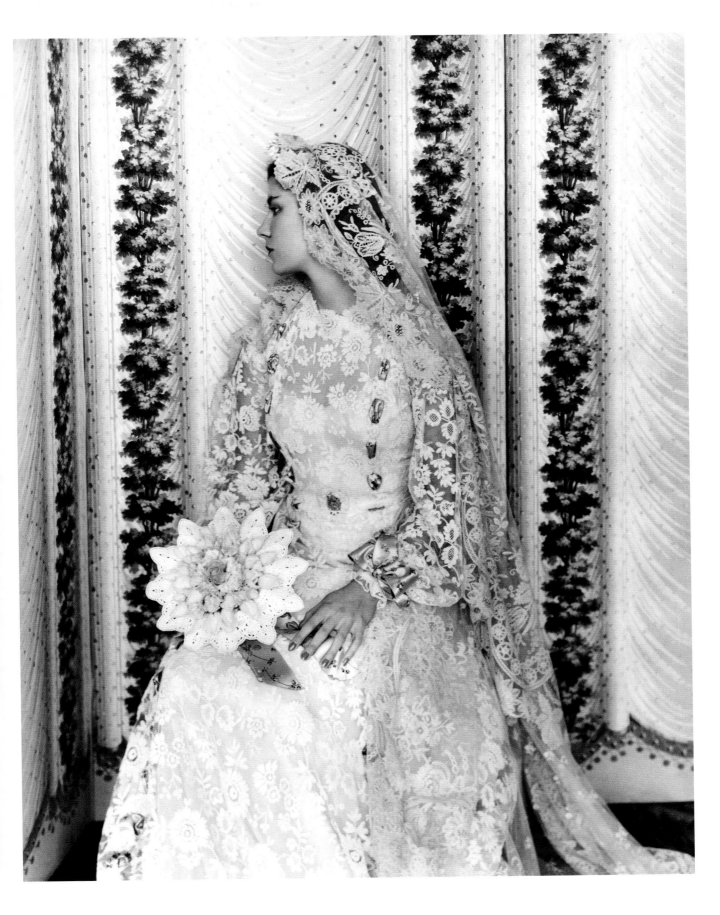

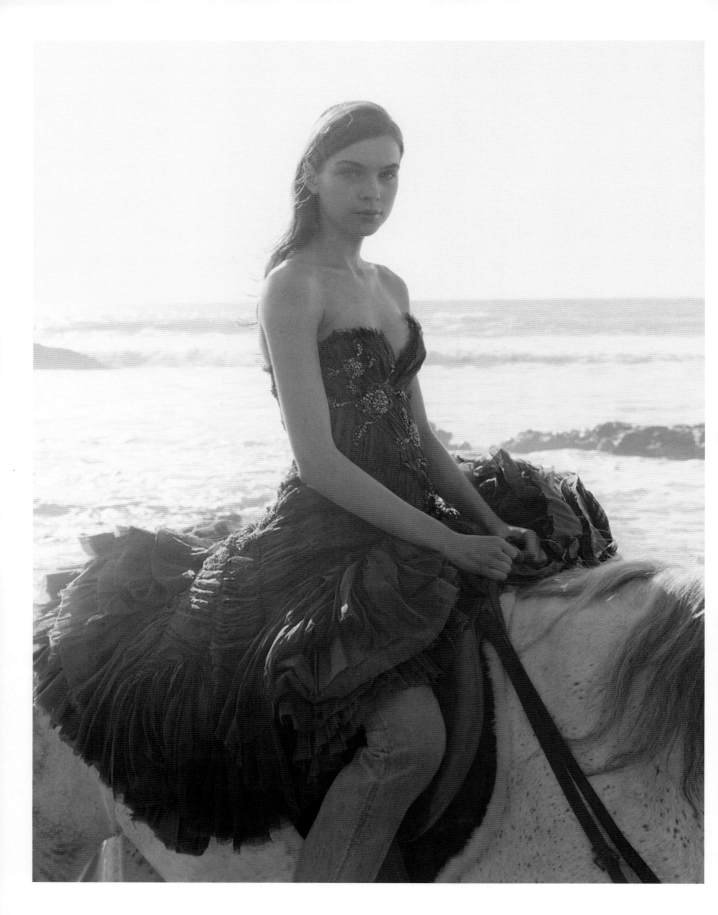

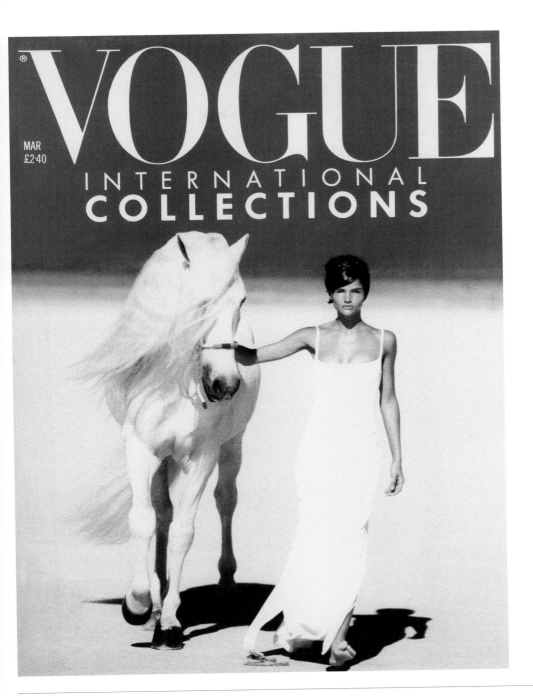

VOGUE

MAR
£2·40

INTERNATIONAL
COLLECTIONS

← **Benjamin Alexander Huseby,
June 2005**
Emanuel Ungaro's bejewelled and ruffled
silk-muslin prom dress pops with vivid
blue, lifting the spirit and emboldening
the mood. When teamed with faded
denims, as worn by the Dutch model
Kim Noorda astride her steed, a beachside
gallop is oh-so-glamorously bohemian.

↑ **Peter Lindbergh, March 1990**
A fashion mirage: Helena Christensen,
immaculate and barefoot in a white silk-
jersey dress by Giorgio di Sant' Angelo,
leads a white stallion across shimmering
desert plains. The new decade is upon
us and fashion has jettisoned the
accessories of Eighties excess and
entered a phase of pure colour, clean
lines and sublime simplicity. The future
is depicted as though imagined in a
dream: look away, and you'll swear
you've seen a unicorn.

→ → **Arthur Elgort, June 1990**
Christy Turlington sets temperatures
soaring at the Mardi Gras, New Orleans,
in a plunging pearl-embroidered dress
by Victor Edelstein. The champagne-
coloured duchesse satin gown is Victor
Edelstein Couture. Who better than
Turlington to give it that extra sass?

↓ Lee Miller, June 1941

The war photographer turns her attentions from the front line to capture the war bride, still clinging to the traditions of white satin and orange blossom, and wearing a graceful pearl-embroidered gown by the London department store Debenham & Freebody. For the wartime wedding, compromise and coupons may have dictated all plans, but the continued belief in the white wedding, even in the most difficult of circumstances, is proof enough of its fortifying power on the human spirit.

↓ Horst P Horst, July 1935

A white dress is given added intrigue with theatrical lighting, an aura of mystery, and the addition of countless ruffles of white tulle. 'Here is a dress for a dramatic entry,' writes *Vogue* of this avalanche of white drifts, by Louise Boulanger, 'and still more dramatic exit.'

→ Norman Parkinson, March 1951

In the year that the ingénue began to grip the popular consciousness and the teenager was given a new voice (J D Salinger's novel *The Catcher in the Rye* was first published in 1951), this image seems to capture that same youthful élan. A simple evening gown, by Angele Delanghe, is made in five tiers of pale grey net, bound with white braid and fastened with a clump of white violets at the waist. 'There is a profusion of flowers – the prettiest in memory,' writes *Vogue*. The effect is devastatingly lovely.

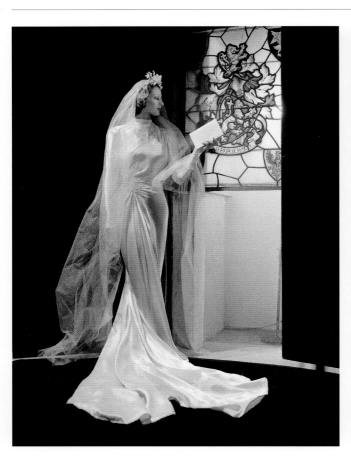

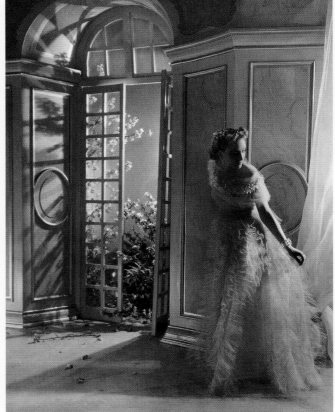

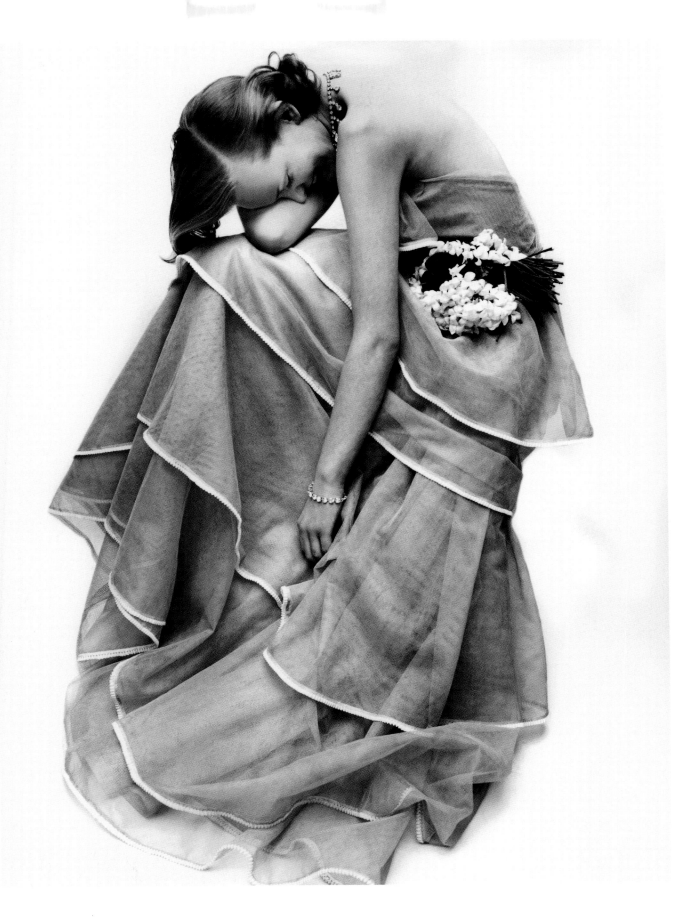

← **Nick Knight, May 1995**
A pristine shoreline, sparkling under a scorching midday sun, forms the backdrop for Nick Knight's Barbudan fairytale starring model best friends Amber Valletta and Shalom Harlow. Dressed in classical dresses in pale dove grey and peach, by Isabell Kristensen, the duo appeal to *Vogue*'s most unashamedly nostalgic sensibilities, recalling Coffin's hazily romantic vision of 50 years previously (below). 'The bell skirt and bodice hark back to a golden age,' writes *Vogue*, 'but look as modern for evening as the straight and narrow silhouette is for day.'

↓ **Clifford Coffin, unpublished, 1954**
Wasp-waisted and bare-shouldered, this glamorous quartet are reduced to mere whispers, ethereal shadows punctuated only by the rich jewel shades of their unidentified gowns. Coffin's last *Vogue* sitting marked an experimental departure for a photographer famed for encapsulating the magazine's impeccably elegant viewpoint. However, these images were, sadly, never published.

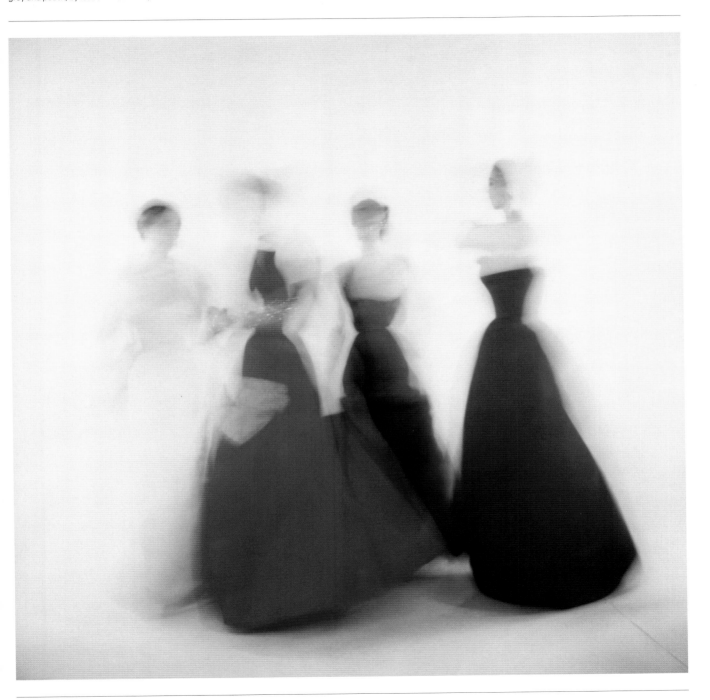

↑ Frank Horvat, May 1962

The photojournalist and fashion photographer brought a curious narrative to his fashion pictures, often putting the clothes in everyday contexts and environments and using a supporting cast of 'real people' to enliven the frame. In his 'Uncover Story', nightdresses are the stars. This one, with lace-scalloped neck and a heavy satin ribbon, by Gossip, is praised for its 'spring-like prettiness' and 'rococo elegance' – not to mention its easy-care nylon/silk mix…

↑ Paolo Roversi, June 2007

A river of candy-coloured duchesse satin, by Christian Dior, runs away from a swishing side bustle, as well as from our model, Daria Werbowy. In the modern era, such sweetly sumptuous glamour is downplayed with bare feet, messy bed-head hair and an air of insolence. In the fables of today, our princesses prefer to play tough.

→ Craig McDean, June 2006

Kate Moss offers us an education in how to dress up for the summer, wearing a dip-dyed tulle dress with studded-leather detail, by John Galliano for Christian Dior. A great enabler of fashion fantasies, the maverick designer is an avowed admirer of 'feminine, romantic, beautiful dresses' (as he told *Vogue* the previous year), and this is no exception.

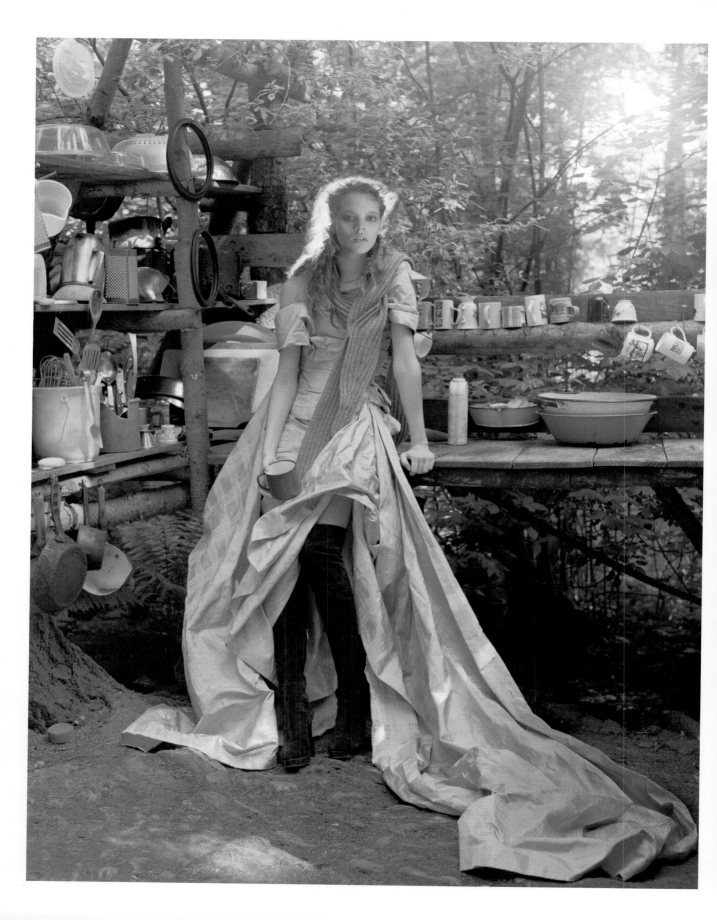

← Corinne Day, November 2006
Fairytale frocks take on an eco-activist edge, as *Vogue* decamps to the woods with photographer Corinne Day to add some grit to the season's new party dresses. Model Freja Beha Erichsen is a very contemporary Titania in a silk-satin ball gown, by Vivienne Westwood, wool scarf and long, over-the-knee suede boots.

↓ Nick Knight, April 2003
The drama of the couture season never fails to excite the wilder imaginings of the most creative minds – practicality becomes irrelevant and clothes become costume. Angela Lindvall and Frankie Rayder play dress-up in Christian Lacroix Haute Couture, a sartorial bacchanal of flamenco ruffles, flesh-shaded chiffon and mauve gauze frills.

↓ Tim Walker, December 2004
In Tim Walker's pantomime, model Lisa Cant is cast as Cinderella and, granted her wish to go to the ball – and what more magical way to make an entrance than while wearing an embroidered green velvet dress, from Dior Haute Couture? As the photographer observed of his story, shot during a heatwave the summer before, and incorporating influences from the Ballets Russes, Eastern European fairytales and the Italian *commedia dell'arte*: 'What's great about this shoot is that we're using genuinely beautiful party dresses. It's very inspiring for everyone. It's the dress that's providing her with the character.'

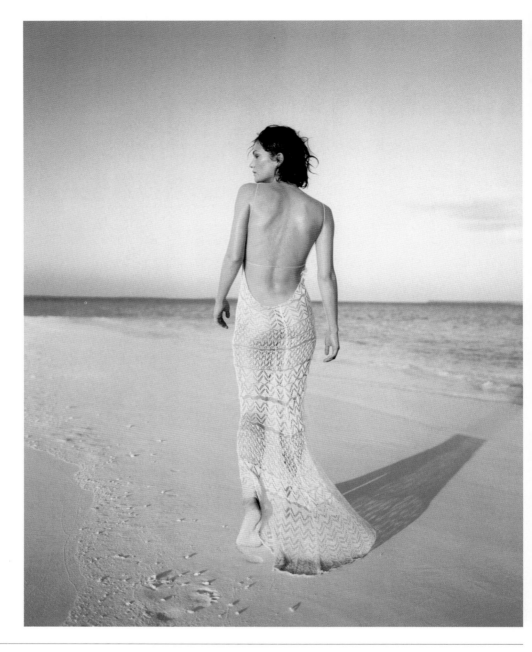

↑ Neil Kirk, March 1997

The Maldives, at golden hour, and a
lightly bronzed body in the sheerest of
slip dresses. The tantalizing fantasy
of an empty beach, azure waters and
the kind of privacy that ensures no tan
lines continues to be one of the most
potent – and one often indulged at
Vogue. Who wouldn't become gripped
by thoughts of escape on seeing this girl
in her gossamer-fine, gold halterneck
dress, by Martine Sitbon, walking along
the shores of her own exclusive paradise?

→ Tim Walker, August 2006

The Lady of the Lamp turns lantern in
a paper-and-tulle creation by the set
designer Shona Heath. Such surreal
fantasies are a hallmark of Walker's
work, where props are oversized
and outlandish, and models become
characters in a narrative imagined
and nurtured for months in the
photographer's mind.

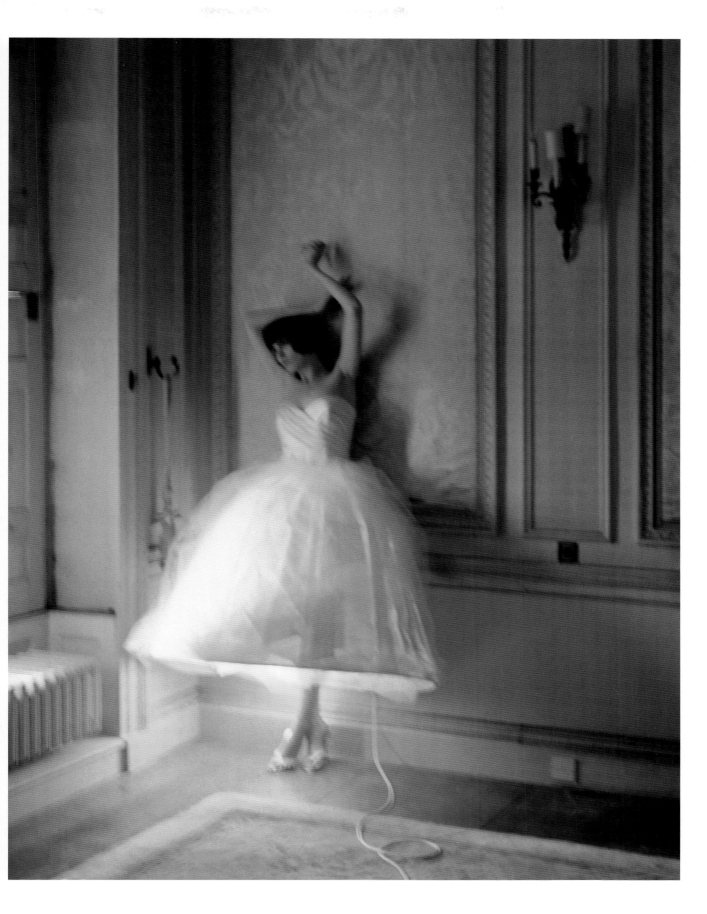

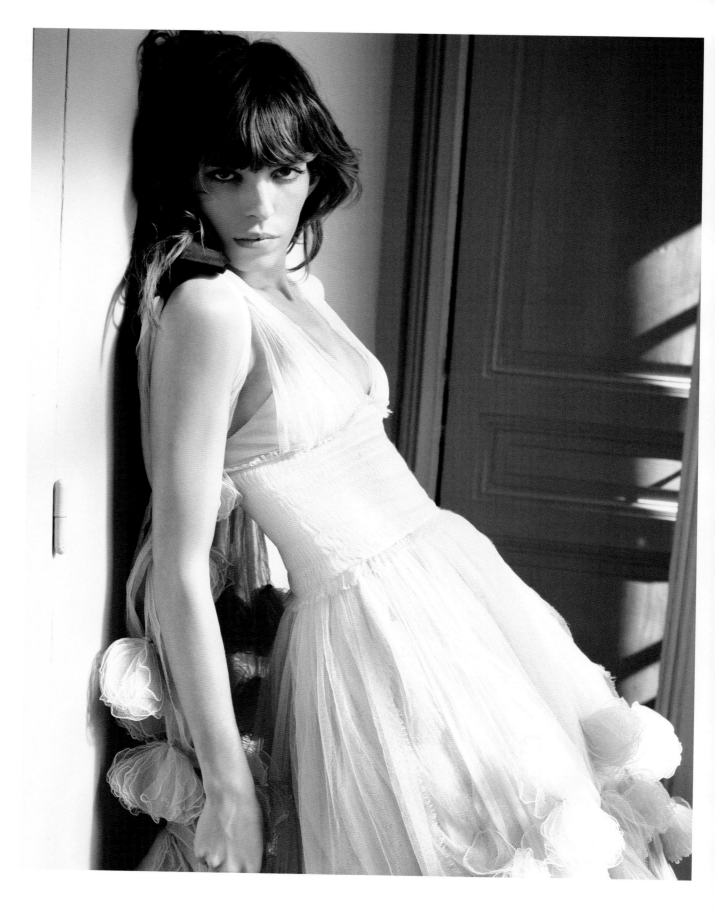

← Jenny Gage and Tom Betterton, July 2007
The daughter of singer and actress Jane Birkin, Lou Doillon was always destined to become a gauche *icône*. 'The fringe, the thin legs, the huge eyes and large mouth have been transposed,' observed *Vogue* of the mother and daughter's uncanny similarity (see above right). 'But where Jane was the yielding gamine, 25-year-old Lou's beauty is more confrontational.' This provocative froideur makes a good foil, then, for this most feminine of dresses, in palest pink silk and chiffon, by Chanel.

↑ Eric Stemp, February 1960
The colour of the season, Windsor grey, was found in its prettiest incarnation when spiced with pink. Susan Small's delicate flower-patterned lace dress overlays a pink satin corset and skirt, making a 'beguilingly pretty dinner dress with a wide becoming décolletage, long sleeves and a floppy silk rose at the waist'.

↑ David Bailey, December 1964
Jane Birkin wears clothes 'for falling in love' in her *Vogue* debut. Yet to become associated with Serge Gainsbourg, the young actress was only just embarking on her acting career. One assumes, then, that this dreamy peacock dress in bias-cut organza and scattered with edelweiss, by John Bates, would have ensured her a lot more attention.

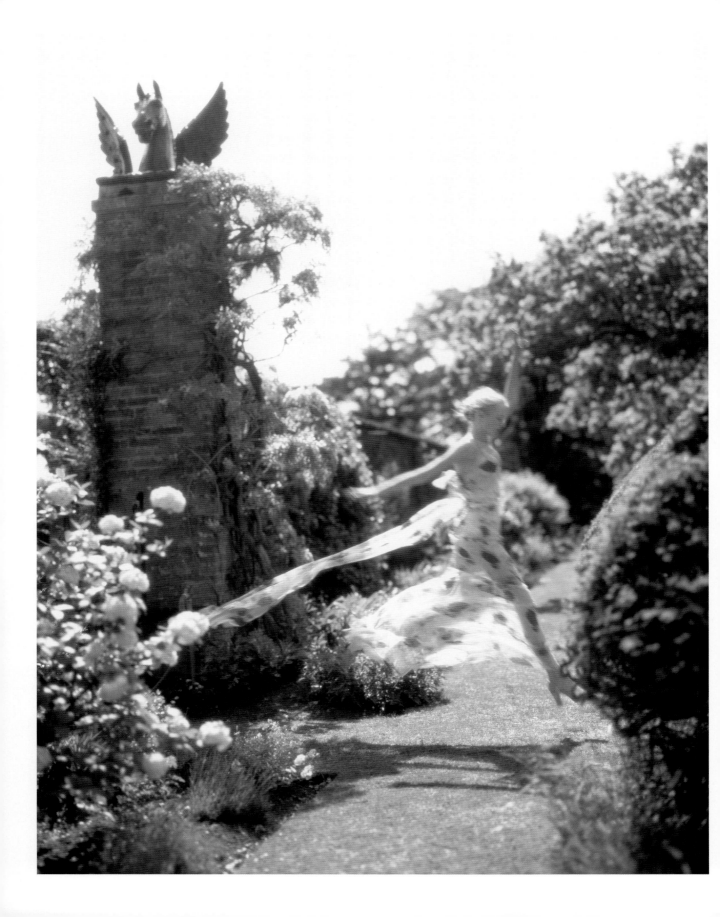

← **Nick Knight, September 1996**
Fashion and the garden make delightful bedfellows, and *Vogue* seizes every opportunity to find fresh air and floral stimulation (as the following pages will testify). Here, delicate silk chiffons printed with splashy, bold red roses, by Dolce & Gabbana, make for a striking burst of colour amid the herbaceous borders and topiary of an English country garden. The scent may be stilled, but the appearance is no less beautiful.

↓ **Rex Whistler, April 1936**
Night falls, and *Vogue* finds the young mistress in a romantic setting in a gown by Eva Lutyens, of deep blue taffeta shot with red wine and scattered with four-leaf clovers. Whistler, a 'Bright Young Thing' and contemporary of Evelyn Waugh (for whom he designed a number of book covers), was killed during the Normandy Campaign of 1944, and his illustrations are haunted by a prescient sadness for the loss of that gilded generation.

↓ **Paolo Roversi, July 1994**
This study of English grandiosity and eccentricity sees the Italian-born, Paris-based photographer interpreting quintessential British looks, from headwear to the 'ultimate ball gown' by Vivienne Westwood. The Derbyshire-born *grande dame* of English couture has always drawn on historic and antiquarian references as inspiration, and her highly romantic, corseted designs are a signature of the fashion house. As this Edwardian-style white and pink lace bodice with cotton organdie and net skirts proves, history lessons have never been so breathtaking.

↑ **Arthur Elgort, November 2004**
Another fairytale, this time imagined
via Hans Christian Andersen and aided
by some bewitchingly beautiful couture
gowns. *Vogue*'s Snow White, flame-
haired Lily Cole, has chanced upon a
tiny dwelling on her sylvan adventure.
Will curiosity demand that she peek
inside? Of that we have no doubt.
She had better be careful not to snag
that blue and white silk moiré gown
with gold embroidery, by Dior Haute
Couture, on the door.

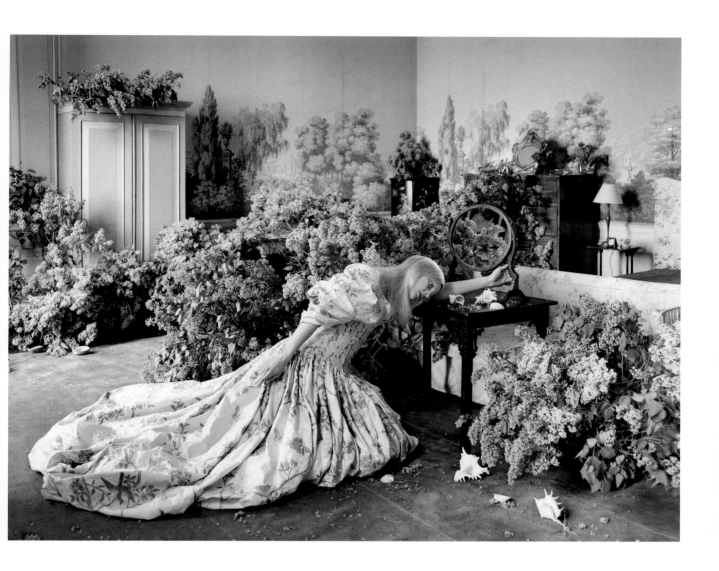

↑ **Tim Walker, August 2006**
The brilliantly named Guinevere Van
Seenus brings an Arthurian majesty and
melancholy to Tim Walker's 'England
Dreaming', a lush pastoral showcasing
Albion's artisanal talent. In a room heady
with the perfume of freshly gathered
lilac, our muse is discovered in a
trance-like state, supported only by the
embroidered silk-jacquard folds of her
Alexander McQueen couture.

↓ **Corinne Day, June 2002**
Gisele is exquisitely *déshabillé* in a bias-cut floral-print silk-chiffon dress, by Roberto Cavalli. Her hair looks unkempt, her scuffed Converse All Stars are untied, and she's still swirling the last dregs of coffee from her morning brew, but the effect is of artless perfection.

→ **Javier Vallhonrat, May 2006**
Couture is here stripped back to basics and the world's most extravagant clothes are given a subversive twist: a ruffled white organdie dress covered in crepeline, by Christian Lacroix Haute Couture, slithers off Freja Beha Erichsen's back towards the floor. And another story begins…

→ → **Patrick Demarchelier, February 2005**
Viktor & Rolf indulge every little girl's fantasy with a confection of ribbons, flounces and swirls. The colours may have been inspired by Barbie's interior decorator, but, this being the work of an avant-garde fashion duo famous for deconstructing and distorting classical designs, the gowns here are anything but girlish.

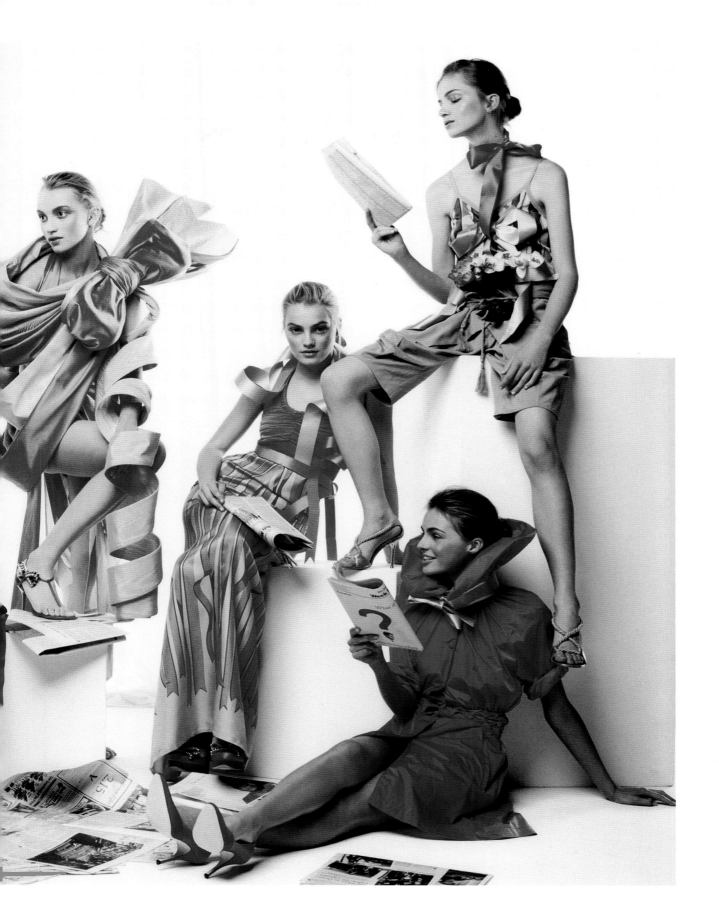

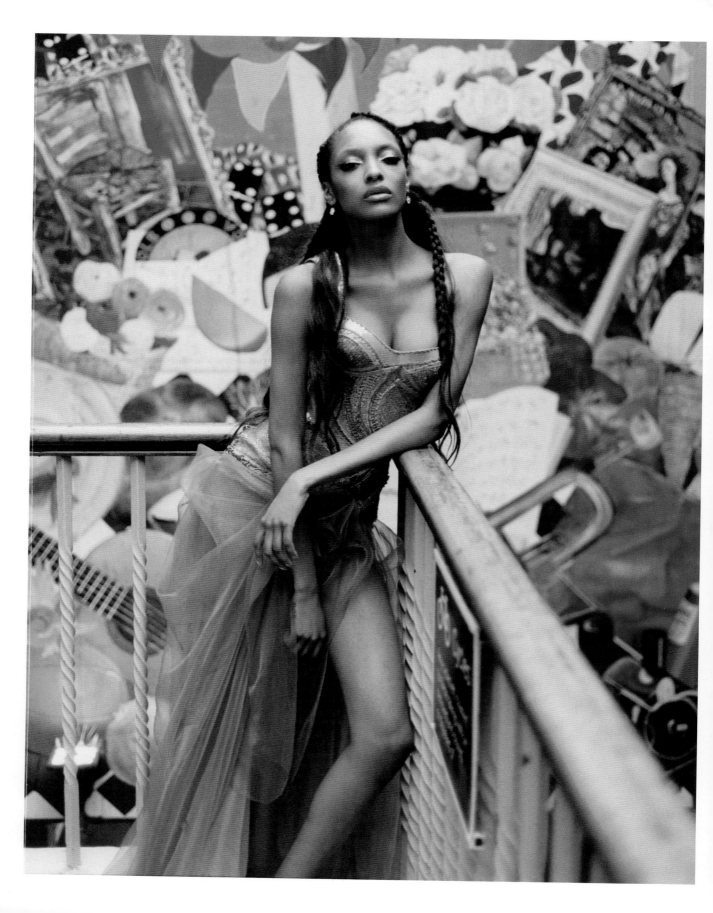

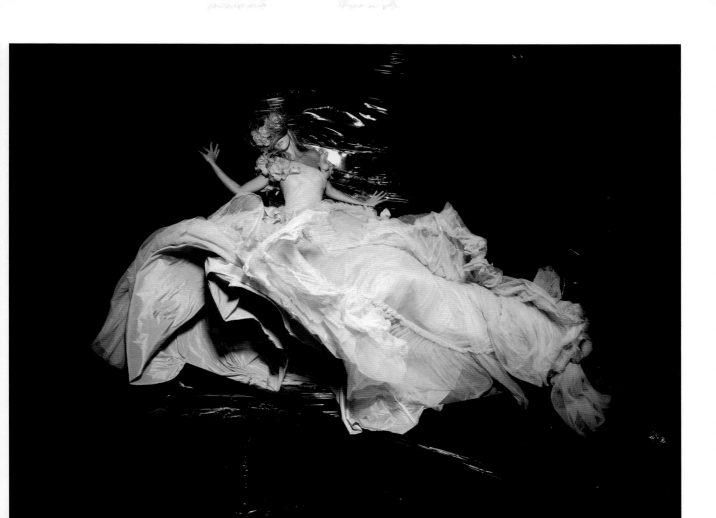

← **Tyrone Lebon, October 2012**

Vogue heads to the streets of Brixton with Jourdan Dunn for a modern shoot that pairs couture with cornrows. Discovered while shopping in Primark aged 16, a single mother at 19, and the first black model to walk the runway at Prada in over a decade, Dunn's story is one of good fortune and mental fortitude: she can more than hold her own in this embroidered silk one-shouldered bustier dress, by Atelier Versace.

↑ **Nick Knight, November 2006**

John Galliano dresses Gisele in the rococo spirit, conjuring a vast crinoline for her to wear to a masked ball in honour of the photographer at Strawberry Hill House, Richmond. The dress was among 12 designs specially created for the event. Knight photographs Gisele as a ravishing fairytale heroine, captured in mid-air as she undergoes a magical transformation, surrounded by layer upon layer of swirling sorbet-shaded tulle.

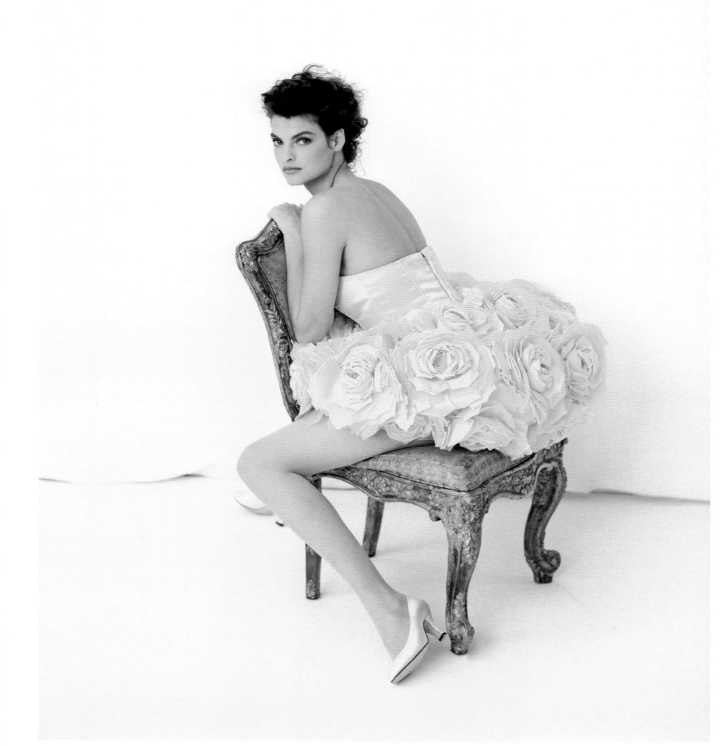

← **Peter Lindbergh, May 1988**

Linda Evangelista embarks on a budding affair in a strapless pale pink satin dress with a blossoming rose skirt from The Emanuel Shop. The design duo behind Princess Diana's wedding dress, with its 25-foot (8-metre) train and 10,000 pearls and sequins, will not be remembered for the subtlety of their design aesthetic – and neither should they be. Blousy, pink satin, strapless dresses worn by supermodels are exactly what Eighties fantasy dressing was all about.

↓ **Nick Knight, February 2003**

Sophie Dahl, the 'outsize model', first exhilarated billboards and editorials with her unusually voluptuous curves in the late Nineties. Years later, she is still being celebrated for her 'pin-up' appeal and Aphrodite-like attributes as she spills out of a silk-organza layered corset dress, by Vivienne Westwood, on the cover of *Vogue*. Even though the magazine's attentions are now concentrated on her new career as a writer, her earthy sensuality and beauty remain transfixing: 'Admiring her creamy beauty, you take pleasure from it in exactly the same way that you might from eating a banana split from Fortnum & Mason: pure uncomplicated pleasure.'

↓ **Arthur Elgort, April 1982**

Back to the Eighties and the mood is playful. 'Let the individual shine out in a crowd,' advises *Vogue*. 'What count now are grooming and suitability, health and presence.' This radiantly colourful silk taffeta and jersey dress, by Zandra Rhodes, just begs to be noticed. And with a huge silk bow to boot, this party season is all tied up.

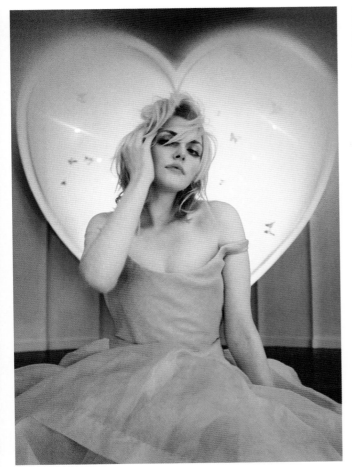

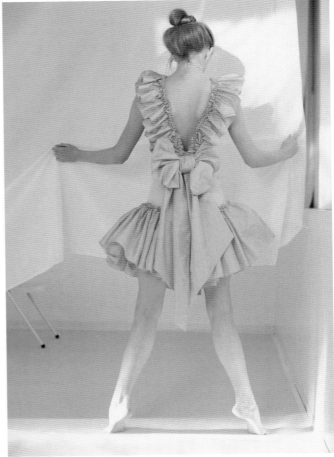

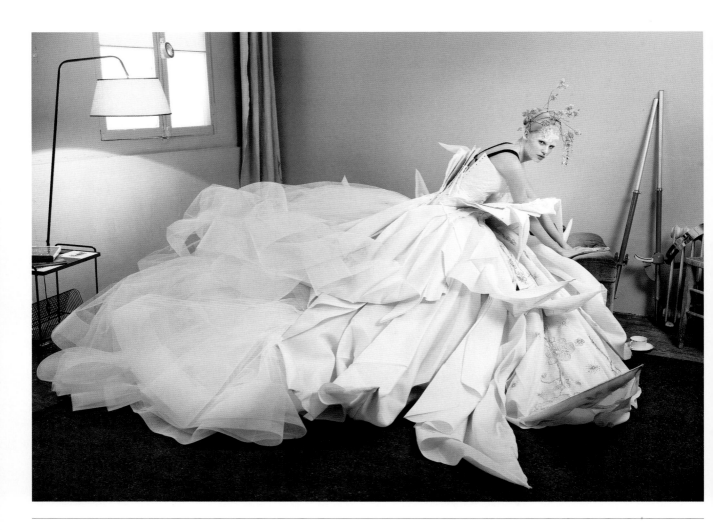

↑ Mario Testino, May 2007
Here couture is presented in stark
white, and sartorial fantasies are
touched with a certain sanitorial chic.
Prettiness is replaced by precision
tailoring, and everything is perfectly
placed. 'Abandon nostalgia,' demands
Vogue, writing of this origami-inspired
silk gazar wedding dress, by John Galliano
for Dior Haute Couture, worn with a
cherry-blossom headpiece. 'This is
a modern fashion love affair.'

→ Cecil Beaton, September 1951
Despite having her pick of all the
London couturiers, among them the
family favourite, Norman Hartnell,
HRH Princess Margaret decided to part
ways with royal protocol to celebrate
her 21st birthday in a gown designed
by the Frenchman Christian Dior, one of
the earliest adopters of the New Look.
In spite of the British Board of Trade's
condemnation of Dior's extravagant
use of fabric, Princess Margaret was

a passionate advocate of the fashion
house and was largely responsible for
popularizing the style in Britain. This
full-skirted, embroidered ball gown is
a typical example. As *Vogue* observes
admiringly: 'A fairytale princess, she
makes the legend contemporary.'

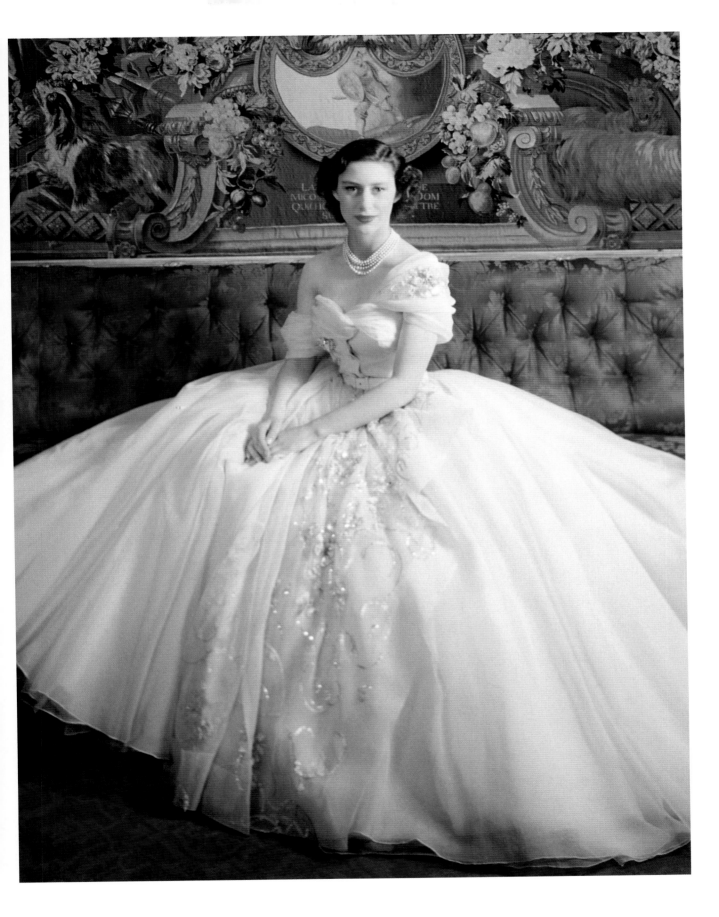

↑ Alfredo Bouret, February 1957

Bouret sketches an evening dress of white-patterned chiffon, by Julian Rose (left), and one of white nylon shantung, strewn with blue flowers, inspired by Balmain (right), all to celebrate 'True Blue'. *Vogue* encourages readers to explore all the prettiest possibilities of this most flattering of colours. 'It's a colour we stole straight from the rainbow, in all its pure unadulterated blueness – before the peacock had dyed it with his green tail, the periwinkle misted it with purple, or chemicals imparted to it their electric harshness. It's a wonderful dawn-to-dusk colour – for dowager and debutante.'

→ Bruce Weber, December 1984

In 'A Style that Could Grow on You', Weber celebrates the idiosyncrasies of style that are born of life in an English garden, from tweeds to mackintoshes, and from overalls to pastel-coloured party gowns: 'English women are best at this,' writes *Vogue*, 'a look where pieces have been pruned but the whole is wreathed in imagination.' Here, we find her at her most romantic, in a water-green satin strapless wedding gown by Bellville Sassoon, wreathed in lengths of white silk tulle and garden flowers, and wearing long white gloves.

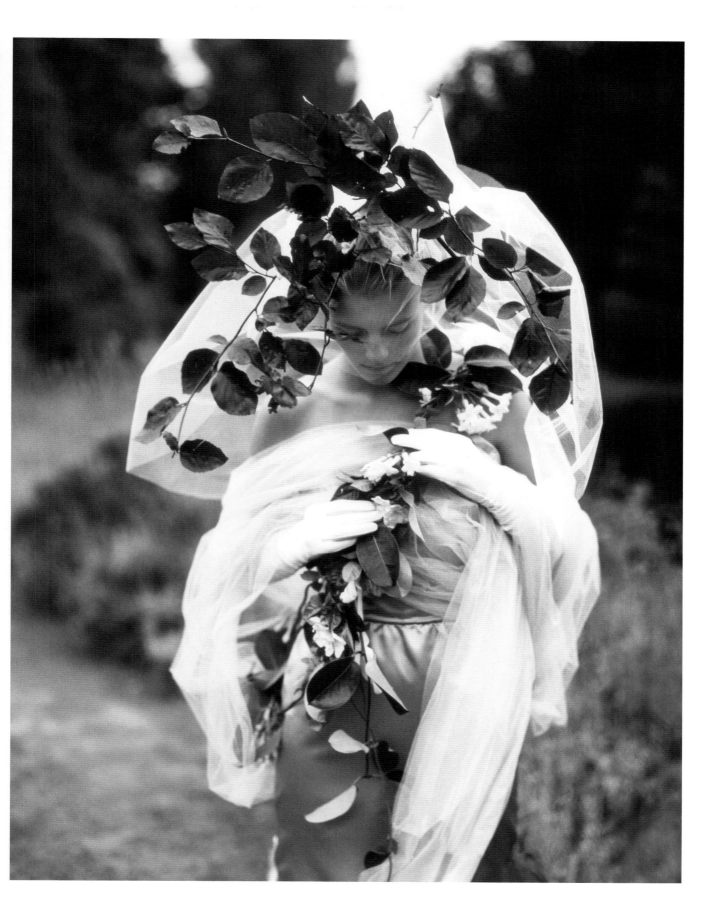

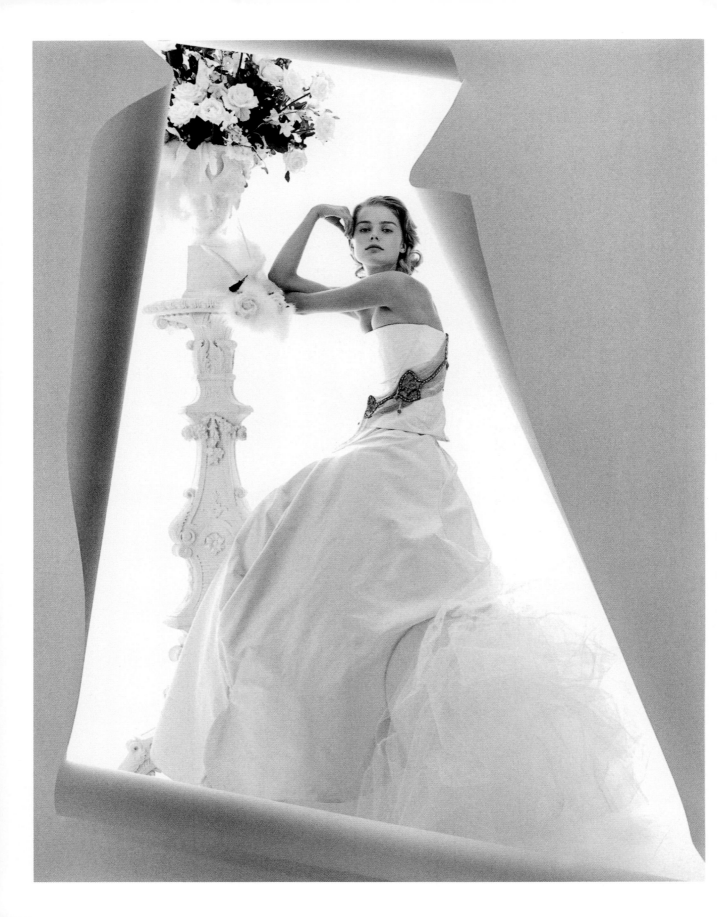

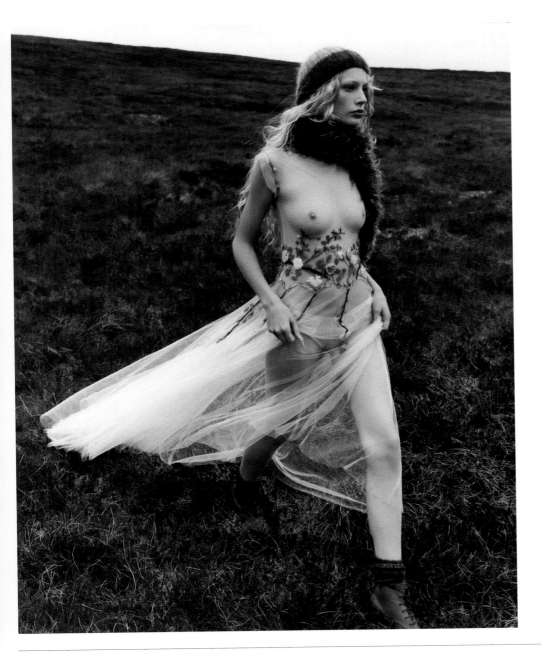

← **Mario Testino, December 2001**
In 'A Right Royal Do', *Vogue* pays homage to Britain's sovereign history with emblematic symbols and royal icons – from cavalry guards to corgis. In this, rather less kitsch tableau, Testino channels the mood of a Beaton sitting with the help of a vast, silk taffeta ball gown with beaded sash, by Vivienne Westwood.

↑ **Mario Testino, September 1997**
Model Kirsty Hume turns Pictish warrior in a sheer tulle dress embroidered with peasant-style woollen flowers, by Antonio Berardi. *Vogue* has fallen under the spell of nativism, and artisanal touches, such as the woollen hat, fake-fur stole and walking boots, give this delicate dress added edge. Hume captures the mood perfectly: once likened by a fashion critic to an 'angelic horse', the Scottish-born platinum-

blonde model married actor Donovan Leitch the year this picture was taken and has since relocated to Woodstock, New York, where she paints and studies paganism.

↓ Arthur Elgort, December 1995
Cindy Crawford was arguably the shiniest of the 'supers', with her corn-fed radiance, womanly curves and savvy business acumen. *Vogue* met 'the All-American Dreamgirl' not long after her divorce from Richard Gere and during her brief foray into acting – but no bad reviews could cast a pall on her dazzling appeal. 'She's young, seen as hip, not promiscuous, and drop-dead gorgeous-looking,' wrote *Vogue*. So it is natural that she should wear a red velvet strapless ball gown by that other American fashion legend, Isaac Mizrahi. 'It's the fairytale image,' she explained.

→ Cecil Beaton, October 1935
Beaton captures Vivien Leigh, aged 22, on the cusp of her career, shortly before she would embark on the volatile love affair with Laurence Olivier that still underscores her legacy. Already married, and a young mother, when this picture was taken, it is clear why the poet John Betjeman ascribed to her 'the essence of English girlhood'. Yet her sparkling column dress, by Victor Stiebel, presages a much darker maturity. Beaton and Leigh became close friends – albeit of an intimacy riven by petty jealousies and perceived professional injustices – and the photographer designed a number of theatrical costumes for her, including the dresses she wore in *Anna Karenina*.

→→ Mario Testino, May 2011
Vogue marked the occasion of the royal wedding between HRH Prince William and Catherine Middleton with a collectors' issue preoccupied with all manner of bridal imaginings. 'Acres of tulle, hours of handiwork and countless fantasies' have gone towards the creation of this, the most breathtaking of wedding gowns. Witnessed by a clamouring crowd of British Airways staff, model Arizona Muse makes her vows in an embroidered tulle and lace gown with flower appliqué and a draped bust, by Elie Saab Haute Couture. A soft tulle train gathers, cloud-like, at her feet, and the dress takes flight…

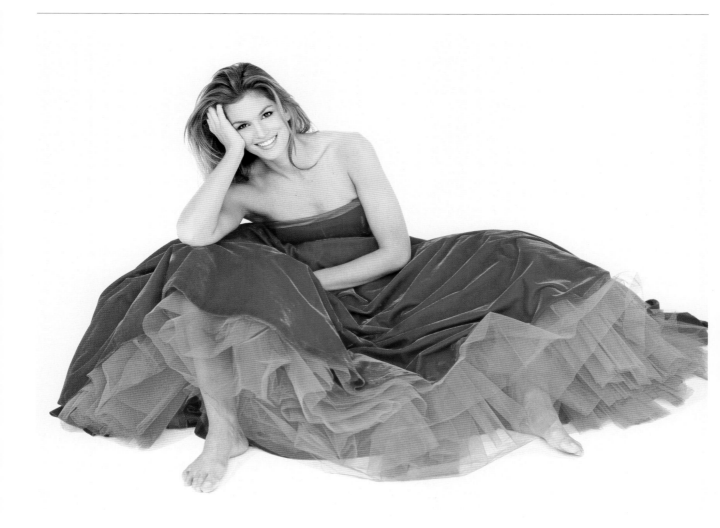

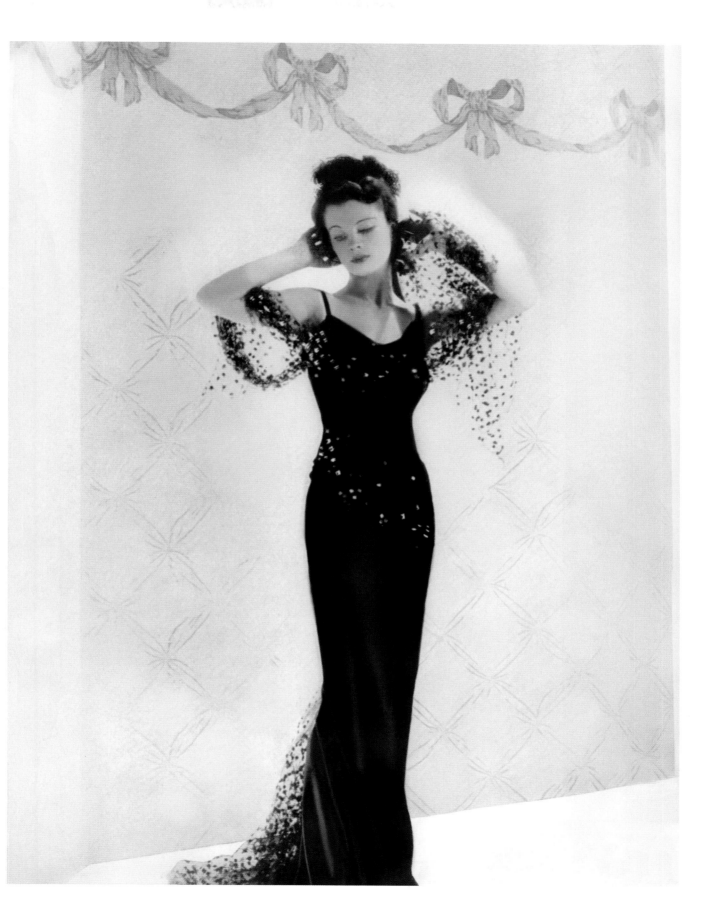

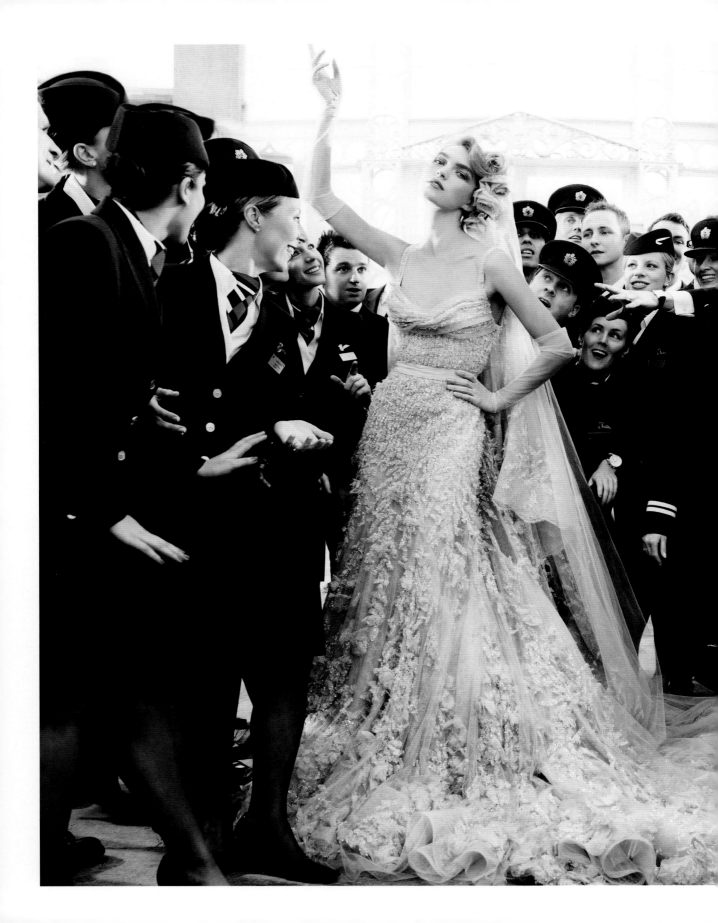

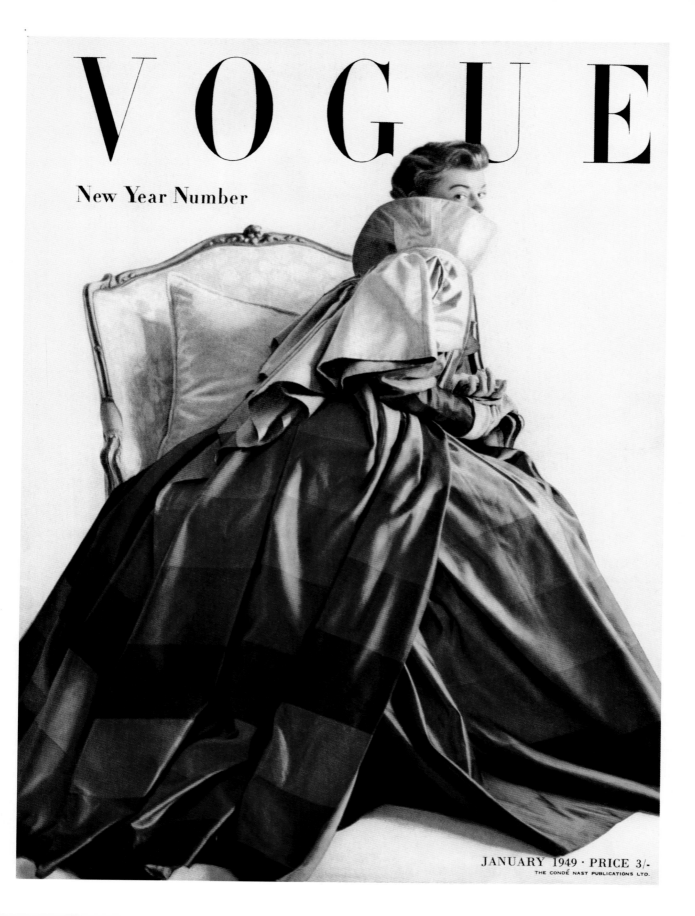

VOGUE

New Year Number

JANUARY 1949 · PRICE 3/-

THE CONDÉ NAST PUBLICATIONS LTD.

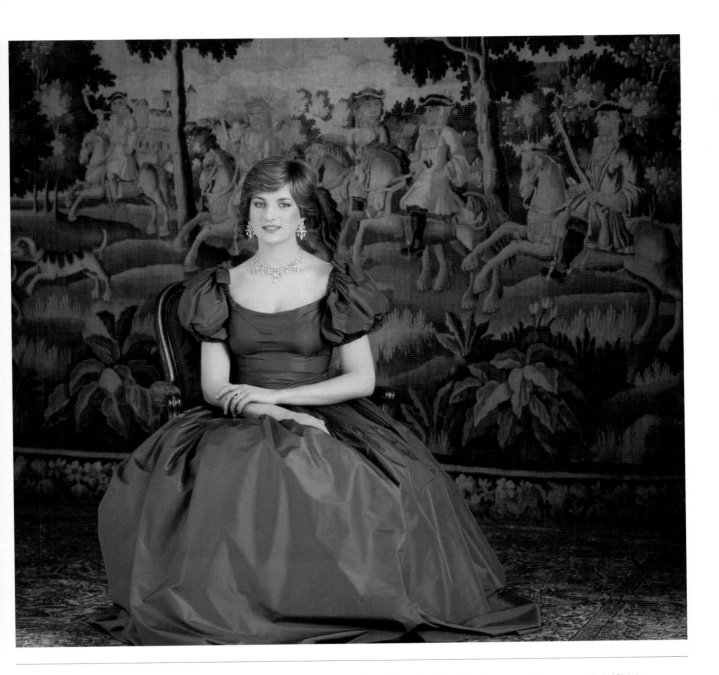

← Horst P Horst, January 1949

The creative genius behind some of *Vogue*'s most enduring images, and a master of the graphic line, Horst's contributions include the iconic Lisa Fonssagrives cover, where her body spells out the letters of *Vogue*, and the 'red balloon' cover, in which a bathing-suited model balances a vast balloon in place of *Vogue*'s 'O'. This finds him in more formal attitude, though the shape of this sweeping multitonal pink robe,

by the Hollywood designer Gilbert Adrian, is no less sublime in silhouette: such sumptuous extravagance seems almost austere under his assiduous eye.

↑ Lord Snowdon, August 1981

A family connection scores *Vogue* an exclusive sitting, as 'Uncle Tony' (the former husband of Princess Margaret) photographs Diana Spencer and Prince Charles on the eve of their wedding. Just out of her teens, she wears a sea-green taffeta ball gown, believed to be by Nettie Vogues, and borrowed jewels by Collingwood, the Spencer family jeweller. The dress's style reflects the voluminous

exuberance typical of Eighties debutantes – and is a significant contrast to the slim silhouettes she favoured a few years later. This is the moment, however, that her image became crystallized in the world's mind and she became the subject of frenzied adoration: the ultimate fairytale princess.

↓ David Bailey, June 1974
Fantasies are charged with a dark eroticism when Bailey is behind the lens, and *Vogue* can't resist a bit of role-play: 'You only ever see her at night: she hardly exists before 10 pm. Her house is all black velvet and mirrorglass, with a private bar and a fishtank bath, a hothouse where she grows spotted green orchids. She wears all shades of black and the Diaghilev colours – fuchsia pink and violet, emerald and kingfisher – and the night scent, Norell.' Marie Helvin is 'The Vamp' in black lace and coffee silk chiffon, by Sheridan Barnett, and fine black stockings by Charnos.

→ Norman Parkinson, March 1950
Meanwhile, back in genteel society, the mid-century is met in debutante gowns by the London couturiers Victor Stiebel (above) and Norman Hartnell. The dresses, in embroidered organdie and stiff white net, have a rare delicacy that Vogue insists must be appreciated as among the finest: 'The London way is a way of its own. Parallel with Paris, abreast of New York, but a gentler, more sympathetic and personal way than either. The London designers make clothes for real women; for women who live in the country, drive cars, go shopping, lunch out, sit on committees, drop in for drinks, go to Ascot, give parties, holiday abroad… In London the fashion point is woven into a wearable design, is life size from the start, and speaks in a quiet, conversational tone.'

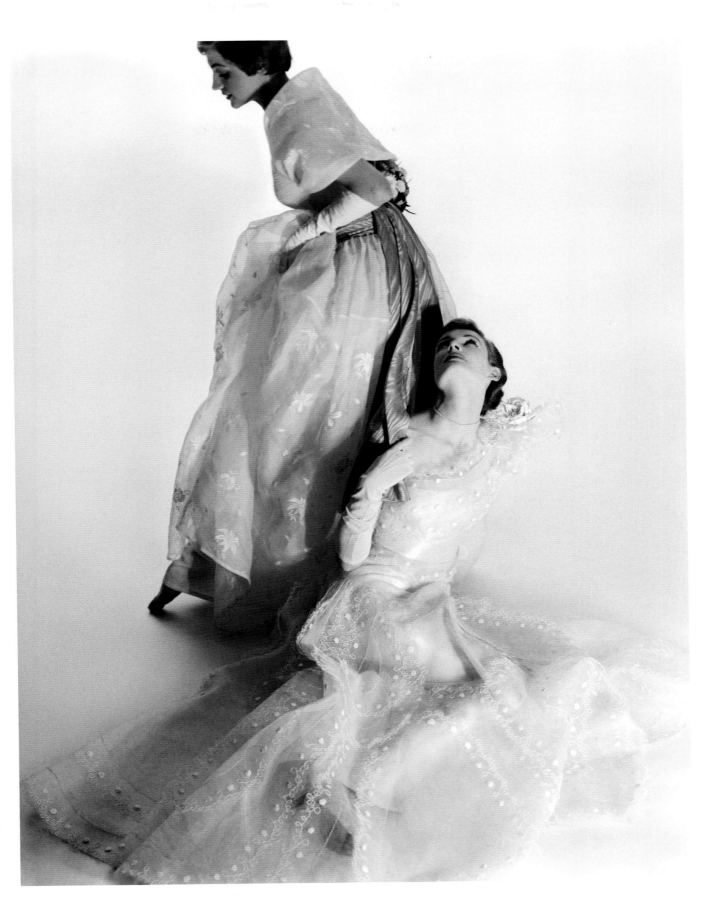

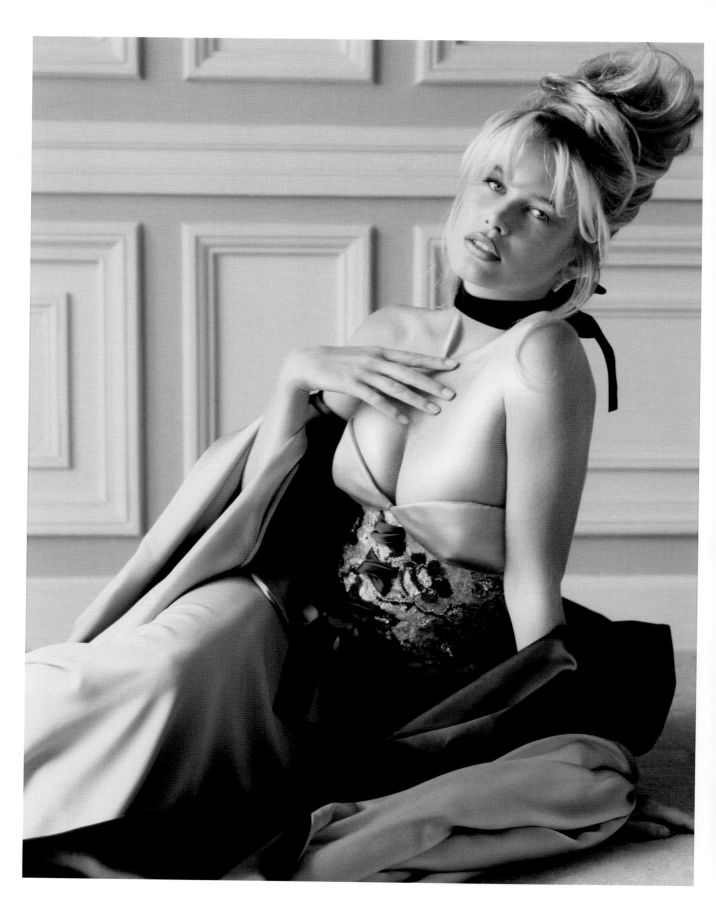

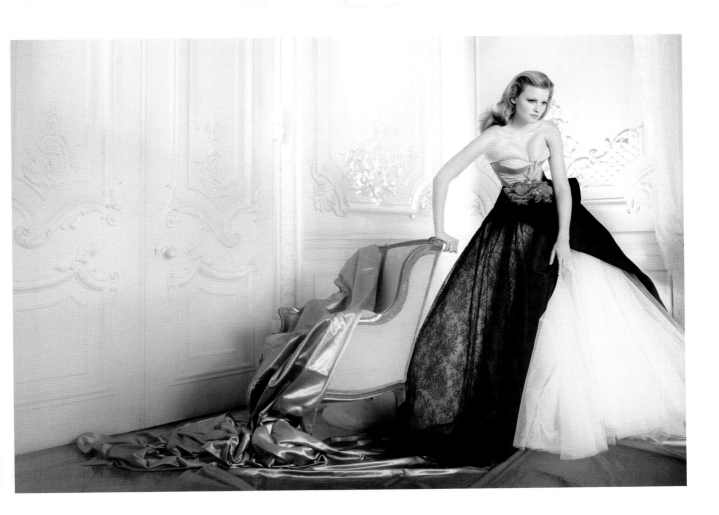

← Herb Ritts, October 1989
'À la recherche du temps Bardot': *Vogue*
heads to Paris with dreams of 'a blonde,
a boudoir, a boy on a motorcycle' – and a
spectacular violet silk crepe evening
dress, by Valentino. Claudia Schiffer is
the bombshell, in a bodice of silk satin
laced with ribbon and embroidered
with flowers. Please forgive us, then,
if we are slightly distracted by her
'delicious décolletage'.

↑ Mario Testino, December 2009
Another alumna of the Bardot school
of seduction, Lara Stone – the Dutch
model 'with the body of a Seventies
Playboy bunny' – squeezes into a silk
faille and lace bustier dress, by Dior
Haute Couture, and a new era in fashion
is announced – the Stone Age. 'She is
the embodiment of the beauty today,'
says Testino admiringly of the model's
uncharacteristically curvaceous statistics
(including a 32D bra measurement).
'We went through an anorexic phase,
but now we have Lara.'

↓ Harriet Meserole, July 1921

A petal gown was the latest thing in floral fashion, and Paul Poiret was delighting Paris with his petal-bodiced gowns with vast hooped skirts. This budding mademoiselle in rose pink seems inspired by Cinderella herself – captured fleeing from the midnight chimes.

→ Barry Lategan, July 1976

A moment of pure Seventies whimsy – with chiffon, wind and flowers. Ossie Clark's bare-backed halter dress, in palest pink chiffon, blossoms with flowers and includes a circle cape in the same billowing print. Crimped hair is encouraged, but *Vogue* has strict instructions regarding underwear: 'No petticoats.'

VOGUE

Late July 1921

CONDÉ NAST & CO LTD
LONDON

One Shilling & Six Pence Net

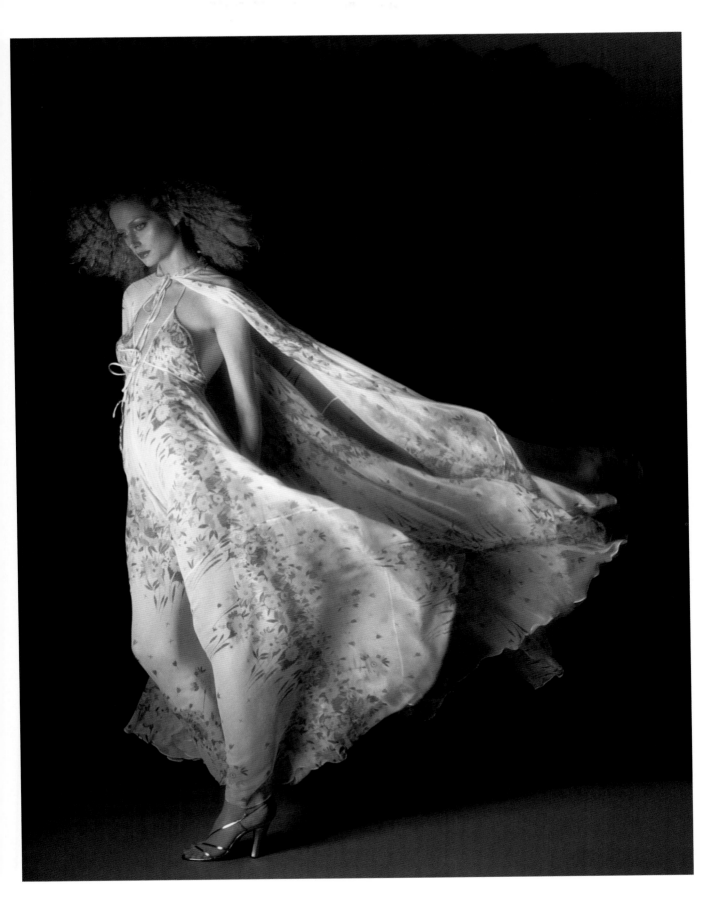

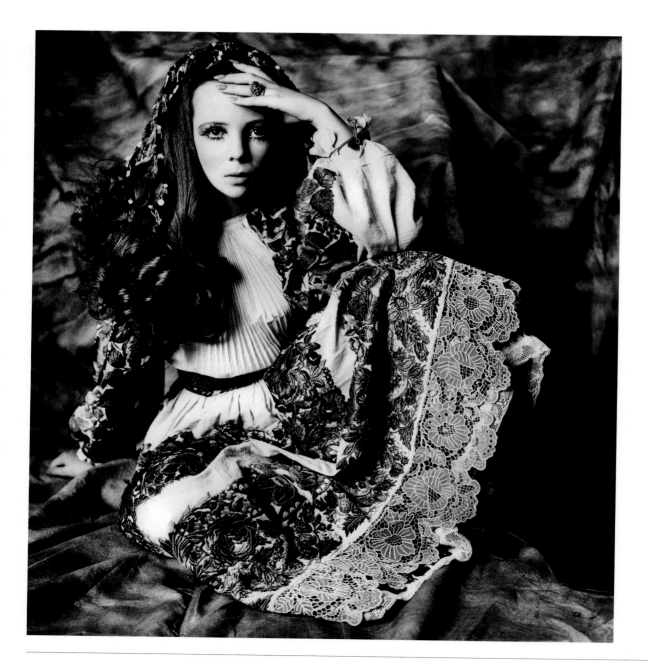

↑ David Bailey, October 1968
Penelope Tree lends her magnificently exotic features to a folk story inspired by 'balalaika music from the Balkans, hurdy-gurdy gypsy camps in Varna and the Ukraine, and straw-roofed Chechen villages'. Such quaint notions seem especially curious when, at that very moment, communism was 'ameliorating' such typical traditions, but the sentiment is at least heartfelt (a rallying cry of support to those trapped behind the Iron Curtain, perhaps?). Tree wears an authentic Yugoslavian peasant dress in blonde pleated linen embroidered in red silk, with a wide hem of flowered lace and a sash of hand-painted velvet.

→ Cecil Beaton, archive image, unpublished, taken in summer 1939
A first sitting with the woman who is to become one of his dearest subjects. The Queen Mother allows Beaton to photograph her in the grounds of Buckingham Palace, in a floaty white chiffon gown by Norman Hartnell. The portrait is refreshingly candid and a good deal less formal than previous images of royalty, and it helped to transform her public image.

'I was determined that my photographs should give some hint of the incandescent complexion, the brilliant thrush-like eyes and radiant smile, which are such important contributions to the dazzling effect she creates in life,' Beaton wrote of the sitting in his diary. 'I wanted so much that these should be different from the formal, somewhat anonymous-looking photographs.'

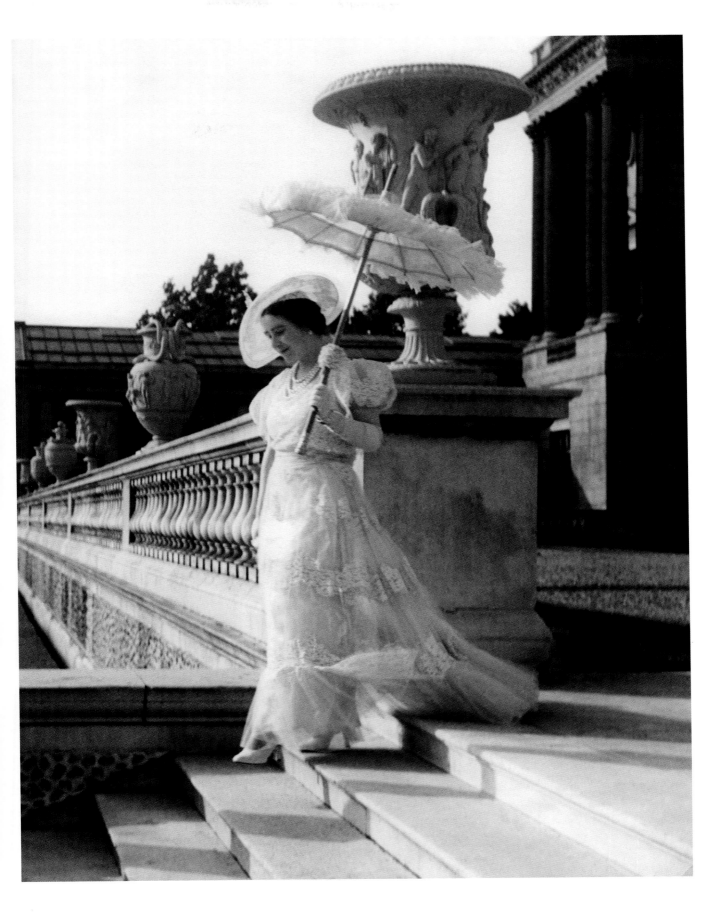

↓ Eugene Vernier, May 1956
Here, an Empire-line dress (left), by Roecliffe & Chapman, sets the precedent for bridalwear: 'The season's prettiest line is here clearly defined – by the flat bow of satin ribbon under the bosom that sets the waistline high, and accentuates the long, lovely flow of skirt.' Need we point out that, this being the Fifties, the mania for artificial fibres (such as cotton rayon) has reached as far as the altar? We think not. Instead, we shall focus on this astonishingly beautiful gown (right), by Ronald Paterson, of embroidered Sudan cotton, layered into tiers, and set off with a short, full veil 'reminiscent of the Tudors'.

→ Don Honeyman, September 1960
Vogue appreciates that the most fanciful dressing can sometimes challenge even the most generous budgets. Here, it offers us 'Clothes You Don't Have to Save up For', starring a turquoise satin, bell-skirted ball gown with a fringed sash, by Robert Dorland. An haute couture look for just 22 guineas: *Vogue*'s added riches include 'ropes of pearl and turquoise beads, and long white gloves'.

→→ Patrick Demarchelier, June 2009
Vogue goes in search of tranquillity and spice in the backwaters and paddy fields of Kerala, India. The local colours are uniquely vibrant, but model Daria Werbowy wears only a palette of palest shades: in a line of jewel-coloured saris, she stands apart in a silk slip dress of sun-bleached white, by Emporio Armani.

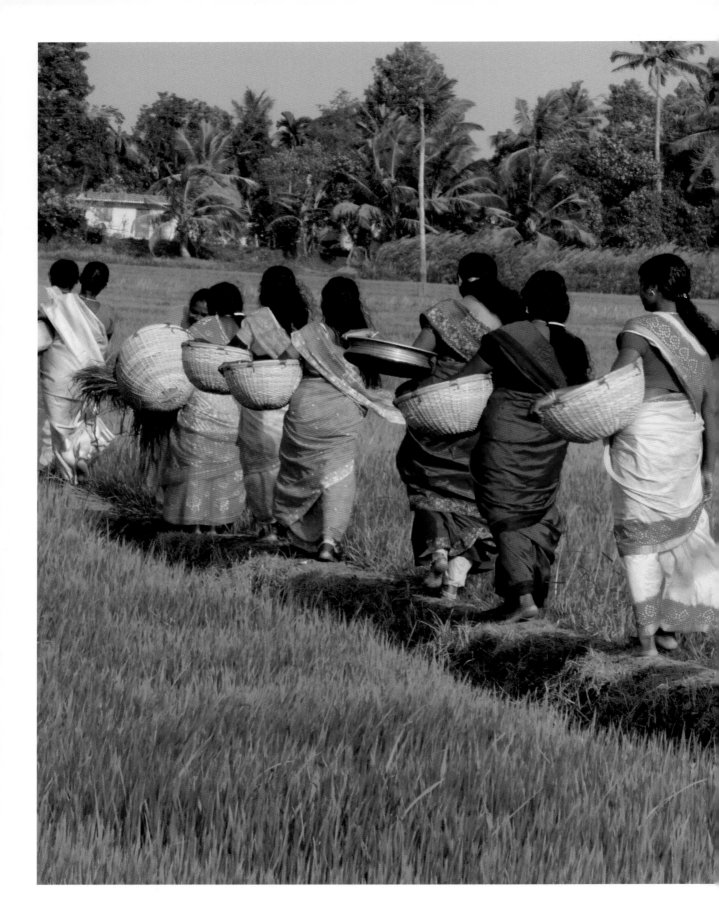

drama

In the world of fashion, a shoot is called a 'story'. And with good reason. Who didn't, as a child, rummage in the dressing-up box only to emerge another character entirely, swathed in curtain, smeared with rouge and usually tottering on borrowed heels?

It is this instinctive desire for role-play that fashion indulges. Who might wear such a dress, we wonder? Where might they be? What might be happening offstage? Stories begin to weave together. An idea takes shape.

Vogue tells the stories that explain the clothes. Sometimes the picture might relate a simple tale about a colour, say, or a detail that has become pertinent that season. Sometimes, it becomes a much greater fabulation: clothes become characters in an epic drama that might find its leading lady cast away, languishing on a piece of driftwood, or as an Edwardian lady perambulating the seashore at Deauville. A fashion editor, in conversation with a photographer, may express her admiration for the work of an Old Master and that might flick a light switch: our muse is suddenly a Renaissance princess, Titian-haired and melancholy with love. The narrative builds. Velveteen gowns are found, more images are gathered as references, golden amulets and accessories are picked over, wigs are adjusted... and a narrative begins to emerge. (The story may be spun on a gossamer thread, but it is woven together by industrious dramatis personae.)

Vogue has always adored to play – what better sop for an inclement isle like Britain than escapism? Cecil Beaton loved a bit of dressing up, sketching elaborate fancy-dress costumes for the aristocratic classes and casting them in quaintly adorable guises. No one was spared – even the Queen Mother can be found in a pastiche of Franz Xaver Winterhalter's portrait of Empress Eugénie (see page 193). Norman Parkinson told dramas on an epic scale, throwing open the doors to the world and taking *Vogue* on impeccable, exotic adventures among Muscovites, maharajahs and Masai warriors. In the Sixties, photographers such as David Bailey and Brian Duffy employed a new 'social realism', juxtaposing grit and glamour to tell tales of modern heroines with their hearts in the here and now. Popular culture has only added to the drama – Noël Coward and Alfred Hitchcock have had big roles to play in *Vogue*'s narratives. And let's not forget the role of the 'great house', those spectacular ancestral seats against which so many stories have played out.

Today, the opportunities for uncovering strange civilizations and far-flung treasure islands are diminishing and fashion stories more often look to fiction and folklore from which to draw inspiration. But drama doesn't always need a spectacular set. Some of the most intriguing tales are told with an artful cock of the eye or a smouldering glower. Nor do great gowns always need a huge supporting cast. There's a certain majesty in seeing a truly wonderful gown in the simplest of settings, still and unspoiled in its beauty – a keeper of its own secrets.

→ **David Bailey, April 1965**
Jean Shrimpton and David Bailey were one of the most tantalizing couplings in fashion history, and their relationship gave birth to a new school of fashion realism. Here, in 1965, the affair has already ended – Shrimpton has begun a relationship with actor Terence Stamp, and Bailey is shortly to enjoy a fleeting marriage to Catherine Deneuve – but the couple's chemistry still collides before the lens with devastating impact. Together, this story illustrates the 'new colour magic, starting with black and white,' with a deep-frilled, V-back dress with mid-calf skirt, by Susan Small.

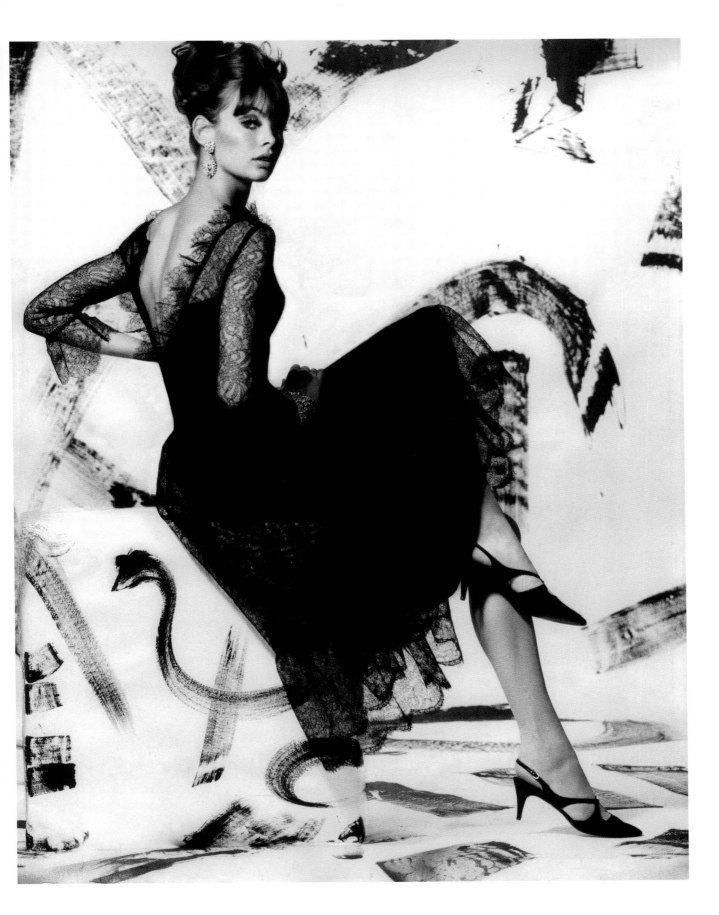

↓ Max Vadukul, November 1992
Vadukul shoots Danish-born model Helena Christensen as the *donna passionale* – a Roman heroine cast among the ruins of the Eternal City. In a chiffon halterneck dress with beaded bodice, by Polo Ralph Lauren, she channels the same smouldering sensuality as that great star of Italian cinema, Anita Ekberg. (Appositely enough, both women are, in fact, Scandinavian.)

↓ Michael Roberts, May 1992
A new René Magritte exhibition in London reignites a passion for Surrealism – and a great deal of reinterpretation. *Vogue* may lament the appropriation of the artist's ideas by savvy commercial operators, but the magazine applauds Michael Roberts' 'Ceci n'est pas une robe', which uses an Emanuel dress with roses on the shoulders (and a short comic verse) to pay homage to Magritte's seminal work, *The Treachery of Images*, with its text 'Ceci n'est pas une pipe'.

→ Nick Knight, November 1993
Embodying an unbeatable combination of high-octane glamour, God-given good looks and *joie de vivre*, Linda Evangelista stars on this late-autumn cover in a black net and crepe dress by Karl Lagerfeld. The faux-jet crucifix at her neck only reinforces her stature as an icon of the modern age.

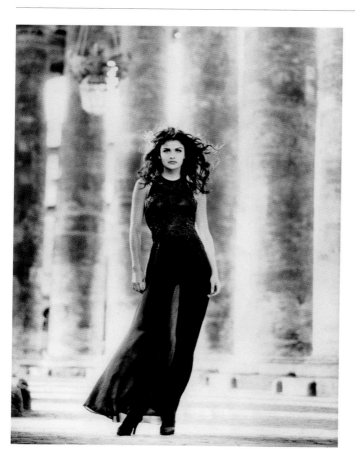

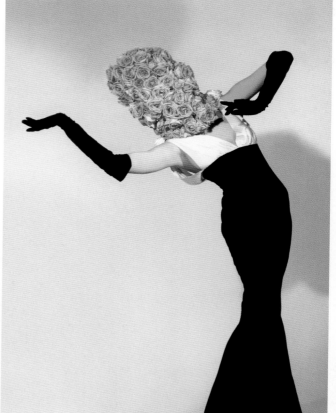

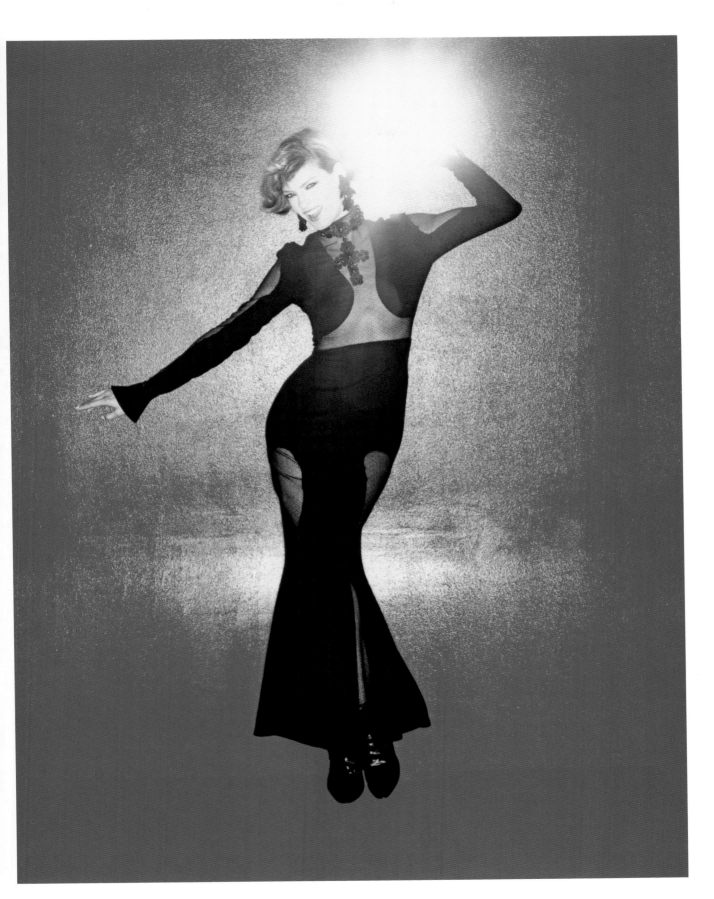

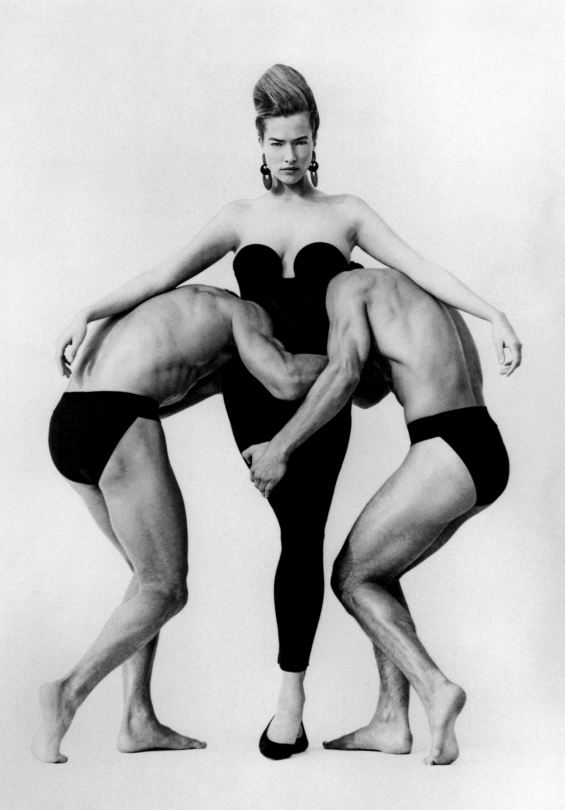

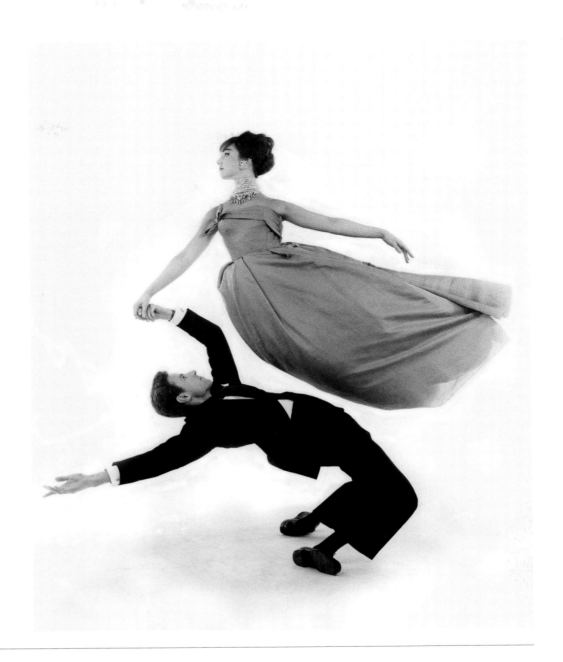

← Herb Ritts, July 1988

The great champion of fierce glamour and Eighties athleticism, Ritts's love of powerful women and the plunging contours of the female form finds great expression here with model Tatjana Patitz, 'statuesque in snake-hipped black stretch, great earrings and a Maria Callas bouffant'. The ankle-grazing sheath dress comes courtesy of fashion's 'king of cling', Azzedine Alaïa. *She* daubs her ears in Chanel No 5. Her attendant Adonises? Antaeus for Men, of course.

↑ Antony Armstrong-Jones, November 1959

'R.S.V.P. or get with it', exhorts *Vogue*, as it swings into the new jazz age with its 'zany, sparkling, absolutely hep cats'. The teenage revolution is afoot, and *Vogue* is quick to jump on the groovy train with this transcendent *pas de deux* – staged with a little help from Armstrong-Jones (later Lord Snowdon), and model Anna Delaney in a Swiss satin organza ball gown in pale violet, by Jean Allen.

↓ Mario Testino, February 2001
Naomi Campbell dons a bright white silk bustier dress with a peacock-feather hem, by Tom Ford for Yves Saint Laurent Rive Gauche, and dances into the new millennium with stars in her eyes, and a megawatt smile.

→ Nick Knight, October 1995
Valentino Clemente Ludovico Garavani (known by all simply as 'Valentino') drew on his Roman heritage, as well as his native city's artisanal workshops, to create some of the most unashamedly romantic gowns of the modern era.

He retired in 2008, after a 50-year career in which he revolutionized attitudes towards Italian fashion. This black-beaded couture gown, with hot-pink overskirt by textile manufacturer Clerici Tessuto, demonstrates his unique gift for the 'extravagant gesture'.

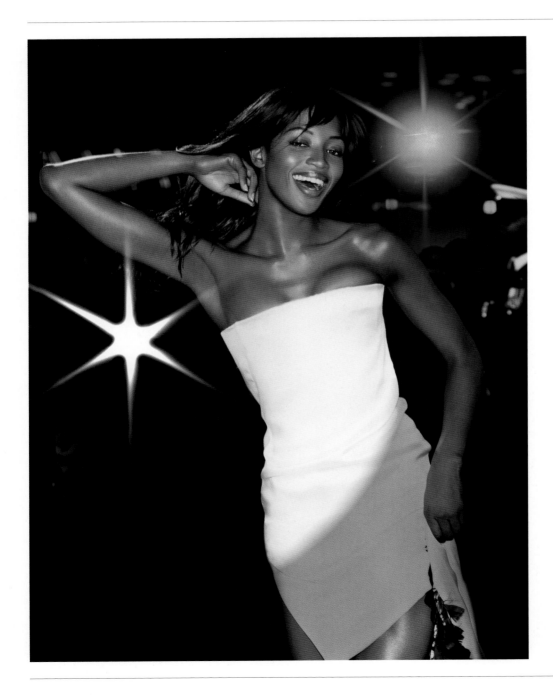

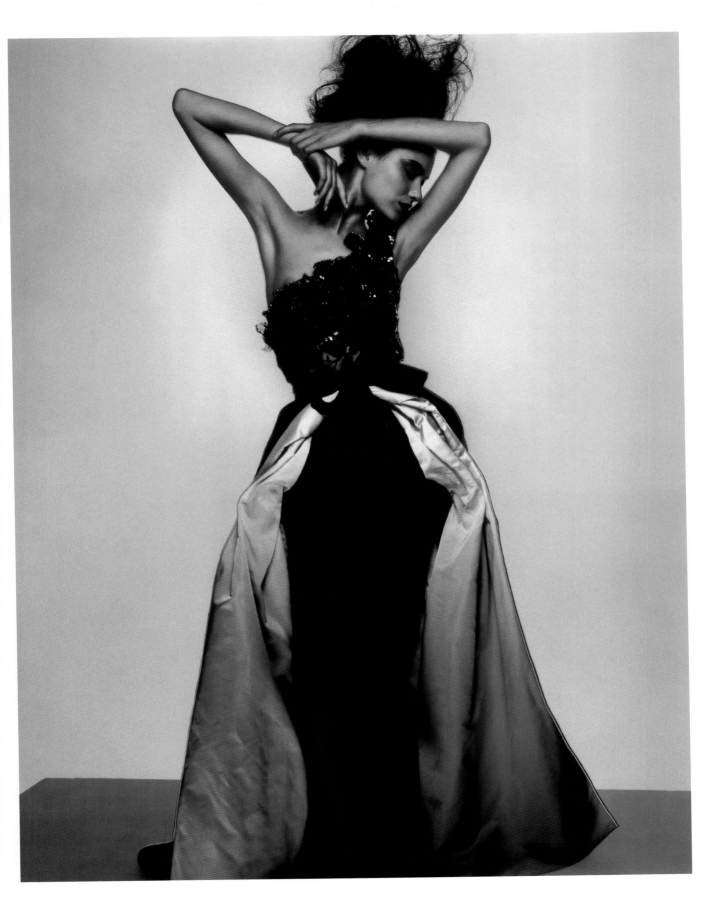

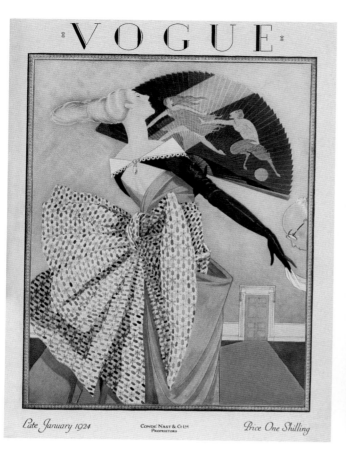

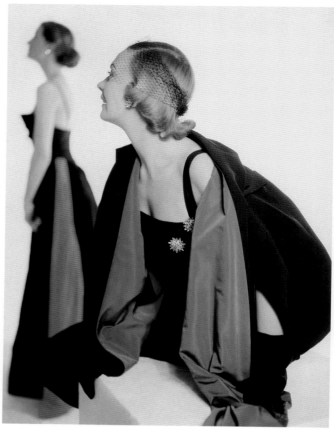

↑ George Wolfe Plank, January 1924
In 1924 George Gershwin's jazz-inspired *Rhapsody in Blue* received its first performance in New York. At the start of the year, however, *Vogue*'s rhapsody is an altogether more verdant affair. An evening's outing requires a jade-green backless gown, with voluminous bow and an admirer – albeit one somewhat challenged in the follicular department. Should the situation become too heated, however, our muse will keep her cool with a flamboyant fan depicting a scene recalling the balletic athleticism of Vaslav Nijinsky's *L'Après-midi d'un faune*.

↑ Norman Parkinson, March 1951
The London collections deliver, *Vogue* opined, 'the most wearable clothes in the world: their fabrics are perfection, their colours sensitive, their lines pleasing to the eye and to the figure, and their details most skilfully devised'. One can only hope, then, that occasions befitting the wearing of Victor Stiebel's black faille dress with cherry-red moiré lines (left) or Mattli's emerald grosgrain-lined cocktail coat and shoulder-strap sheath dress (right) were forthcoming.

→ David Bailey, January 1974
Vogue toasts the New Year with Anjelica Huston and shoe designer Manolo Blahnik, willing players in a fashion love story set on sun-drowned beaches in the south of France and Corsica. (The real affair was actually shared between the photographer and Huston, who rejected Bailey's proposal of marriage and went back to Jack Nicholson when the sun finally did set on this mini drama.) Blahnik wears a white suit by Walter Albini and a splash of Espada. She wears a sea-green ruched silk jersey by Bruce Oldfield and the scent of Eau de Love.

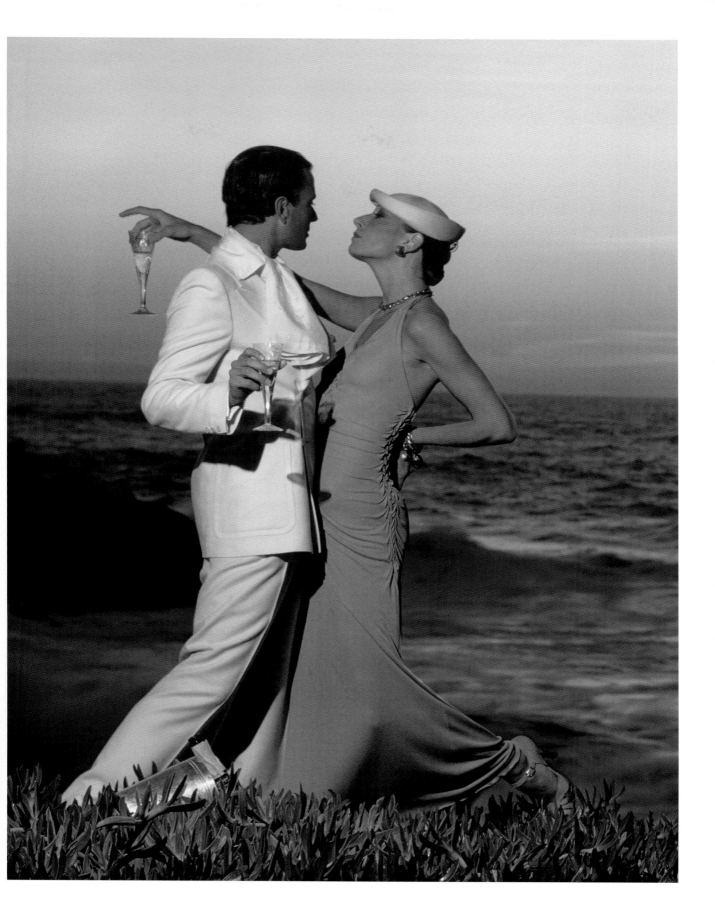

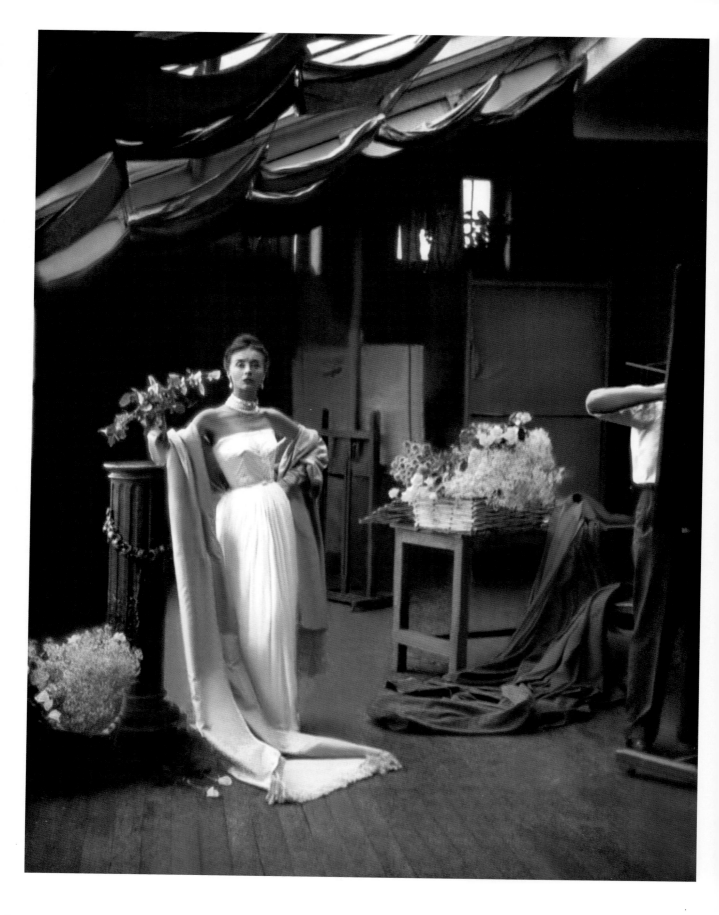

← Cecil Beaton, October 1951

An immense chartreuse fringed satin stole drapes the shoulders of our young ingénue. The Paris collections had arrived, and, as ever, the changing rules of fashion were of seismic importance: 'New lines are not imposed on you,' thundered *Vogue*. 'You accept them because you like them – or reject them because you don't…

Dior shows the high waist; Balenciaga the middy. Are they both still too far ahead of the public, or does one take your eye? You are the public. You will decide.' The decision here is elementary: who could resist this exquisitely draped white jersey dress, by Jacques Fath.

↓ Don Honeyman, September 1951

A soupçon of gossip and a dash of mischief add no small amount of intrigue to these evening gowns. In a tale of two attitudes, Peter Russell's bare-shouldered contour-skimming dress in slate-blue and copper brocade (left) is as racy as the buttoned-up dress with full sweeping skirt, by Worth (right),

is demure. Together, they make perfect partners in crime.

↓ **Photographer unknown, December–January 1932–3**
Little is known about this enigmatic lady with her jewel-green gown, snug kid-leather gauntlets and fur stole. She sits as contemplative and still as the study behind her, an independent soul lacking in the usual vigour of a *Vogue* cover model, but no less beguiling to behold.

→ **Cecil Beaton, December 1951**
A 'great house' and the sweeping architecture of grand living, so beloved by Beaton, invests Balmain's ball dress – with its plaid polonaise of taffeta – with infinite maturity. But no antiquated duchess she – Elizabeth Arden's 'Redwood' lipstick and a tightly bound bodice ensure that this particular evening belle will stay forever youthful.

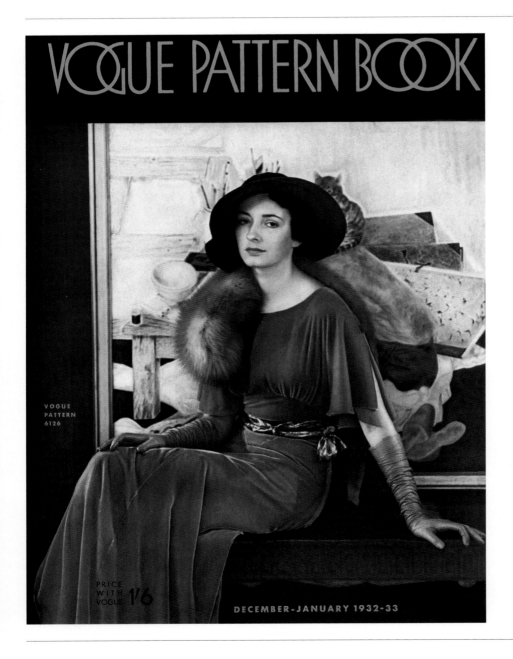

VOGUE PATTERN BOOK

VOGUE
PATTERN
6126

PRICE
WITH
VOGUE 1'6

DECEMBER-JANUARY 1932-33

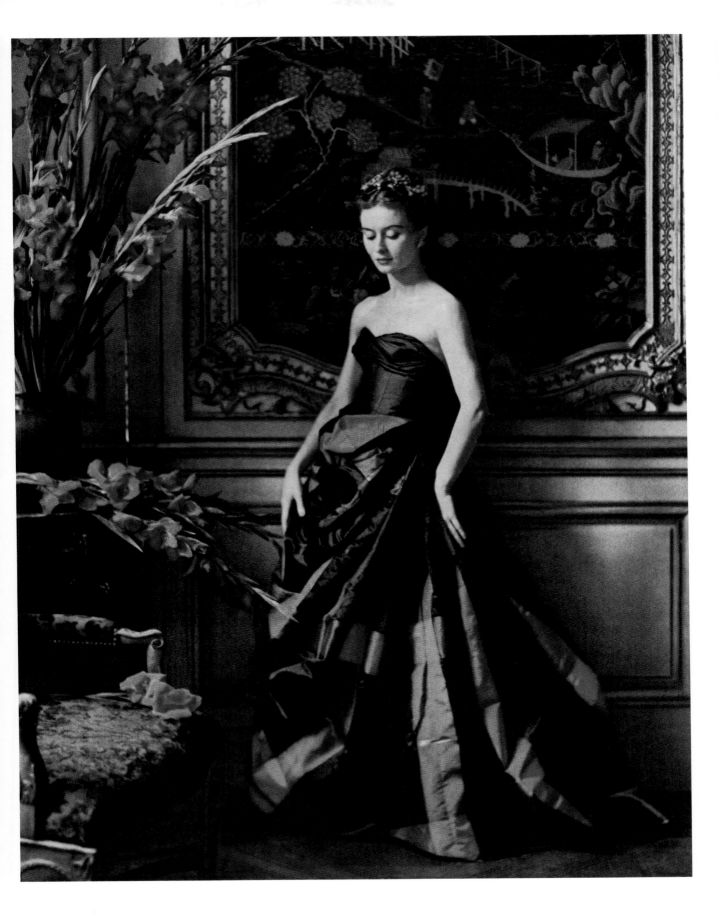

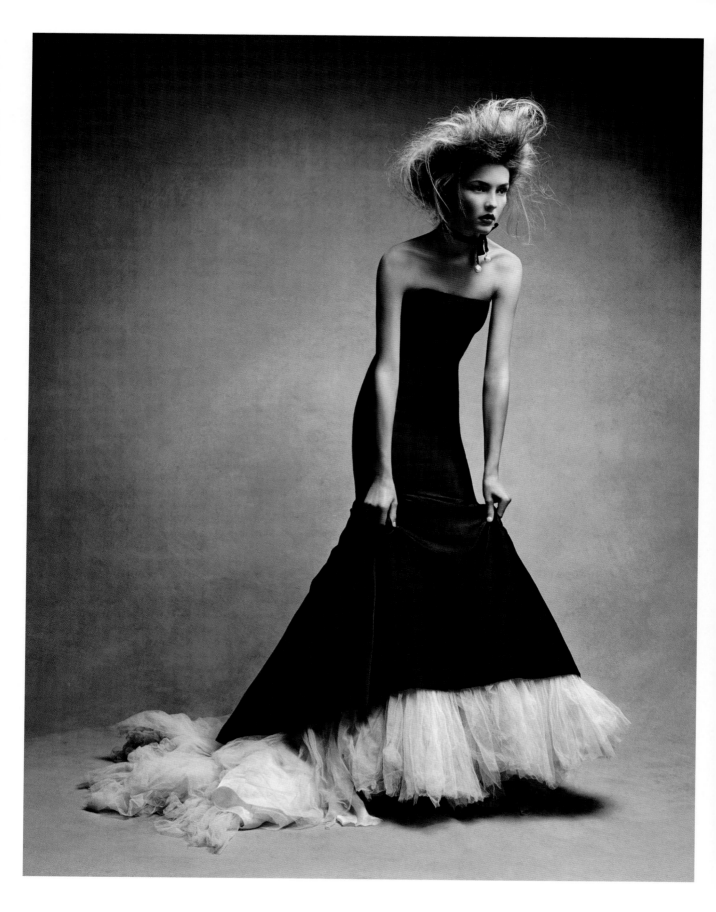

← Patrick Demarchelier,
December 2005

Vogue turns time-traveller to showcase the influence of past eras in the current crop of eveningwear. Alexander McQueen cited Hitchcock blonde Tippi Hedren and Marilyn Monroe as inspirations for his Autumn/Winter show in 2005, and sent great floor-sweeping gowns like this one down the catwalk. Yet, Old Hollywood va-va-voom is tempered by the crumpled tulle underskirt of this duchesse satin bustier dress, making the look at once more romantic, magical and faintly forlorn.

↓ Norman Parkinson, September 1975

To Versailles, where Jerry Hall is cast as a modern Marie Antoinette, resplendent in Christian Dior's one-shouldered black satin column dress, slit to the thigh and worn with a bell-sleeved jacket with feather fringe. 'Marie Antoinette had a passion for feathers,' explains *Vogue*. 'The "coiffure à la Minerve" had as many as ten, which were so tall that one day she found it impossible to enter a coach to go to a ball given by the Duchesse de Chartres.'

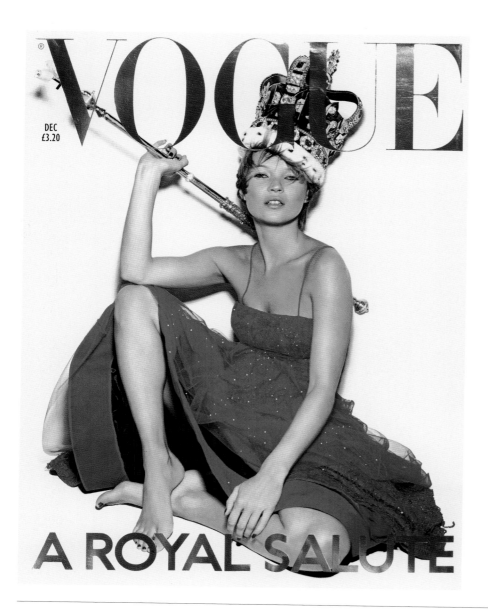

VOGUE

DEC
£3.20

A ROYAL SALUTE

↑ Nick Knight, December 2001
In 'A Royal Salute', *Vogue* indulged its monarchism with a Christmas issue dedicated to all things regal. Among the features were pieces on royal style, Wallis Simpson's advice on the 'art of the dinner party' and a portfolio of royal portraits as captured over the decades by *Vogue* photographers. Yet there is no question as to who was queen here: Kate Moss, newly shorn and barefoot, graces the cover in a Swarovski crystal-studded gown, by Giorgio Armani, wielding a replica sceptre and crown.

→ Norman Parkinson, November 1956
The first photographer to trademark the epic fashion shot, Parkinson's foreign adventures for *Vogue* found him crouching under cascading waterfalls in Jamaica, camping in Monument Valley, crossing continental Africa in a biplane and, here, afloat on a Kashmiri lake. Model Barbara Mullen (together with Anne Gurning) accompanied the photographer on this Indian odyssey, and the resulting images capture the dying embers of a colonial past, as well as introducing the world to a culture of such dazzling vibrancy that, on seeing them, Diana Vreeland declared

pink to be 'the navy blue of India'. This fashion maxim is much in evidence here, as Mullen reclines on a 'boat built for indolence', in a bold grosgrain dress with a huge skirt, by the London couturier (and later costume designer) Frederick Starke.

→→ Alex Chatelain, April 1979
'Dare to be the brightest,' insists *Vogue*. Disco fever still infects the dance floor, and getting noticed is what mattered most. 'Colour your clothes brighter than bright, compelling, sometimes clashing, often shocking: black, white, black with scarlet, crimson, fuchsia, ruby, pink…' On the other hand, showing flesh is encouraged: 'so apply yourself to shape, diet – on avocados, perhaps.' Confused? Don't be – all you need is Saint Laurent's knife-pleated shocking pink chiffon shift, bound in purple satin and worn with a scarlet chiffon apron, and, finally, some 'jazzy décor'.

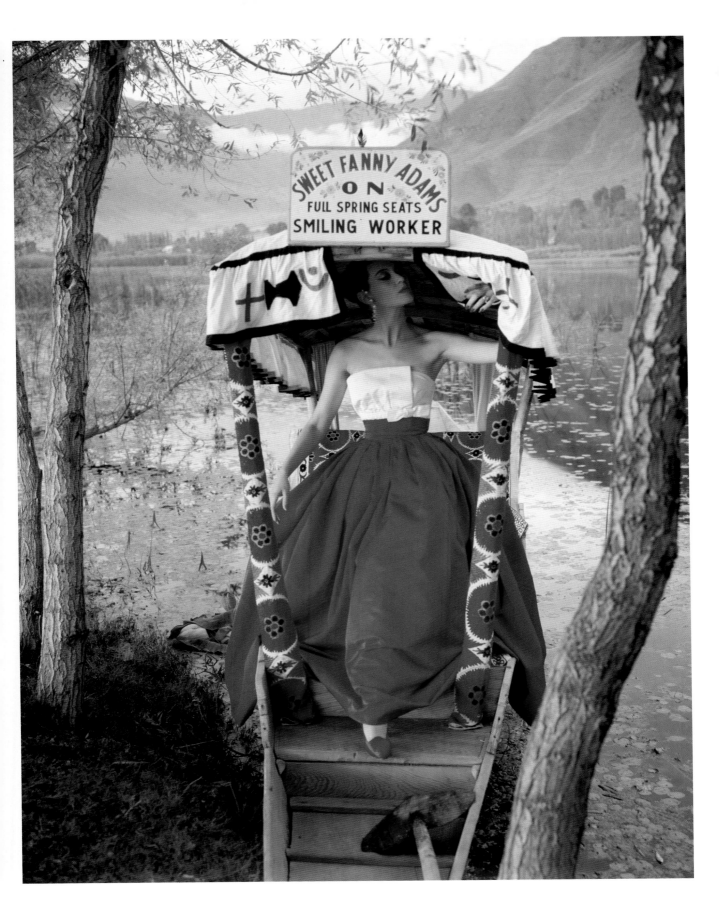

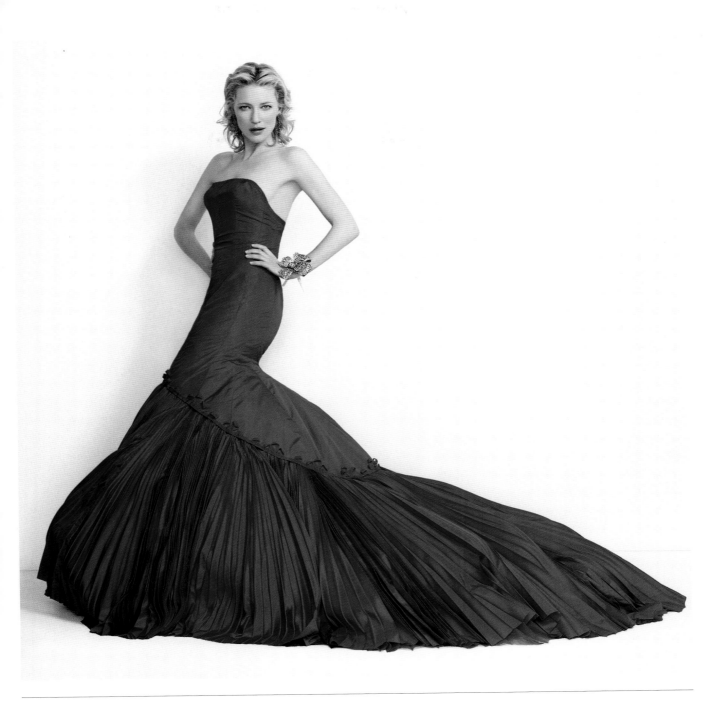

← **Tim Walker, December 2008**
Film director Tim Burton and model Karen Elson unite with Walker to tell 'Tales of the Unexpected', a fashion mash-up, drawing on both Roald Dahl and classic fairytales for inspiration. The results are gently charming: Elson is more scarlet woman than Little Red Riding Hood, in a Jenny Packham ruby-sequinned gown, sprinkled with Swarovski crystals, and red wedge shoes, while Burton's Gieves & Hawkes-clad wolf is about as menacing as a teddy bear.

↑ **Regan Cameron, June 2005**
An award-worthy gown fit for a Hollywood queen: Cate Blanchett sweeps onto the cover of *Vogue* only days after accepting an Oscar (for her turn as Katharine Hepburn in *The Aviator*), wearing a red silk-taffeta gown by Alexander McQueen. The actress is celebrated for wearing clothes that enhance her personality, rather than turning her into a clothes horse. 'I wanted to step up and meet that dress,' she says of red-carpet dressing and the glamorous ensemble she wears here. 'I'm not a natural exhibitionist, but I think to myself: this is just what's happening today.'

↓ **Henry Clarke, September 1968**
Valentino's stately evening dresses, printed with Delftware-inspired flowers and foliage, birds and butterflies, are here photographed in the Palazzo Borghese in Rome. The mood is sombre and beautiful, simmering with intensity and as mercurial as the political and cultural upheavals then in full flow. *Vogue* encourages readers to adopt a similar attitude: 'Whatever's the happening, you are part of it, and at last you can be yourself and look as you choose.'

↓ **Norman Parkinson, January 1973**
A mysterious woman in a fine black jersey gown caped with frills, by Gina Fratini, has an appointment in an abandoned square under the blazing Portuguese sun. The black hat makes her anonymity only more alluring: this, surely, is the chicest of high noons.

→ **Henry Clarke, October 1962**
Is this young ingénue escaping unwanted attention in her 'dazzly blue satin' gown, by Fredrica? Or is she herself in pursuit? Eveningwear is 'a long, devastating, slink' this winter and our girl has places to go. She had better be careful, though: too fast and she will lose one of those lovely kid slippers…

↑ Tim Walker, December 1997
Fair Isle sweaters, gumboots, fancy
dress and woolly socks – the sartorial
eccentricities of British style have always
enchanted Walker and inspired his work.
In this shoot *Vogue* takes a spirited look
at eveningwear, using vintage touches
to draw a picture of a quintessentially
English Christmas: this sleeveless flared
gown in raspberry-red silk satin has been
stitched together from an old *Vogue*
pattern and paired with a frilled tulle skirt,
by Bellville Sassoon.

→ Edward Steichen, May 1935
Few photographers have ever captured
the drama in a face, or a gesture, as
well as the American photographer
and painter Edward Steichen. Here, he
captures another incomparable talent,
the German-born actress Marlene
Dietrich. Shot in 1935, at the height
of her career, and at the culmination of
a prolific collaborative period with the
director Josef von Sternberg, she wears
a dress by the Hollywood designer
Travis Banton. Despite the dress being
described as a 'frou-frou of black tulle',
Dietrich still appears deadly serious.

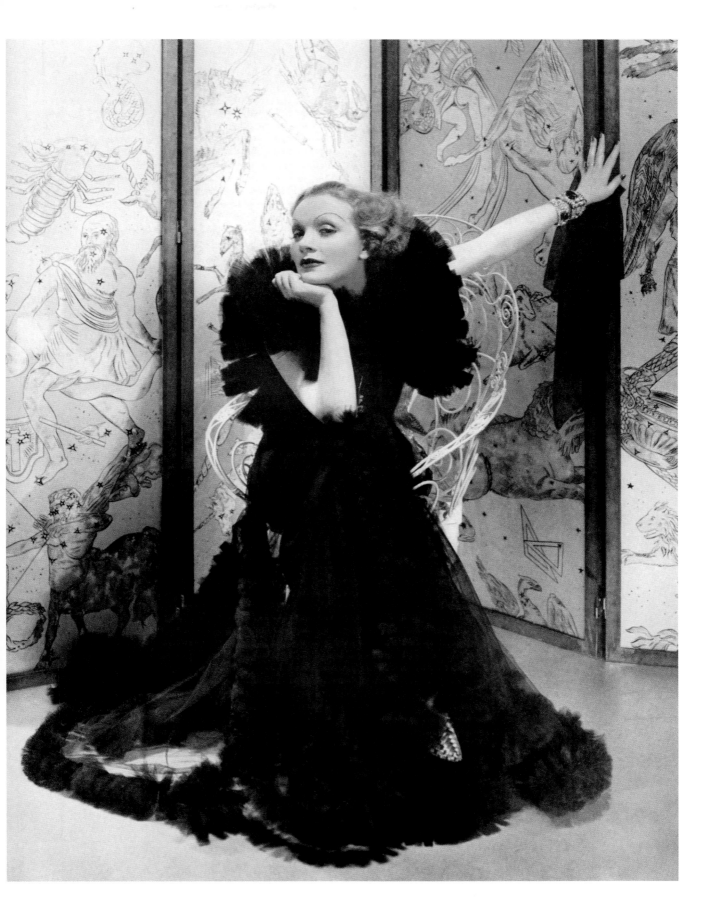

↓ Cecil Beaton, September 1950
Our heroine makes her way to dinner in a dove-grey, tightly fitting brocade gown, that spills down into a wide net skirt by Victor Stiebel. There is a new formality in the air, and clothes are 'strong in personality and insist on certain accessories'. Fabrics glint with metal thread, skirt lengths have risen, a 'feeling for asymmetric detail continues', and sleeves are long.

↓ Helen Dryden, November 1916
Amid the gloom of World War I, and the 'anguish of evolving a new silhouette' that will dictate a 'lean and hungry year ahead', *Vogue* consoles itself with thoughts of an indoor garden party. The fashion illustrator Helen Dryden imagines costumes for (left to right) an orchid, Night, and a garden fountain, and while the editorial laments the male tendency to become 'painfully self-conscious' at the prospect of such gaiety.

→ Norman Parkinson, February 1951
In *Vogue*'s first 'Britannica' number, the magazine celebrates the country's special excellences: 'We have tried to avoid blowing Britain's trumpet too loudly. If this traditional modesty is a mere façade to conceal inordinate pride – well, that's as may be.' In this photographic study, Parkinson steers a fashion narrative about British style, here spiriting up an elegant ghost dressed in Norman Hartnell's strapless evening dress of lilac tulle, haunting the perimeter paths of Clytha Park, in Monmouthshire.

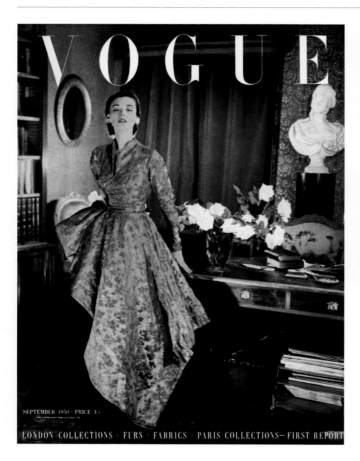

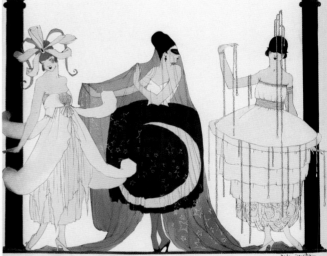

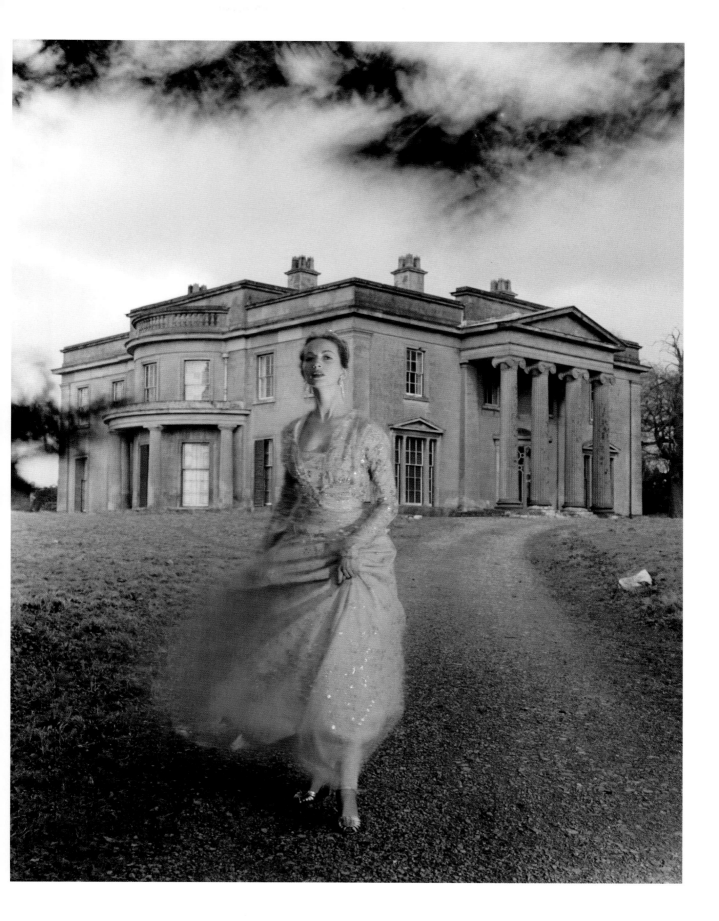

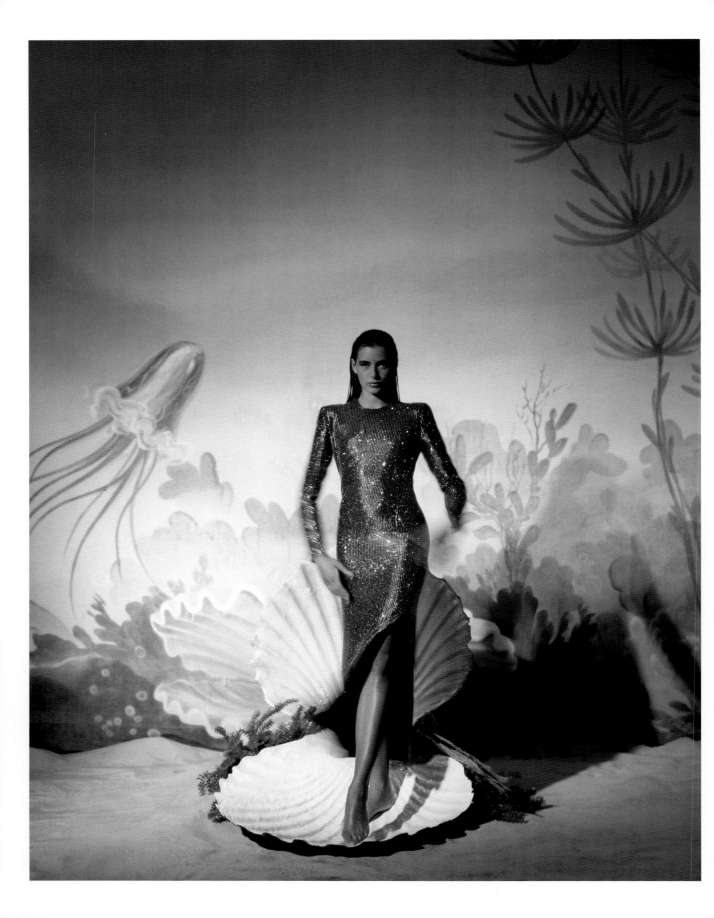

← **Peggy Sirota, June 1991**

As part of the magazine's 75th birthday celebrations of 'great dresses, great images', Sandro Botticelli's *The Birth of Venus* is reborn, Nineties style. Model Bettina Meinkohn emerges from the surf in a rhinestone-covered silk column dress, by Giorgio Armani. And the Italian designer sends his felicitations.

↑ **Barry Lategan, October 1970**

Vogue unveils a 'Portrait of the New Renaissance', with acknowledgements to the artists Titian, Il Bronzino and Giorgione. Sumptuous fabrics are decorated with ravishing prints on panne velvet and fine wool, colours are highlighted with gold thread and gilt braiding, and craftsmanship is key. A landscaped linen pinafore, gathered to embroidered ribbon and appliquéd with Renaissance portraits, by Bill Gibb for Baccarat, sets the scene. A lute player, in Reformation booties and a muffin hat, plays the score.

Price Now One Shilling

VOGUE

Price Now One Shilling

CONDÉ NAST & CO. LTD.
PROPRIETORS.

Early November 1923

Price One Shilling

↑ **Edward Buk Ulreich, November 1923**
An elegant brunette in burnished gold inspects another seasonal invitation. A passion for chinoiserie has clearly taken hold among the affluent classes, and the elaborately illustrated panel, depicted here by the Austro-Hungarian painter, sculptor and illustrator, signifies to readers that this room houses the very chicest of occupants. By contrast, her gown, with its elegantly fluted sleeves and clean lines, is almost thrillingly plain.

→ **Mario Testino, March 1997**
'The hippest dress for evening is a barely-there slip of velvet with a jagged hem,' says *Vogue* of Martine Sitbon's chartreuse gown in silk devoré. This summer, florals are amped up for maximum sex appeal, splashed over dresses cut to reveal flashes of flesh; lips and limbs are 'glossed to the hilt'.

→→ **Mario Testino, March 2012**
Karlie Kloss is the lady-who-lunched in Valentino's crocus-yellow guipure lace dress, bright, immaculate and ready to sail through a calendar of social obligations and engagements. *Vogue* shot this decadent tale of the *haute bourgeoisie* at the showroom home of Italian interior designer Lorenzo Castillo and at the Hotel Santo Mauro, in Madrid, an opulent space of lacquered antiques, gilt edges, jewel-coloured textiles…and the odd elephant's foot.

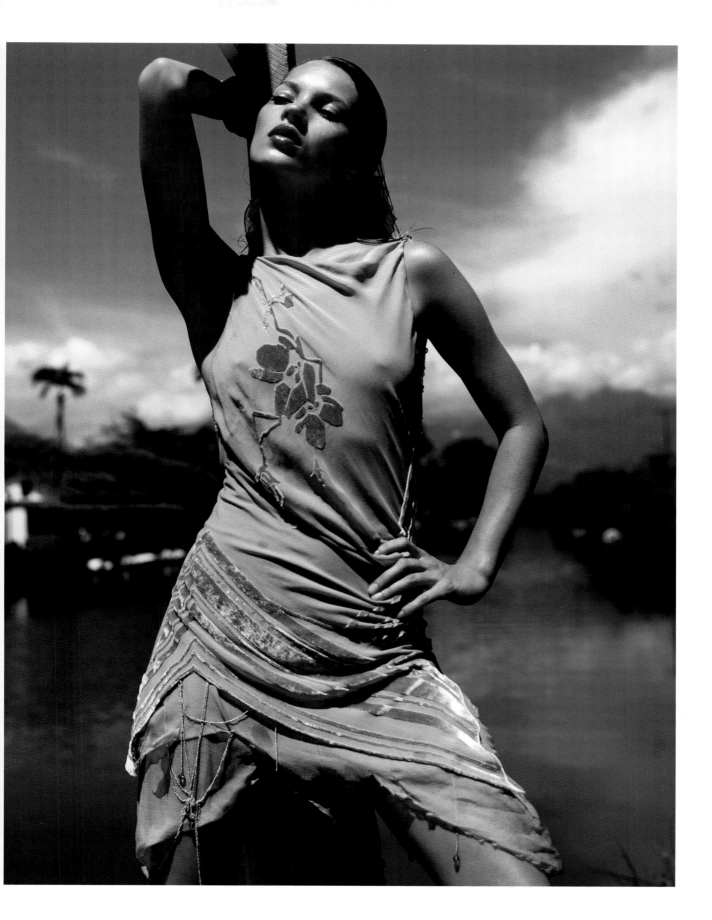

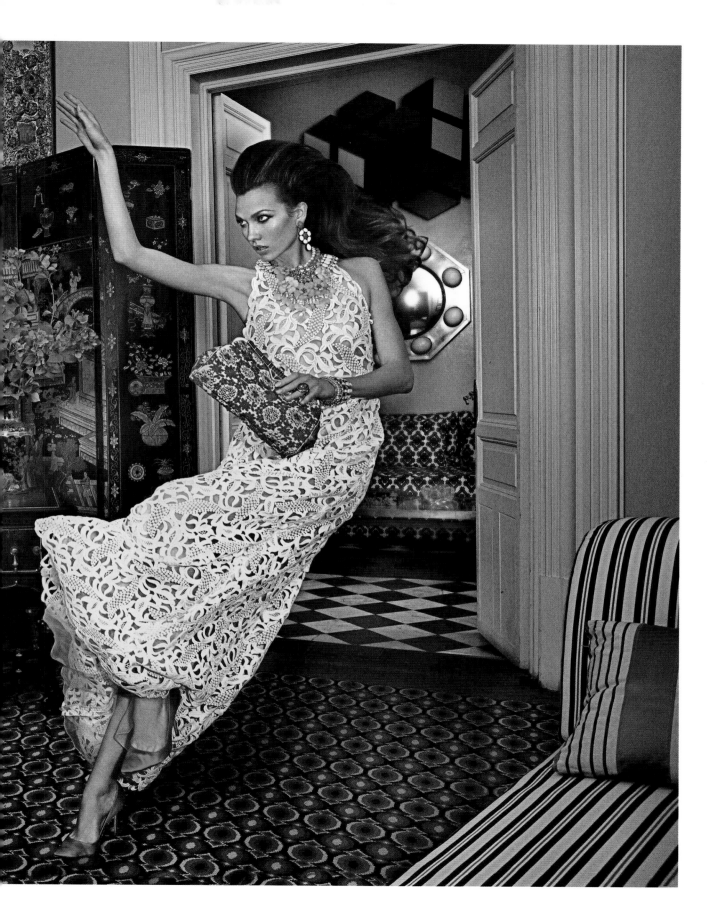

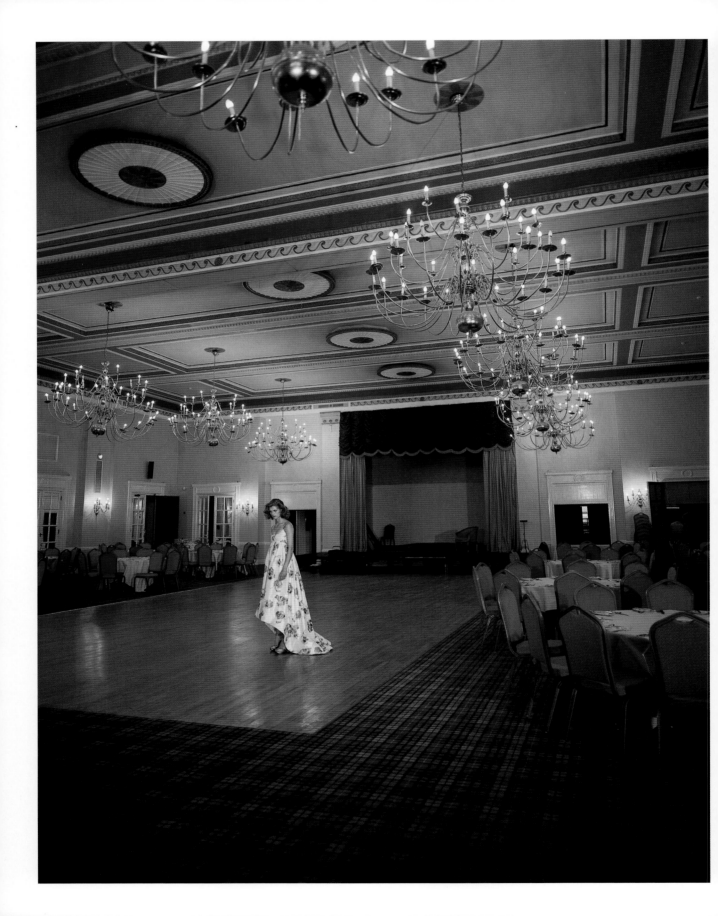

← **Tom Hunter, January 2006**

In 'Hunter's Tale', the art photographer marks a major exhibition at the National Gallery with a fashion story for *Vogue*. He tells the tale of a recently arrived *émigrée* from Eastern Europe (played by Polish model Małgosia Bela), set against the faded Edwardian grandeur of the Adelphi Hotel in Liverpool. 'It would be strange for her, having had such a lack of information for so long, and not having travelled before,' explains Hunter, in reference to the girl's sartorial disconnect. 'She dresses to suit the surroundings and what she expects.' Wearing an Oscar de la Renta taffeta ball gown, she stands dejected on the hotel's dance floor, a modern-day Cinderella waiting for her Scouse Prince Charming to spin her around the floor.

↓ **William Klein, May 1958**

The subversive American photographer and film auteur is perhaps best known for his 1966 film *Who Are You, Polly Maggoo?*, a brutal satire about the fashion industry that is as biting as it is bewitchingly glamorous. His work for the magazine was largely the product of a meeting with Alex Liberman, the art director of *Vogue* (nearly a decade before that film's creation), and even this simple commission about Parisian trends, illustrated with a Nina Ricci column dress, in tawny organza and worn with a 'full-blown ivory rose' at the waist, is captured with the same sense of wicked irony.

↓ **Mario Testino, April 2004**

Polish-born, Canadian-raised model Daria Werbowy, is deeply tanned and sphinx-like in Jean Paul Gaultier's desert-yellow gown, worn with silk flowers in the hair, coral-coloured beads and paste. The mood for the picture is heavily inspired by the couture season's exotic themes, drawing on global styles from Tibet to Timbuktu.

→ → **David Bailey, March 1976**

Vogue enters the Technicolor world of British designer Zandra Rhodes to dramatize a fashion story starring Bailey's then wife, Marie Helvin, and the film producer Sandy Lieberman. Rhodes entreats her fans to think of her dresses 'as an artwork that you will treasure for ever. Everything by me is an heirloom for tomorrow.' In 'Scene II', however, her brightly coloured West Coast cactus-print dress seems destined for the disco rather than the archive. Rhodes heartily approves: 'I give women what makes them happy. Look at any dinner party – the women who are laughing are wearing my dresses.'

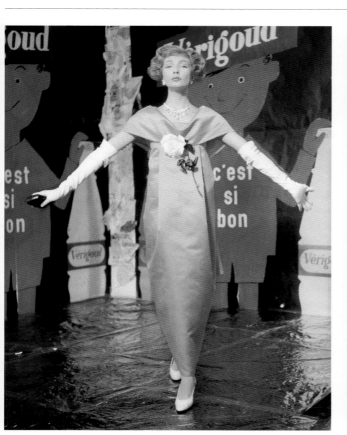

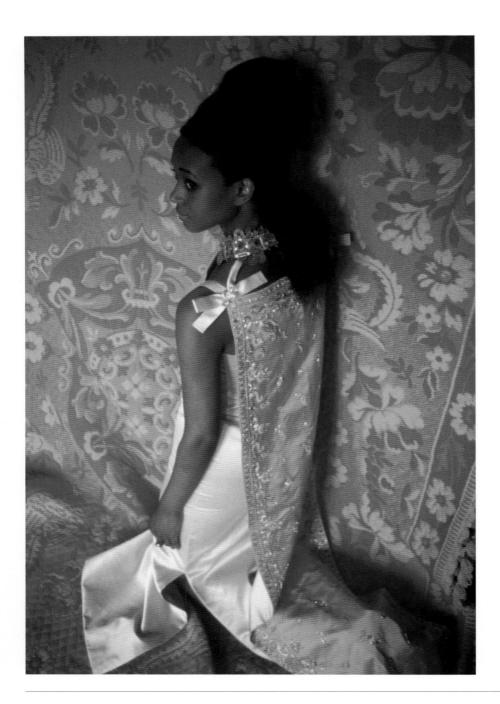

↑ Norman Parkinson, October 1965
Despite an attitude that bore occasional hallmarks of late colonialism and entitlement, Parkinson was surprisingly radical in his efforts to present diversity in the magazine. This portrait features Elizabeth of Toro, daughter of Sir George David Matthew Kamurasi Rukidi III, the 11th Omukama of Toro, who was about to become the first East African woman barrister at the English Bar. 'The whole concept of being a princess in Uganda is totally different from here – I don't think I particularly want to look like one,' she demurs, as she poses in a gown of palest baby-pink and a tabard of hot fuchsia. 'You can't help it,' retorts the photographer, clicking away.

→ Corinne Day, October 2007
Day takes couture gowns on a jaunt around London, juxtaposing the decadent splendour of fashion's most extravagant dresses with rather more mundane landmarks. A hand-painted silk organza bustier dress, by John Galliano for Dior, partners beautifully with a graffiti-daubed train carriage-cum-art space in East London's Village Underground. Proof, perhaps, that on occasion even the rarefied world of haute couture must pay heed to the street.

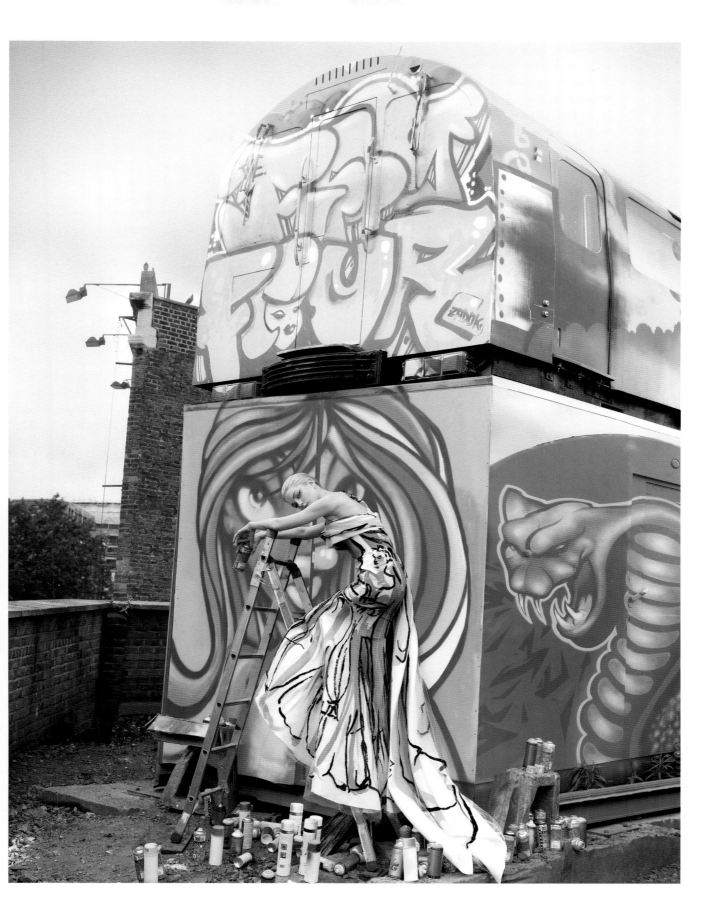

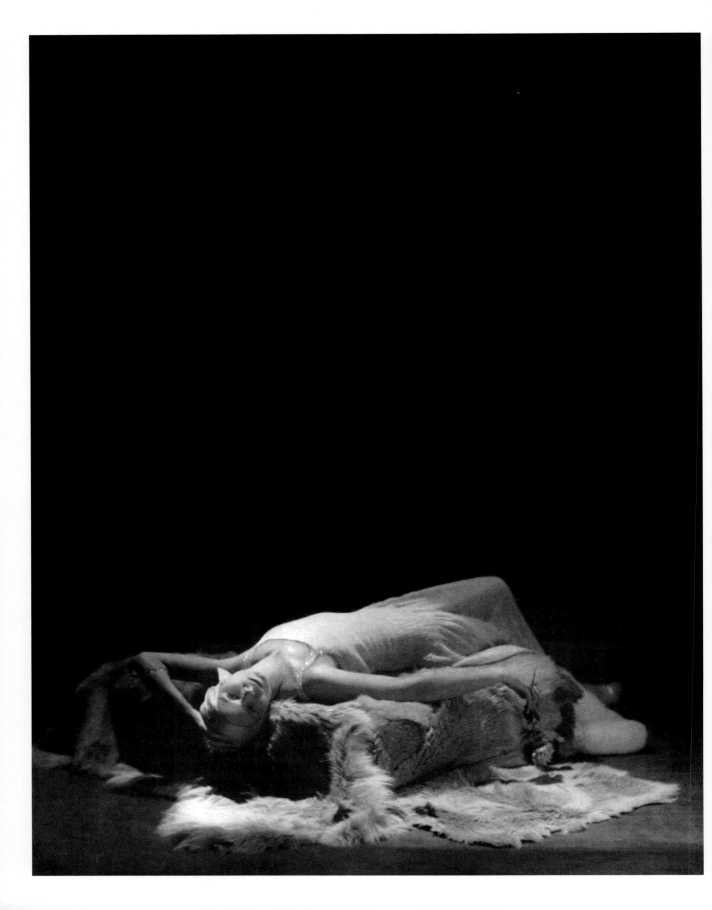

← George Hoyningen-Huene, January 1930

Caught in the mode of a martyred tragedienne, and sprawled across an animal skin in a white georgette crepe frock and silver lamé headdress, by Lanvin, actress Lucienne Bogaert inhabits the role of Leda in *Amphitryon 38*, a play by the French dramatist Jean Girandoux. The portrait accompanies a piece about the theatre scene, bemoaning the lack of matinée idols onstage and nominating names to watch: Messrs Laurence Olivier, Frank Lawton, Leslie Banks and (ahem!) Noël Coward are among those who make the cut.

↓ Norman Parkinson, October 1973

Marisa Berenson is the 'toast of the visible scene, wherever it happens to be playing'. The fashion model and actress is celebrating performances in *Cabaret* and the upcoming *Barry Lyndon*, by Stanley Kubrick, as well as her career as a *Vogue* model. Parkinson captures her in full film-star mode in an Ossie Clark chiffon dress, washed with hyacinth and rose prints, by Celia Birtwell, and all the better to show off her 'dazzling five foot nine inches, cavalier curls, ivory skin and sea-blue eyes'.

↓ Adolph de Meyer, May 1918

A wartime bride seems to 'step out of the Middle Ages to the altar…as gleamingly white and glitteringly silver as a path of moonlight,' writes *Vogue* of this image featuring an unidentified wedding dress. Even while delighting in the stately elegance of the gown, the magazine is mindful of encouraging nuptial excess during a time of scarcity, and has strong counsel on the subject of the bridal trousseau. Yet, *Vogue* cannot help cheering the optimism of a wedding in such difficult times: 'All it asks is the inestimable privilege of arranging the bride's veil – it will then be content to sit in an inconspicuous corner of the church and beam with delight and pride.'

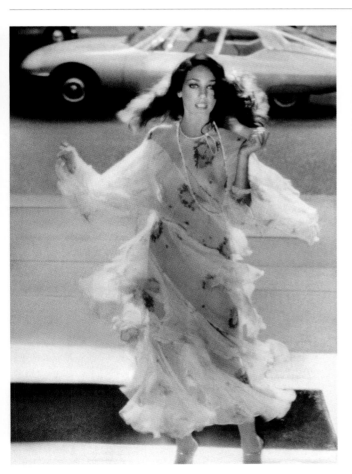

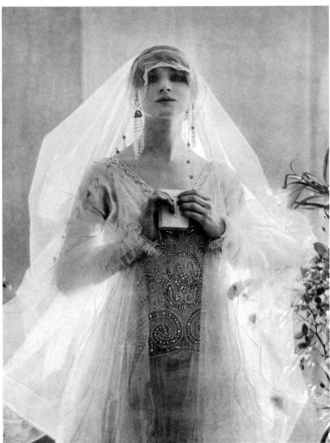

← Cecil Beaton, June 1964

Now in the twilight of his career, Beaton was here partnered with Sixties icon Jean Shrimpton in order to create a range of looks and guises showcasing her transmutable beauty. Cast as a spirited *flamenca*, she strikes a pose in a black crepe, ankle-long, ruffled gown, by Mary Quant. 'A remarkably intuitive person, she [Shrimpton] responded as if Cecil Beaton were a conductor,' says *Vogue* of the couple's first meeting, 'needing no more than the simplest shrug of shoulder from him to understand his changes of thought.'

↑ Norman Parkinson, May 1950

Another dance, but this time it is a more alluring affair. While our performer's face remains in the shadows, her breathtaking white satin sheath dress, by Cristóbal Balenciaga, steals the show, with its gigantic red taffeta bow – 'streamers falling to the ground' – and over-layer of black, paillette-embroidered lace.

↑ David Bailey, December 1974

Bianca Jagger makes 'a late-night entrance no-one forgets'. (The magazine's assurance proved prophetic: Mick Jagger's former wife would make fashion history when, only three years later, she arrived to celebrate her 30th birthday at New York's Studio 54 astride a white horse.) Bianca is our expert guide in making a first impression in a black Bianchini Férier silk shirred dress, by John Bates. The pearl-and-diamond earrings are borrowed; the bracelet, choker and in-your-face sexual confidence are all her own.

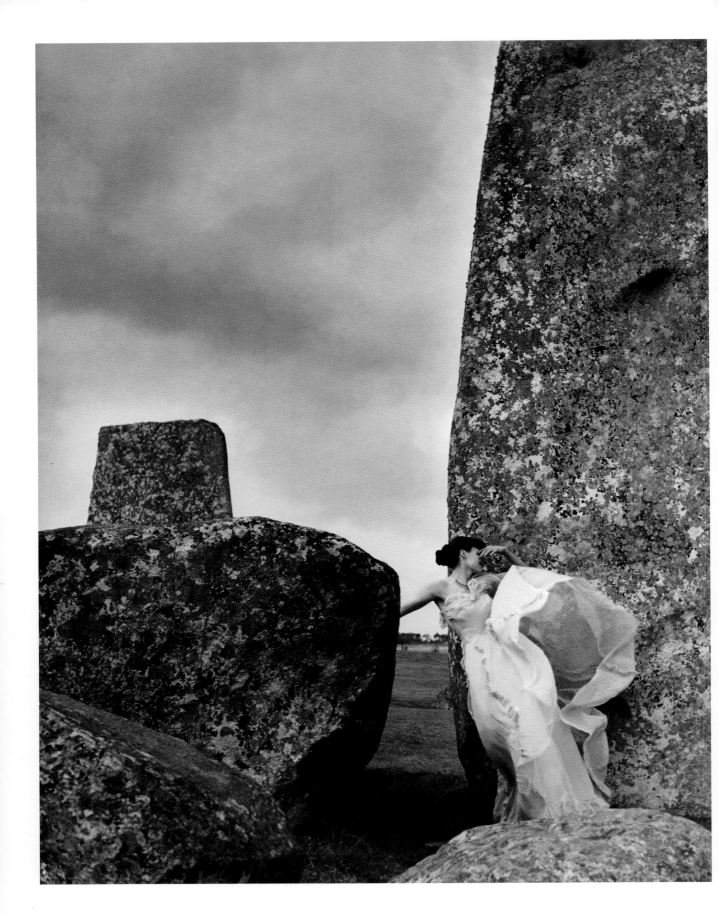

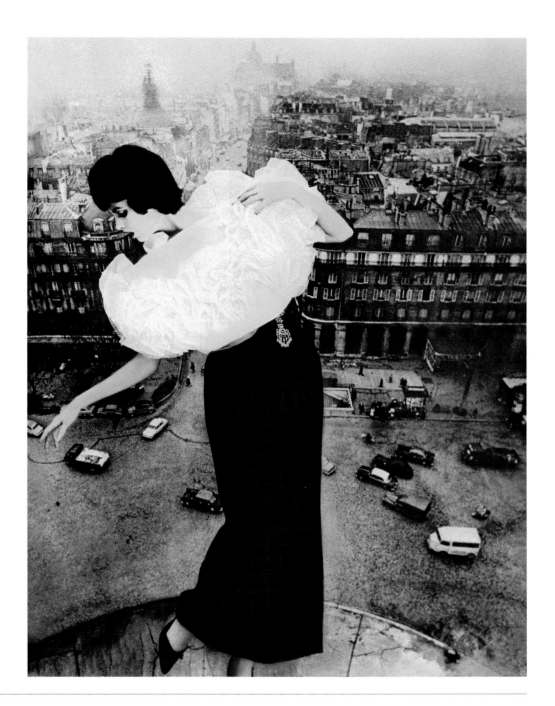

← Clifford Coffin, July 1948

Cherry Marshall shelters by the great menhirs of Stonehenge in a blue printed organdie evening dress, by Matilda Etches. The model's own life was no less dramatic than the scene depicted here: famed for her tiny 22-inch (56cm) waist, she was a dispatch rider with the ATS during World War II, enjoyed a torrid marriage with the poet Emanuel Litvinoff, became the house model for London designer Susan Small, established the highly successful Cherry Marshall Model Agency and managed the careers of Vidal Sassoon, Grace Coddington and Pattie Boyd. She lived out her final years in Frinton-on-Sea, where she was known locally for scouring the local charity shops for clothes she would later transform into haute couture.

↑ William Klein, March 1961

Our imperilled heroine tiptoes precariously above the Paris skyline in Lanvin-Castillo's slim tube evening dress, topped with a hugely ruffled organdie boa. Our heroine may be ruffled, too, at finding herself suspended from on high, but in Klein's hands the look remains frightfully composed.

↓ **Horst P Horst, June 1952**

A voluminous blue satin skirt and a draped cowl-neck top are looped together with a red satin cummerbund, by Jacques Fath. Such billowing ostentation needs a ballsy attitude: 'The effect – as dramatic as it's new.'

↓ **Irving Penn, January 1950**

For this issue, *Vogue* marked the half-century with an overview of five decades of fashion, attempting to discern a political and social history from the clothes that defined each decade. The turn of the century is remembered as being a time of lavish entertaining and glittering society functions, when gowns were bought from Paris and worn indoors (floor-sweeping hemlines had no business on the street) when petticoats were gradually discarded, and all was topped off by 'fantastic hats'.

→ **Cecil Beaton, October 1932**

A smiling lady in a gold Jeanne Paquin dress stands before the curtain to introduce the best of the new London collections. *Vogue* trains the spotlight on 'the busy workrooms of the great English dressmakers' as well as on the traditional fabrics of the British Isles, to herald the increasing influence of the fledgling fashion industry on the international stage. And while the models are English roses, the frocks are the stars of this show.

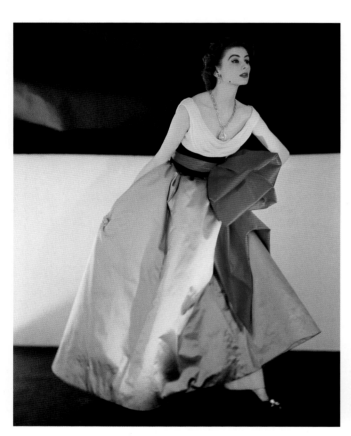

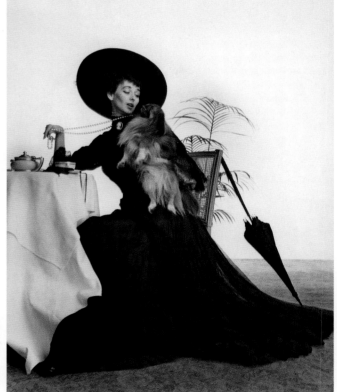

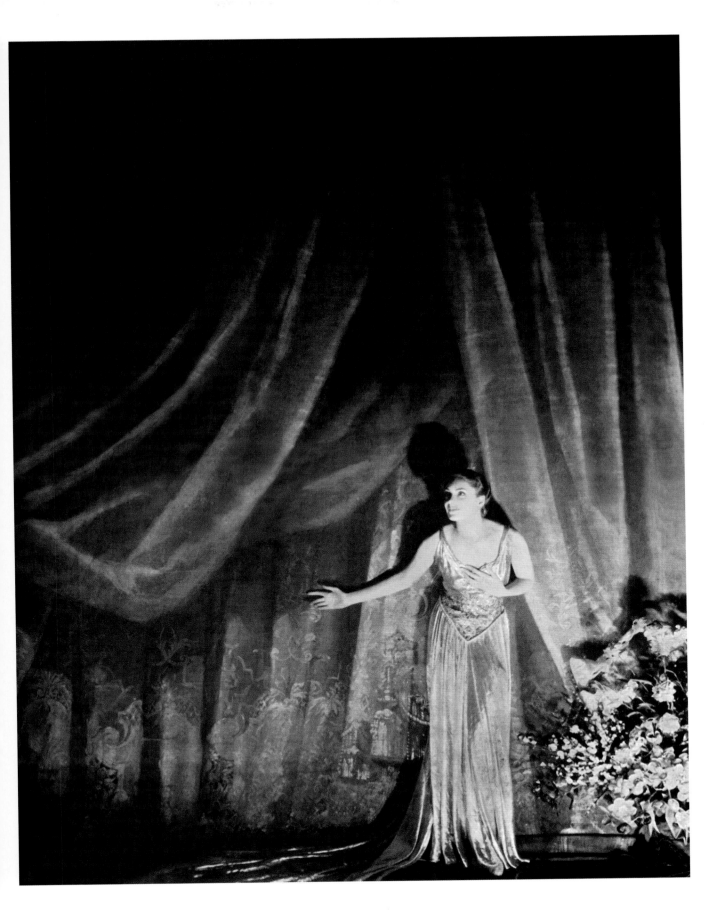

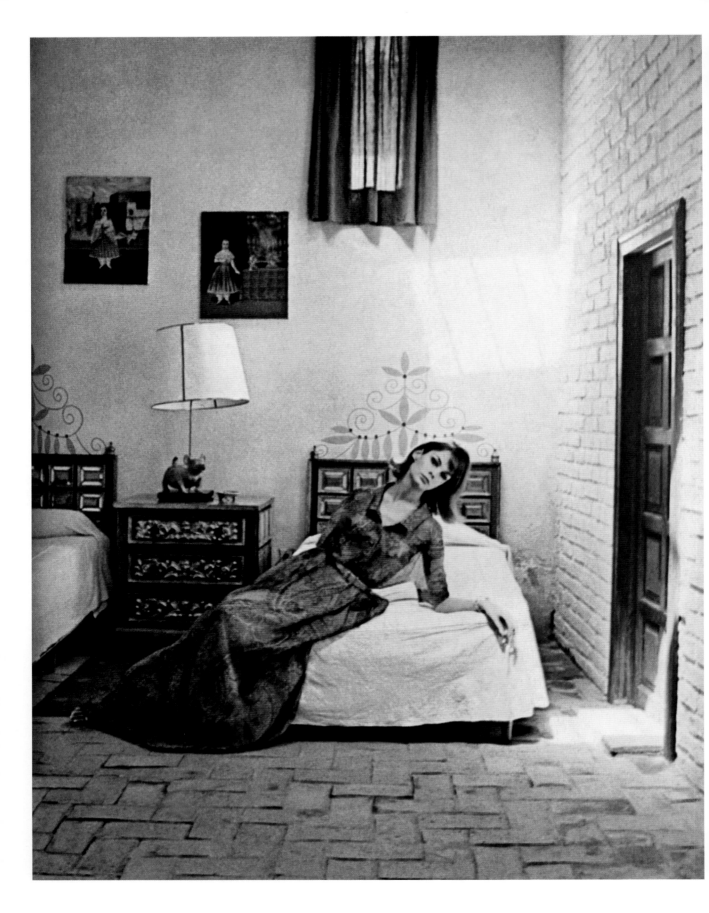

← David Bailey, January 1963
David Bailey and Jean Shrimpton embark on a Mexican adventure: 'where the sun is deliciously scorching, the bougainvillaea and hibiscus are rioting, beaches are rampant with bathers, and life proceeds with a skyscraper bustle in the cities and a charming *mañana* languor in the villages.' Lodging in Teotihuacán, in a typically rustic local inn, Shrimpton readies herself for a long dinner-at-home in a shirtwaister dress in lilac, gold and aubergine printed silk organdie, from John Cavanagh.

↑ Eugene Vernier, July 1957
The prospect of a holiday in Deauville is thrilling: 'All the glitter of a fashionable resort set cheek by jowl with the simpler, more solemn gaiety of *la douce France*.' Yet, there is nothing solemn about an evening at the casino, declared to be the resort's 'beating heart' and 'the hub of a society that blossoms every summer into a most urbane elegance'. Our young card-sharp fits right in, in a short evening dress in pearly satin with a full skirt, by Susan Small. Nobody is going to accuse *Vogue* of being a tourist.

↑ Cecil Beaton, June 1937
No-one cut a more imposing figure than Coco Chanel, here wearing one of her own designs, a slender pale gold lace gown, sewn with sequins of varying sizes, shapes and colours. Despite the emphasis on sparkle, the mademoiselle's haughty imperiousness and whip-slim silhouette put pay to any air of frivolity.

→→ Clive Arrowsmith, January 1971
Vogue turns puritanical on a trip to an Amish sect in Lancaster County, Pennsylvania, 180 miles from New York City and centuries away from the modish ideas that traditionally occupy *Vogue*'s fashion pages. 'They believe in functional clothes,' intones the accompanying text. *Vogue*'s young Anabaptist attracts the watchful eyes of the brethren in a flowing black dress in crepe de Chine, by Ossie Clark, and an Amish hat.

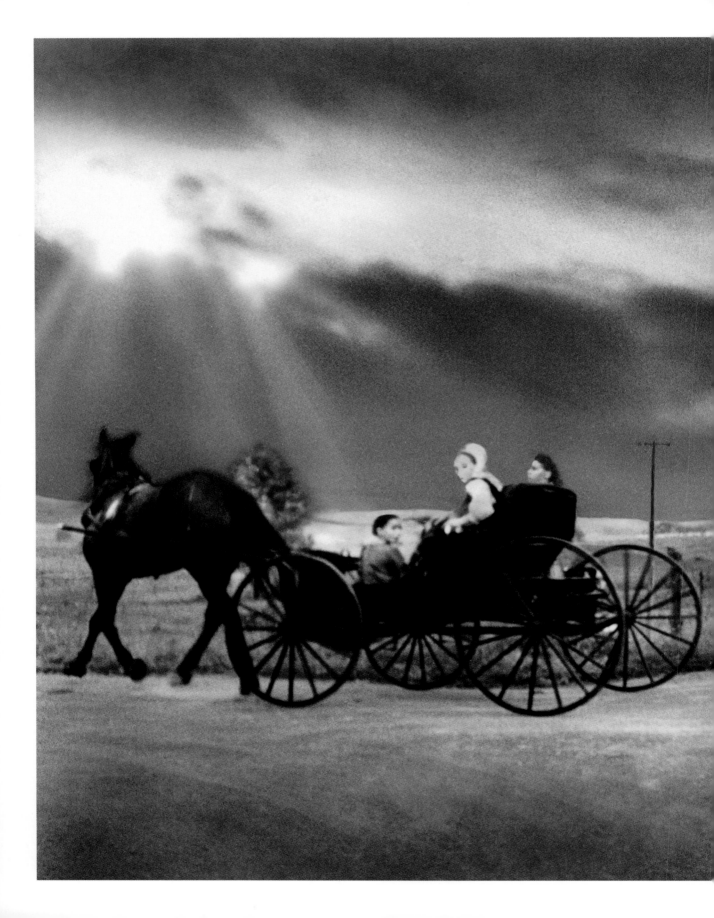

↓ **Henry Clarke, May 1957**
Vogue takes a seat at the Théâtre de Louis XV at Versailles in a lavishly oriental turquoise chiffon dress (the textile by Zika Ascher), with an obi sash and kimono jacket in blue embroidered shantung. The magazine tells us that in Paris, at least before the 1st of July each year, formality is still considered an imperative, although full-length evening dresses are not absolutely necessary – 'even for Galas at the Comédie-Française or the Opéra, a dressy short dress is perfectly acceptable.' This theatregoer, however, remains stubbornly conventional.

→ **Craig McDean, November 1996**
'Think Hiawatha, think Pocahontas!' John Galliano takes a tip from the Mohawks to create this beige suede fringed dress with lilac crêpe shell. In the new fashion alphabet, 'I' stands for Indian, although the board for political correctness might prefer that it represent the Iroquois instead.

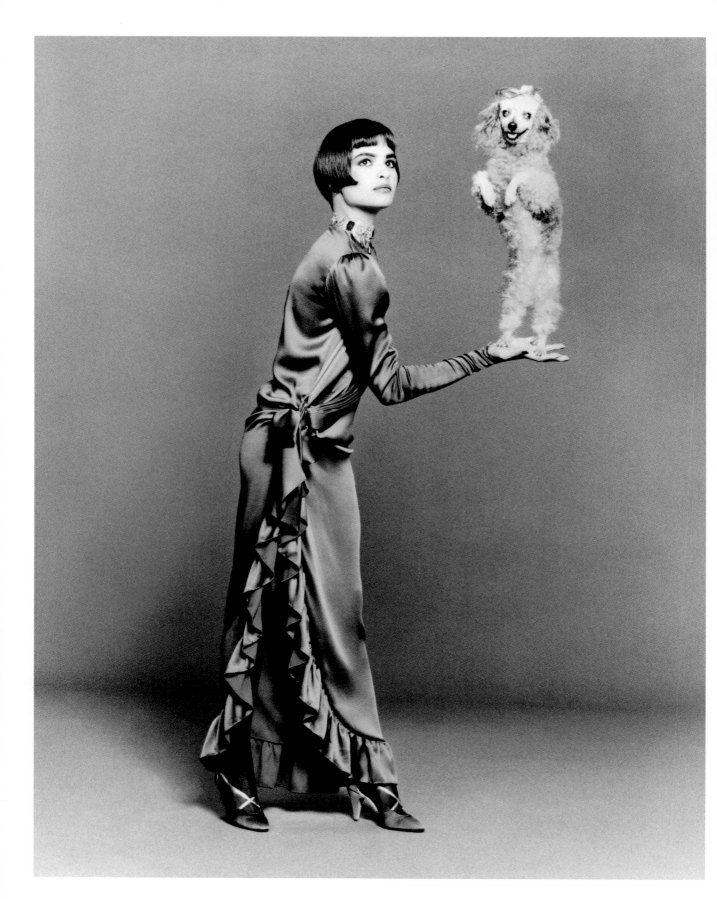

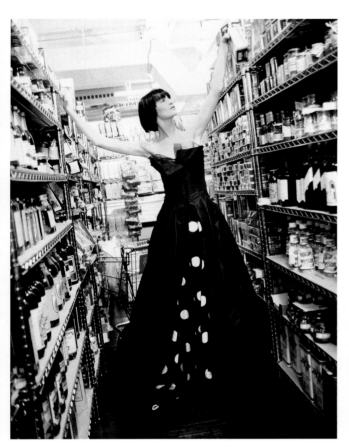

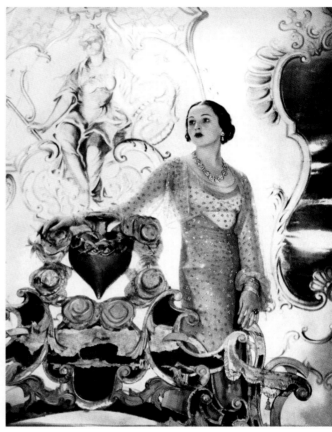

← Bruce Weber, November 1982

The American photographer makes
no apology for his love of animals, and
lambs, dogs, goats, cats, chimpanzees,
cheetahs and pigs have frequently
invaded his pages. Here, a grinning
performing poodle threatens to upstage
Talisa Soto's long, violet satin dress with
ruffled hem, by Givenchy Haute Couture.
In fact, the dog was a subsequent
addition to this homage to the spirit of
silent-movie heroine Louise Brooks.
But the results are simply paw-fect!

↑ Arthur Elgort, May 1999

Model Erin O'Connor takes a trip down
the aisles of Dom's Grocery Store,
on Lafayette Street, New York. And
what should one wear to restock one's
larder shelves? Why, four multilayered
bustier dresses worn at once, by Yohji
Yamamoto, of course. One silk, one
chiffon, one lace, and one polka-dot…
and in any colour, as long as it is black.

↑ Cecil Beaton, October 1932

One of the brightest young things of
the Thirties, and as comfortable in the
company of Coco Chanel as she was
with Winston Churchill, Lady Pamela
Smith (later Lady Hartwell) is puckishly
beautiful in Norman Hartnell's filmy blue
chiffon dress 'powdered all over with tiny
groups of spangles'. Worn with jewels
by Cartier, the robe recalls an Italian
altarpiece, according to *Vogue*, but the
look is quintessentially English.

↓ Norman Parkinson, June 1950

In 'Dressing for Occasions', *Vogue* has asked the actress, singer-songwriter and comedienne Joyce Grenfell to annihilate our sartorial mistakes, and she cheerfully obliges. 'There are lots of not particularly eccentric ladies who get a spring madness as they fling aside their winter wool,' she writes. 'It is Occasions that bring out this weakness. Not full-dress and chandeliers and tiara Occasions, but weddings, regattas and, of course, dear old Ascot.' Big eveningwear, she opines, may be current, but such 'line and design' must be free of the 'rash of little extras that spoil what might have been all right if only we had left well alone'. This tomato-red and green/blue gown, by Madame Grès, is a case in point. Featuring a full skirt comprising two layers – a mist of green and blue floating atop a cloud of red – it should be worn with only the simplest jewels and a slash of carnation lipstick.

→ Patrick Demarchelier, June 2011

A dancer from the Royal Ballet School sweeps up model Arizona Muse for a spin around the floor. Her dress, in primrose and off-white dégradé tulle, from Dior Haute Couture, is straight out of the Jazz Age. The atmosphere is swinging.

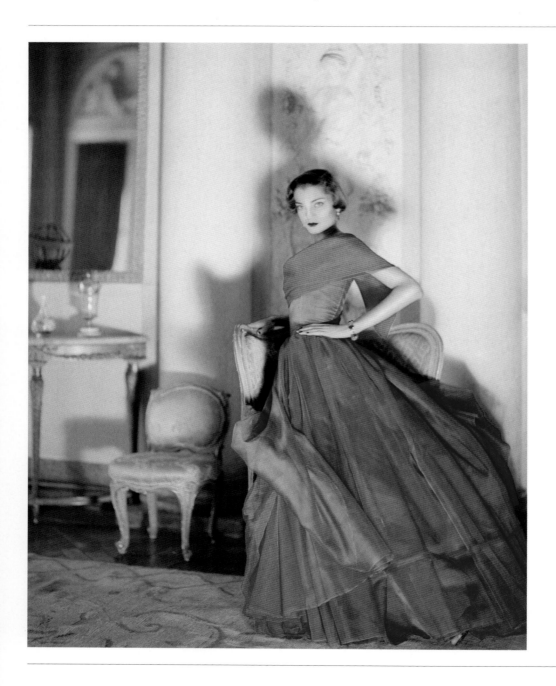

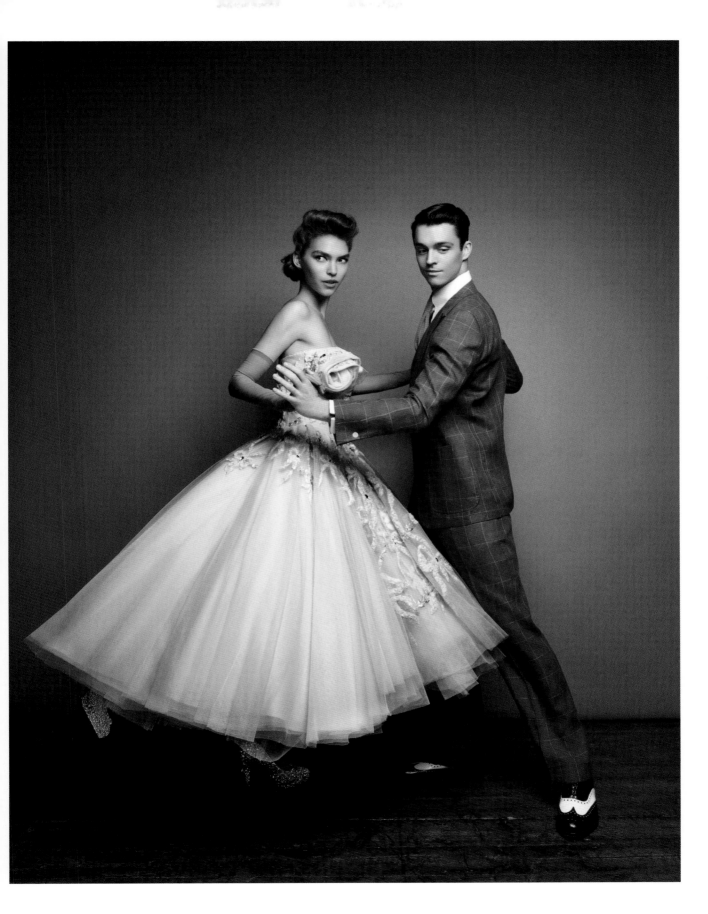

↓ Reinaldo Luza, February 1921
The dawning spring promises to bring
with it several silhouettes: one has
'a fitted waistline and distended hips,'
writes *Vogue* of the drop-waisted,
hipless style to come, and another has
a 'straight long bodice and bouffant skirt'.
No prizes for guessing which Luza has
chosen to represent on this cover.

↓ Photographer unknown, May 1927
Here, Madeleine Chéruit has found a
new use for taffeta, fashioning it into
an evening summer wrap: 'the flounces
have an unusual fullness and a feeling
of buoyancy'. The greater innovation in
this image, however, is found in its
immediacy: the model's easy stance and
level gaze – with hair pulled back from the
face – creates a startlingly contemporary
portrait of enduring elegance.

→ Hugh Stewart, September 2007
Dusk falls over La Croisette in Cannes,
and French actress and former Bond
villainess Eva Green strikes a pose on
the Riviera shoreline. The actress is
attending this most glamorous of film
festivals to promote her role in *The
Golden Compass* and, in true Old World
starlet style, she is wearing Dior Couture.

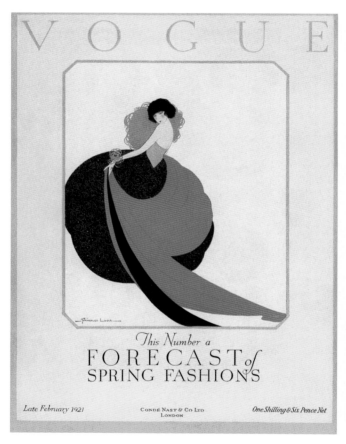

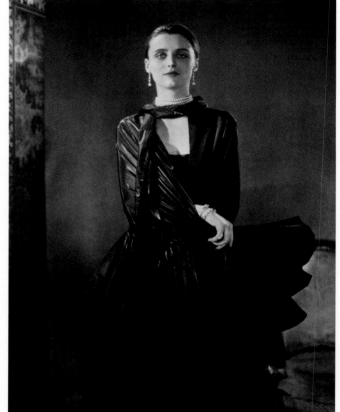

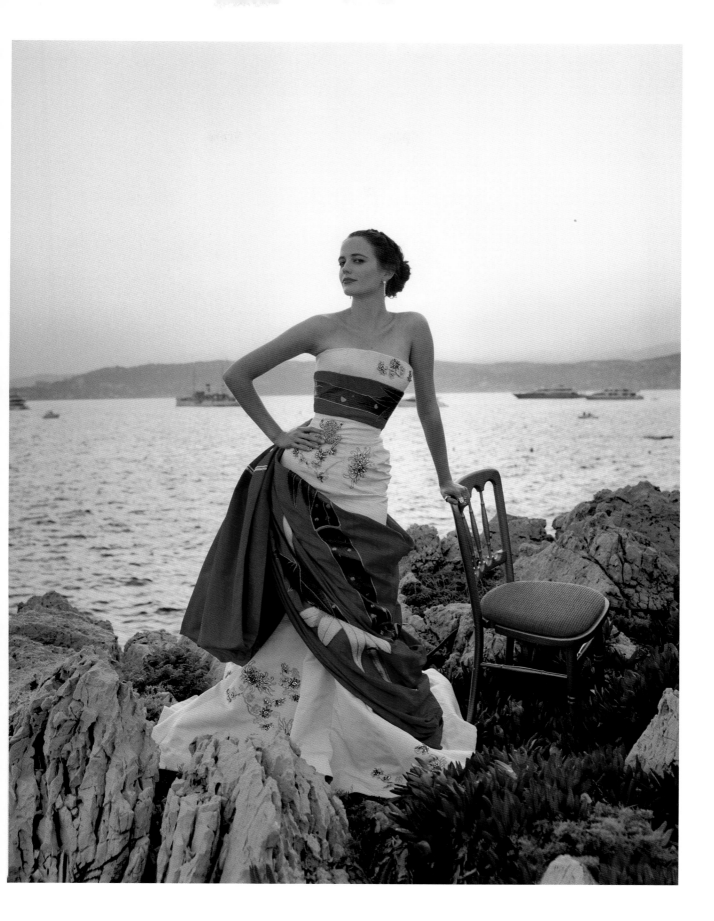

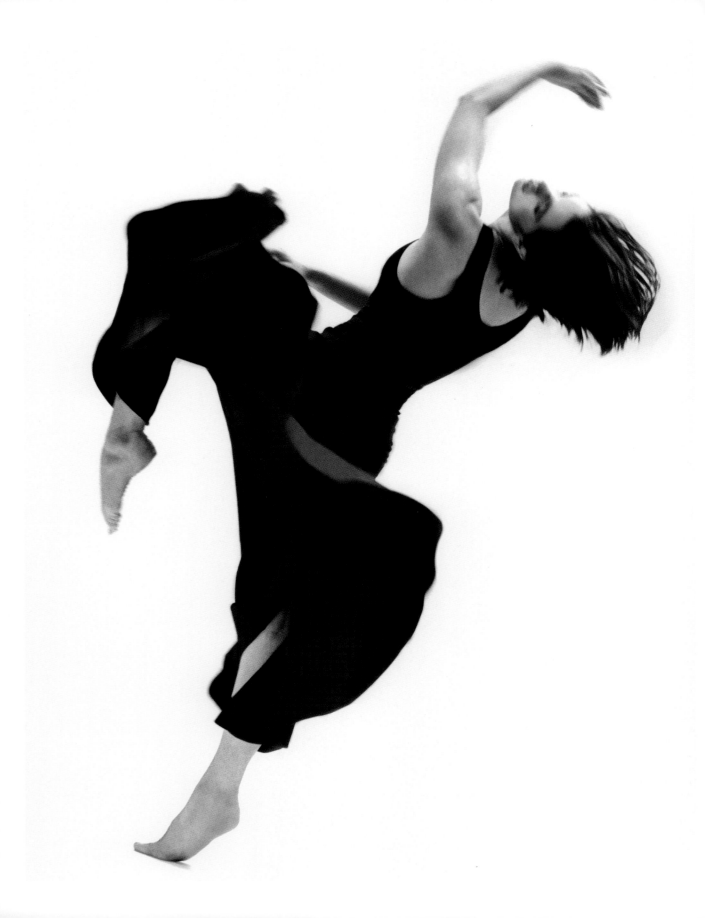

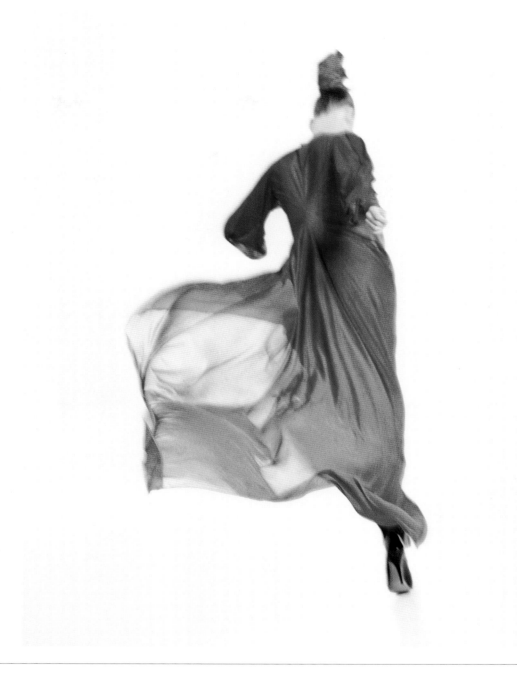

← **Mario Testino,**
beauty supplement 1983
Athleticism in the early Eighties was fiercely individual, and everyone had to dance – like 23-year-old modern dancer Gaby Agis – to their own tune. The London-based 'postmodernist' brings dynamic expression to a full black jersey number, by Norma Kamali. The workout is footloose and the body is free.

↑ **Arthur Elgort, November 1994**
Dressed in Alexander McQueen's vermillion cobweb jersey dress with a train, anyone can make a grand exit. Fashion is seeing red, and this evening dress is just one gown that is sure to inspire a scarlet fever.

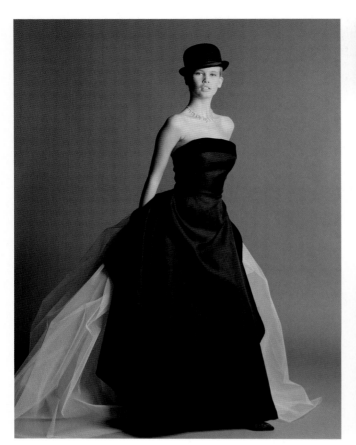

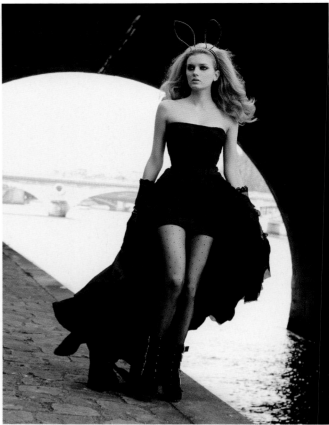

↑ **Terence Donovan, December 1989**
Claudia Schiffer is here captured on the cusp of her stratospheric ascent into model superstardom. The trainee-lawyer-turned-Guess-jeans girl wears a black silk bustier ball gown, by Norman Hartnell Couture. Yet so many metres of velvet and tulle cannot contain her creamy complexion and curvaceousness; even the businessman's bowler fails to censor her sex appeal.

↑ **Patrick Demarchelier, August 2009**
At the Paris collections, designers have become enamoured of the 'flirtatious coquette' and flood the catwalks with little black dresses. Balmain's silk micro-minidress with a long train typifies the playful new mood. But lest it seem too sweet, the look here is given a punk edge with the addition of polka-dot tights and sharp, suede Balmain boots.

→ **Arthur Elgort, June 1990**
In the Big Easy, the Southern belle still reigns, especially if that belle is Helena Christensen at Mardi Gras. In New Orleans, the dresses are expansive and the attitude sultry. Missie Graves and Graham Hughes create a sugar-pink confection with a mille-feuille of tulle layers, worn with white opaque tights (befitting this most genteel of societies) and satin slingbacks. This cat is sizzling hot.

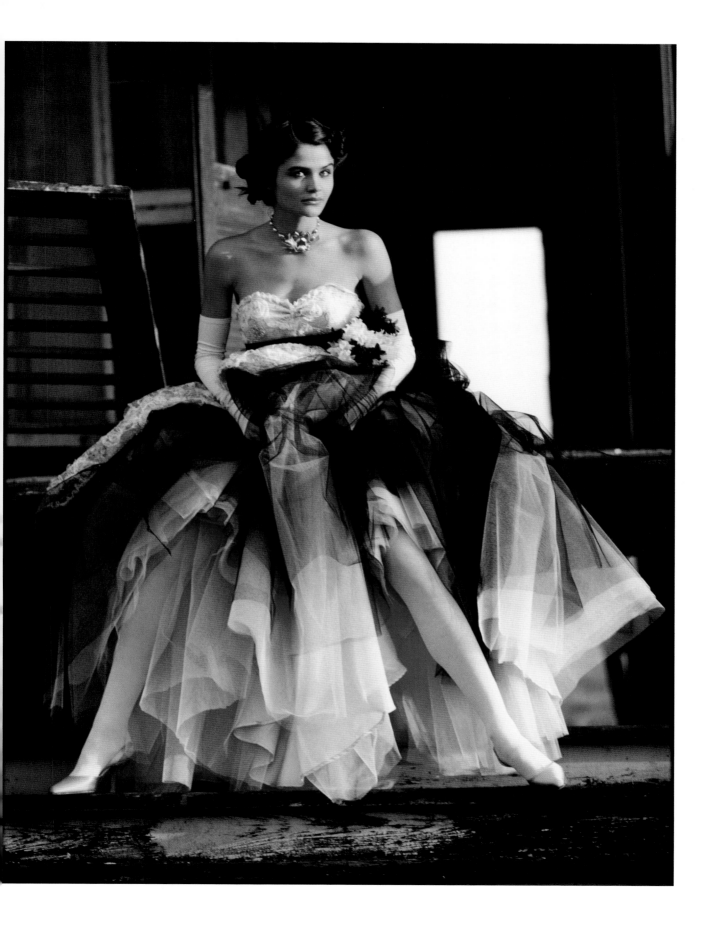

← **Tim Walker, December 2004**
Sophie Dahl can barely support the
weight of her silver-embroidered,
red satin gown by John Galliano for
Dior. Exhausted by her efforts, she
slides gracefully down the wall as
the dress pools around her feet, a
dramatically beautiful Queen of Hearts
in Walker's pantomime parade of folk
heroines and villainesses.

↓ **Henry Clarke, July 1961**
Our girl is in the mood for dancing and,
dressed in Susan Small's short evening
dress in scorching Siamese pink, she
won't wait long for a partner. The chiffon
layers are wrapped like a sari on top
before yielding to form a 'delicious floaty
skirt: all of it pure enchantment'.

↑ Frank Horvat, September 1960

Vogue allows readers a glimpse inside London's most exclusive ateliers in order to answer the question: 'Couture Clothes: are they worth the money?' In doing so, they introduce just some of the seamstresses, furriers, doorkeepers and button matchers who make the collections possible. At Michael Sherard's studio, Madame Sette supervises a fitting while her younger colleague, Miss Smith, looks on. The dress, made in ilex-green paper taffeta, is swirled into gathers on the bodice, short at the front and sweeping to the floor behind. As to the question of the industry's worth, the answer is an emphatic, 'Yes!'

→ Cecil Beaton, October 1948

The drama of royal pageantry is captured at its most darkly appealing in this portrait of Queen Elizabeth The Queen Mother, wearing a bespoke black velvet crinoline, by Norman Hartnell, two diamond necklaces, a tassel brooch and the Oriental Circlet Tiara, once presented as a gift to Queen Victoria by her husband, Prince Albert. Beaton was a great favourite of Elizabeth Angela Marguerite Bowes-Lyon, who sat for numerous portraits by him and extended her influence to gain him considerable access to other members of the Royal Family. In this sitting, taken just after World War II – and nine years after their last significant work together – she is posed in a pastiche of a portrait of Empress Eugénie, by the German painter Franz Xaver Winterhalter, a fashionable court painter of the nineteenth century who was famed for casting his subjects in a sober, but deeply flattering, light.

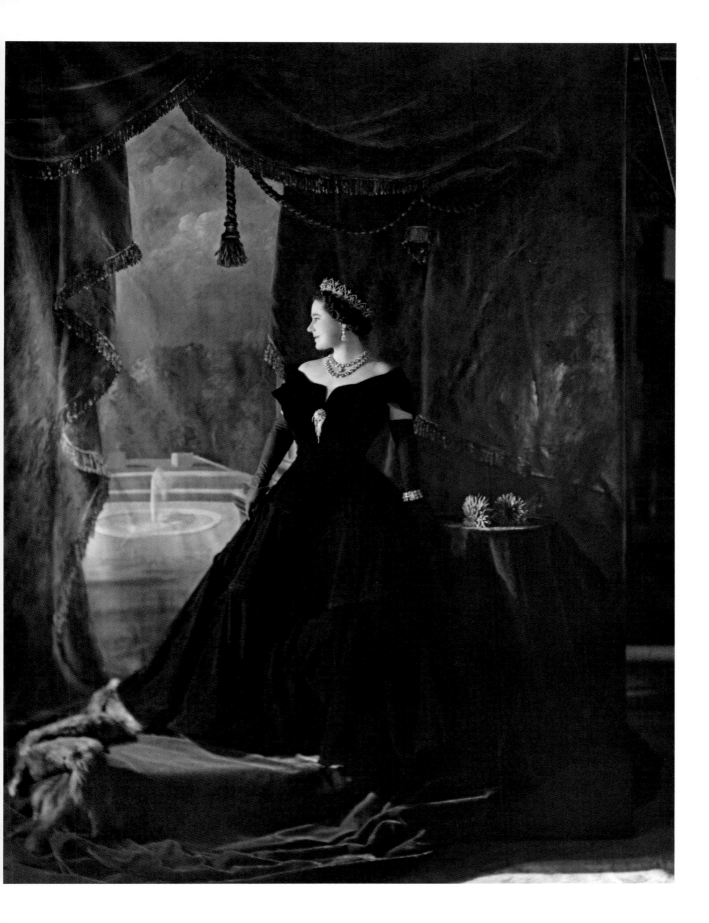

← **Eugene Vernier, June 1958**

Vogue's 'Young Idea' was an occasional feature in the magazine debuting fledgling talent. This month, 'Young Idea' goes to the Royal Academy of Dramatic Arts to discover actress Susannah York, 'a gorgeous scatty blonde' – wearing a princess dress of radiant pink moiré, by Nettie Vogues. Her young admirer is played by James Christie. The décor is the work of the artist and set designer Richard Beer.

↓ **Eric Stemp, February 1959**

A glowing silk paper taffeta dress by Frank Usher packs a colourful punch in nasturtium red. The short, strapless evening gown has a tiny bodice and knotted centre, with ends that fall to the hem. Nasturtium was such a big colour for that spring, it even merited an announcement on the cover: 'bitingly brilliant', 'sunny and gay', and available in every shade, from creamy apricot to 'deepest glowing red'.

↓ **Alfredo Bouret, August 1956**

Three years earlier, and it is rose red that has set the fashion world aquiver: 'It's warm and gentle, and the softest-spoken flatterer that ever turned your head.' Jean Allen's drifting red organza dress, with a tiny bud-like bodice that blossoms into a vast blooming skirt, sees the trend at its most dramatic and delightful.

decorative

Fashion has played fast and loose with the *arts décoratifs* theme. The bold, graphic design movement from which art deco sprung may have peaked in the Thirties, but fashion has drawn from its broader ideals of hedonism, decadence, embellishment and sparkle – so much sparkle! – ever since.

Coming of age at the zenith of the Gilded Age, *Vogue* magazine was at the very centre of the deco movement, delighting in its rigorously pared-down silhouettes, lean lines and *esprit jeune*. Illustrators such as Georges Lepape and Eduardo Benito captured the era's vigorously young heroine as a creature of infinite style and energy, as chic on the tennis court as at the opera, and with never so much as a hair out of bobbed place.

No wonder that the period coincided with the emergence of some of the great design houses of the twentieth century. Jean Patou, Coco Chanel and Jeanne Lanvin all dressed this fashionable youth with her keen eye for snappy sophistication. Haute couture boomed as the gowns typically favoured by the aristocratic classes were snatched up by the grasping hands of the new elite – singers, ballerinas, industrialists' daughters, Hollywood ingénues and ateliers became ever more crowded with seamstresses sticking bugle beads and sequins onto the gauziest of chiffons, dazzling their new clients with their wares.

But society tired of this feckless creature with her boyish hips, diamonds and voice 'full of money,' as F Scott Fitzgerald described his ultimate deco heroine, Daisy Buchanan. She sat abandoned through the Forties and Fifties, replaced by a more worldly sort of glamour – mature, curvaceous and infinitely more sensible – until the Sixties youthquake, when a new *gamine* burst on the scene. *Vogue*'s new muse was Lesley 'Twiggy' Hornby, with her Vidal Sassoon crop, thigh-grazing skirts, saucer eyes and that same puckish sense of devilry beloved of her flapper antecedents. In the Seventies, the It girl became a mistily romantic figure – wearing cloche hats, tiered chiffons and a dreamy expression – or darkly mysterious and vermillion-clawed – as imagined by photographers like Helmut Newton or Guy Bourdin.

The Eighties designers grappled with deco; such decadent excess seemed befitting for those boom times, but the supermodels were super*women*, and such waifish girlishness seemed a little out of step with that era's new sexual empowerment: Linda Evangelista and Helena Christensen wore their marabou feathers and sequins with a newly muscular swagger.

Yet, the deco theme is never overlooked for long. Every generation of designers is eventually seduced by the vitality and romance of the Gilded Age: Gianni Versace, Alexander McQueen, Yves Saint Laurent and Karl Lagerfeld have all revisited the flapper muse – with her bias-cut gowns, uninhibited appetites and (vitally) boyish contours – to tap into the unfettered spirit of that age. And what girl could resist?

→ **Helmut Newton, October 1966**
Skittering on fawn-like limbs, crop-haired, kohl-eyed and elfin-featured, Twiggy is as indissociable from the Sixties as flower power or The Beatles, and her face has become iconic of that era. Curious, then, that she can traverse the decades and capture the spirit of the Roaring Twenties so easily. Five years before taking on the role of the toe-tapping understudy Polly Browne in *The Boy Friend*, she channelled the flapper's spirit for *Vogue* in a ruffled tiered dress by Gini Fratini – a 'complete flurry of leaf-green layers…flared and fluted with continual motion'.

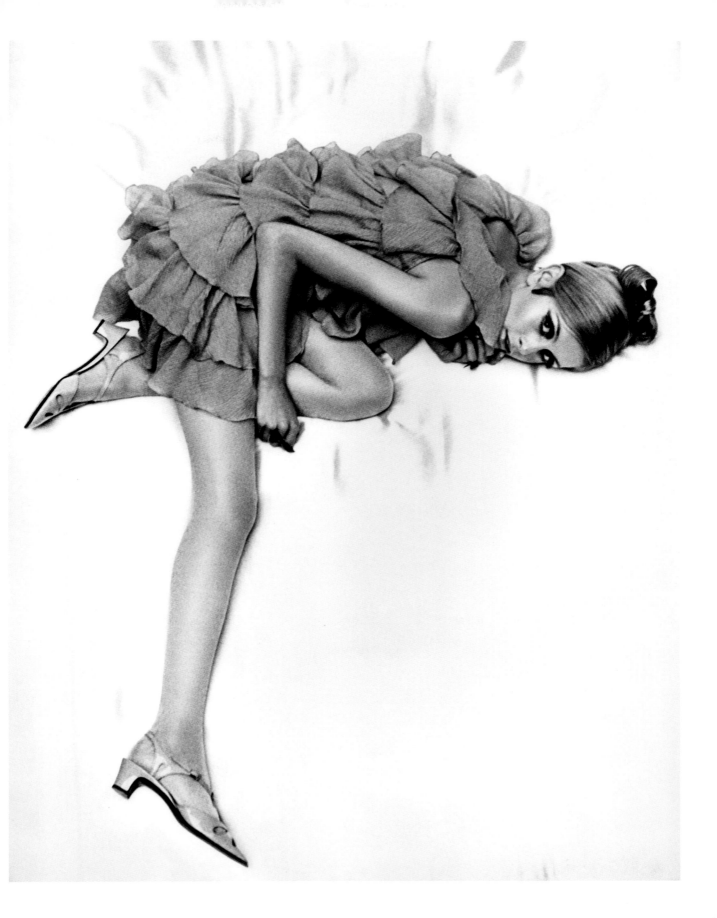

↓ Oberto Gili, April 1998

A modern couture shoot places our heroine in contemporary surroundings, but the details on this chiffon and georgette dress by Atelier Versace are a study in the *arts décoratifs* of yesteryear. Beaded embroidery enlivens a backless bodice, while the deep-fringed train, 'showered in dazzling topaz' is surely designed for 'Puttin' On the Ritz'.

→ Corinne Day, October 2003

When *Vogue* sent novelist and critic Geoff Dyer to cover the couture shows early in the new millennium, his wonderment at 'our capacity to produce excess' led him to compare the 'fabulous extravaganza' of the shows to some ancient bacchanal. F Scott Fitzgerald would surely have approved. But, here, the party is nearly over, and Day has captured our Emanuel Ungaro-sheathed showgirl in a more meditative mood.

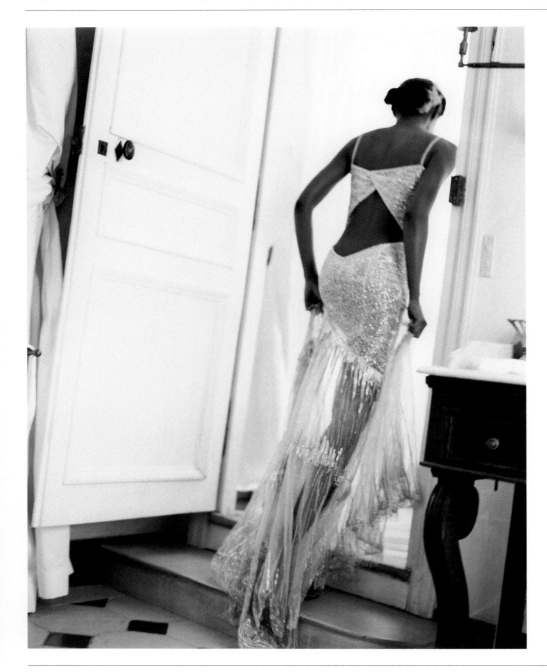

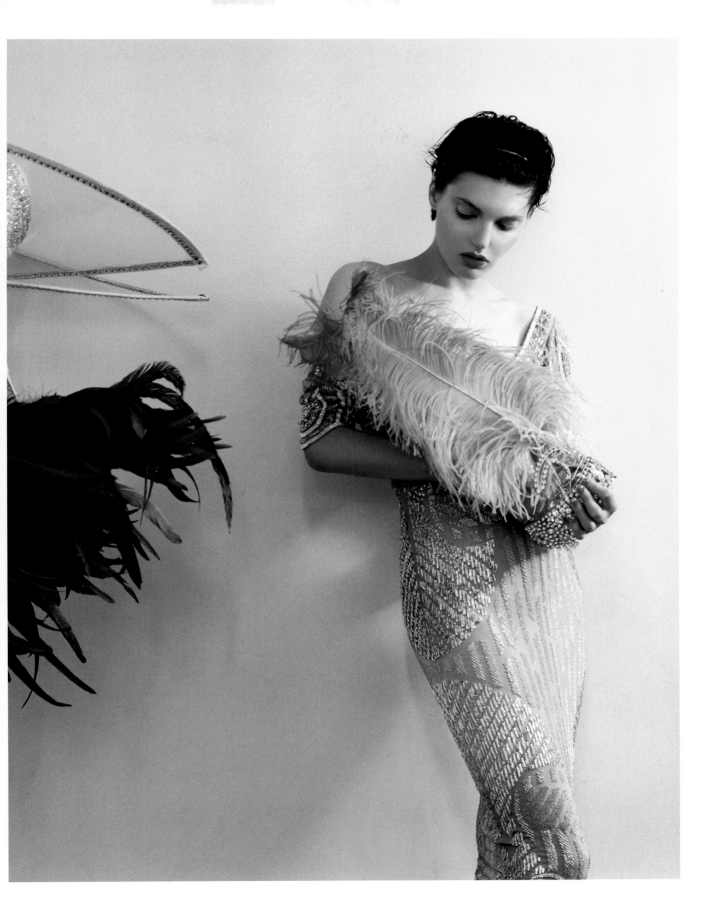

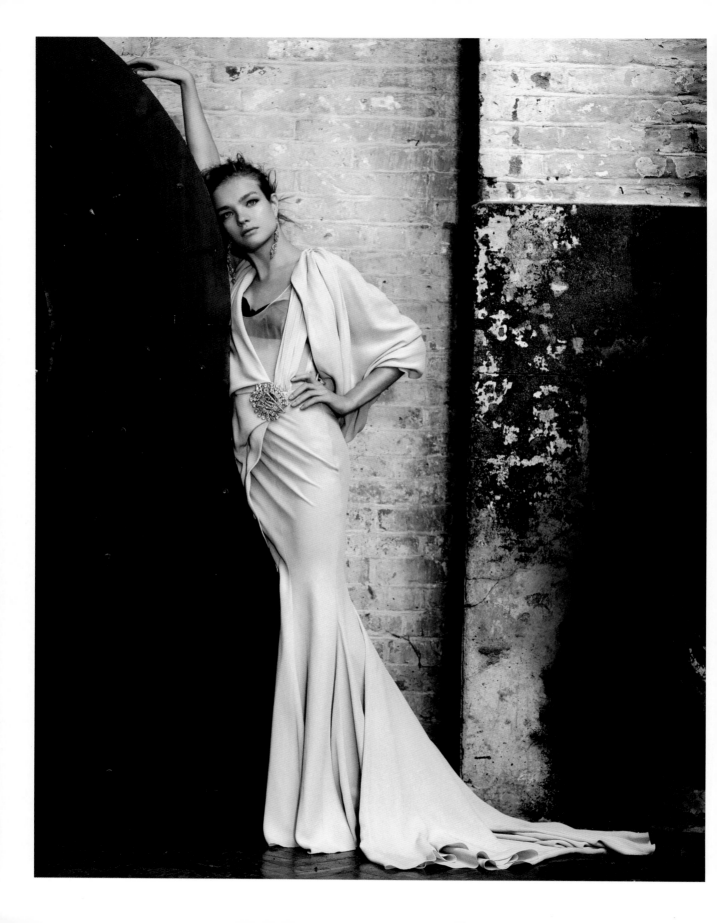

← Mario Testino, May 2009

Natalia Vodianova, the goddess from Gorky, brings a worldly sophistication to Riccardo Tisci's bias-cut fishtail gown for Givenchy in the artfully *déshabillé* story 'State of Grace'. The brooch at her waist is paste. The drop earrings at her neck are diamonds by Erickson Beamon.

↑ Carter Smith, April 2005

Retro styles dominate this shoot, 'The Dress Rehearsal', with its emphasis on 'soft, sexy eveningwear' and 'sweet pastel shades'. Model Erin Wasson stars in this particular performance, wearing a nude jersey voile dress, draped, ruched and embroidered with beads by the new disciple of 1920s tailoring, John Galliano.

→→ Javier Vallhonrat, June 2008

As in the early decades of the twentieth century, fashion's fascination with the heady luxuriance of the Orient – its sumptuous fabrics, feathers and sensuality – returns with cyclical continuity. There is something of the Belle Époque about this Ottoman romance, and McQueen's gold frogging and draped tulle gown only adds to the sense of bohemian splendour.

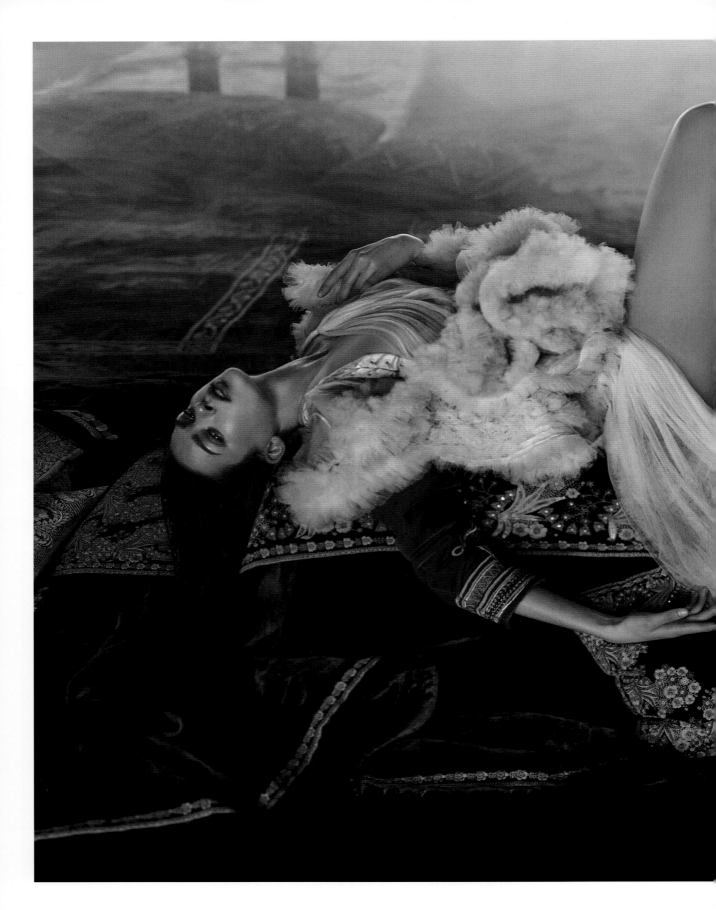

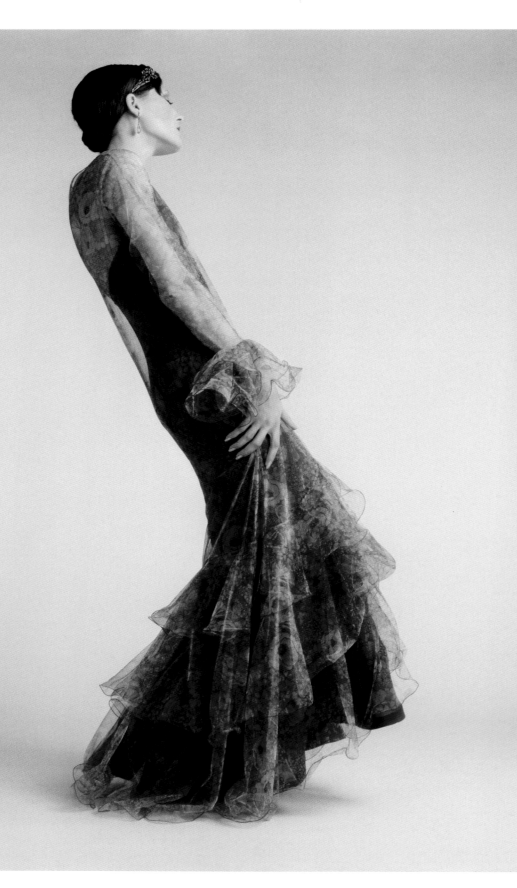

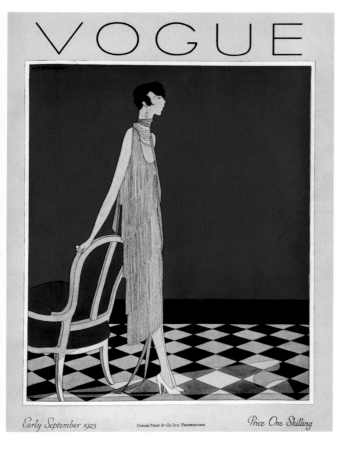

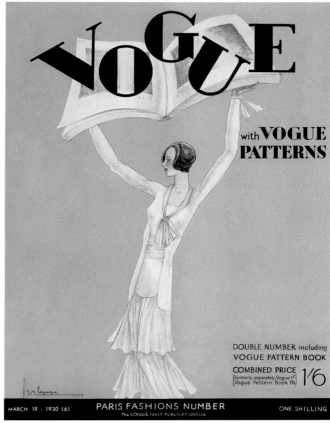

← **David Montgomery, April 1973**

This inky chiffon tea-gown with sheer sleeves, by Walter Albini, is a sure fit for a quickstep. But this is the Seventies, and our young flapper is more likely to be doing the Hustle. Whatever her preference, it doesn't matter because, this month, *Vogue* is all about 'glamour, and glamour is a feeling as much as a look'.

↑ **Harriet Meserole, September 1925**

The dress is lean, the silhouette is long and the limbs are simply endless. Fashion illustrator Meserole captured the Roaring Twenties in all their languid elegance and simplicity. Her muses are vigorous, independent young creatures with packed agendas and places to go. Dressing up in 1925 should have been a simple matter, and the smart set would have absorbed *Vogue*'s accompanying editorial, stating that 'the outstanding feature of the evening mode is metal fabric', and that there 'must be no conflict between the lines of the coat and frock'.

↑ **Georges Lepape, March 1930**

The French illustrator Georges Lepape presents his 'Thoroughly Modern Millie' as a fine line drawing, as she wields an enormous book of *Vogue* patterns. Something is in the air, and the silhouette is becoming more shapely at the dawn of this new decade: 'A waistline is nothing to be ashamed of', insists the editorial, while trumpeting the news that 'hips be unconfined'.

↓ **Javier Vallhonrat, April 2011**
In 'L' Air Du Temps', the shapely
Guinevere Van Seenus embodies
the charms of boudoir dressing in
dusky florals and diaphanous chiffons.
Here, Kenzo's bricolage maxidress
is paired with a silk waistcoat and
varnished metal necklace to evoke
the persona of a Bloomsbury artist –
albeit with added va-va-voom.

→ **Benjamin Alexander Huseby,
September 2007**
Vogue heralds a new era of elegance –
'siren gowns that sweep the floor with
sinewy lines'. But surely we have seen
those bugle beads and rhinestones
somewhere before? Stella Tennant is
the sassiest of showgirls in Roberto
Cavalli's beaded silk dress, worn with
a Swarovski-crystal-studded cap and a
blonde pompadour.

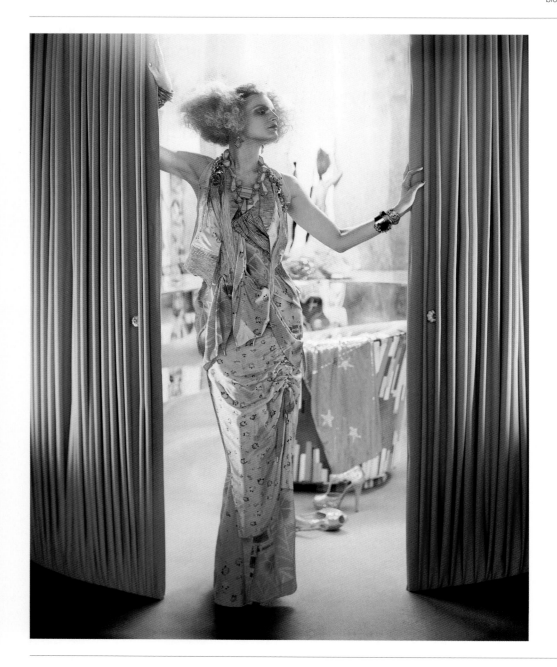

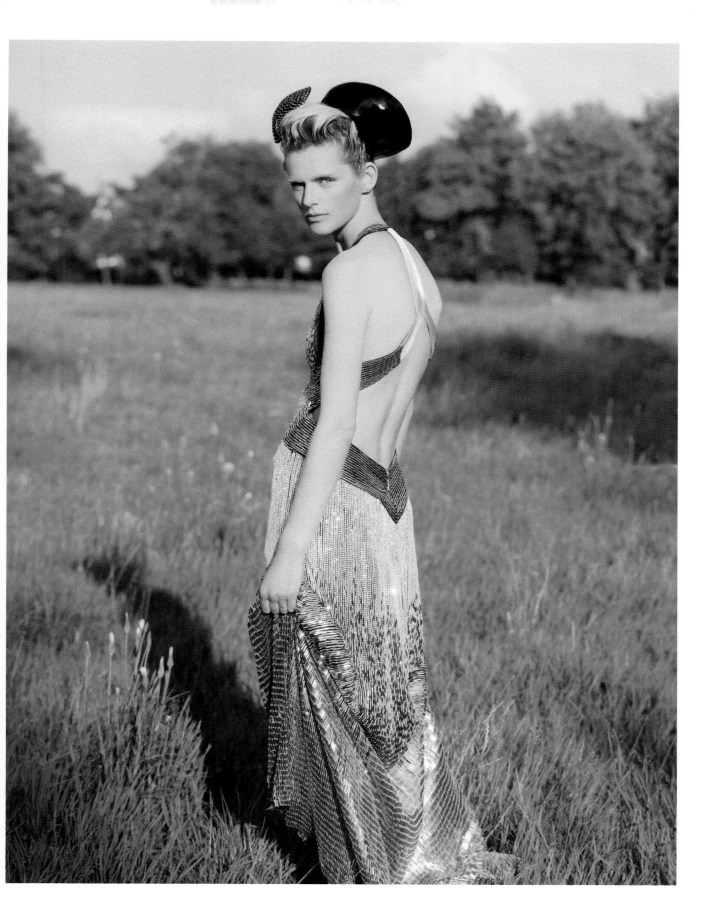

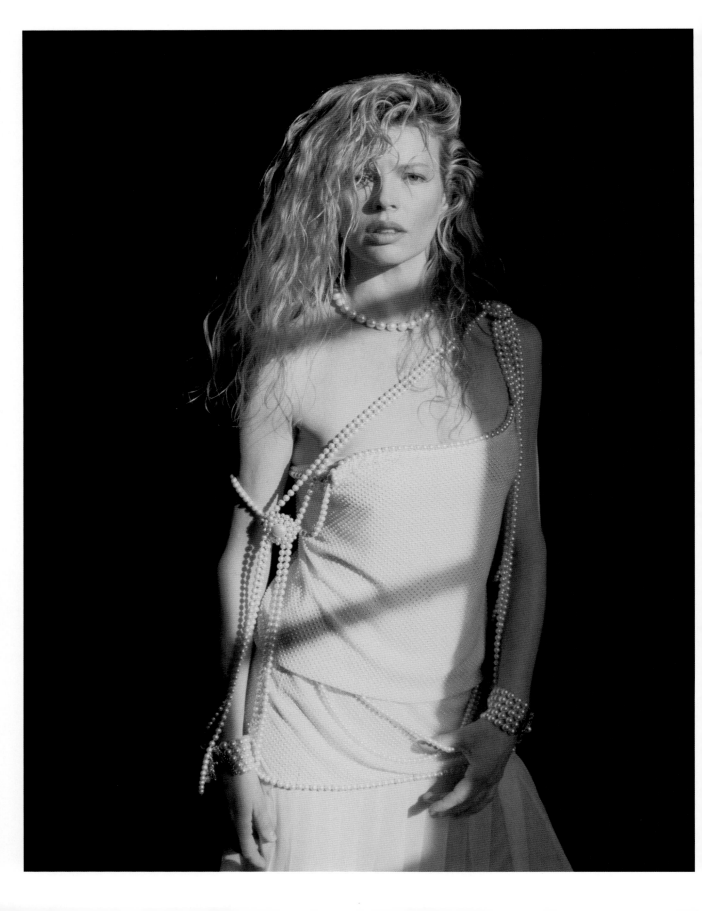

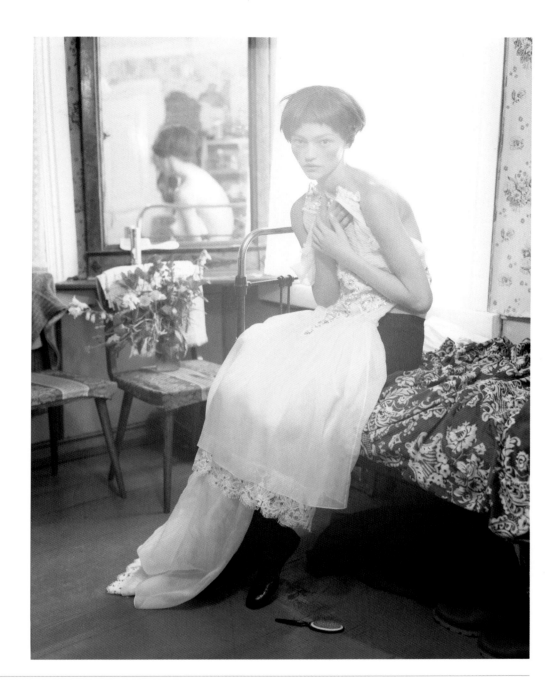

← Herb Ritts, April 1989
Think of Eighties dream girl Kim Basinger and one pictures bombastic curves and bouncing blonde curls. Not typical attributes, one might assume, for showcasing rigorously unyielding couture cuts, nor a house whose design aesthetic consistently celebrates a hipless silhouette. But you would be wrong. Before Ritts's lens, Basinger becomes *Vogue*'s embodiment of the 'living woman' – an object lesson in earthy sensuality – and suddenly it seems no-one could better work a one-shouldered, drop-waisted, pearl-strewn dress by Chanel.

↑ Tim Walker, January 2007
At the other end of the spectrum, Sasha Pivovarova is most demure in Chanel's communion dress on a trip back home to the dreamy landscapes of St Petersburg. And, while Pivovarova's bobbed hair may have been given a choppy modern twist, the painstaking work in the gown's elaborately crafted lace panels remains splendidly traditional.

Vogue's cover girl Gwyneth Paltrow
makes her first appearance post
Emma – and post-Brad Pitt – and
as all-American and effervescent as
the shiniest of bright young things.
Short-haired, honey-limbed and
playful, in Marc Jacobs' raspberry-pink
tulle dress, Paltrow unlocks her
secret weapon, and an It girl's most
delightful accessory, a thousand-
megawatt smile.

→ **Tim Walker, December 2004**
'Some day my prince will come,' sighs
Jacquetta Wheeler in a sorbet-pink silk
and organza fringed dress by Gucci.
Don't worry. Of course, the patrician-
faced Wheeler won't have to wait long –
just until Tim Walker has dropped
the curtain on his seasonal *Vogue*
pantomime, co-starring Erin O'Connor
as Mother Goose and Alan Rickman as
the Lion King…or until her patient white
steed gallops off.

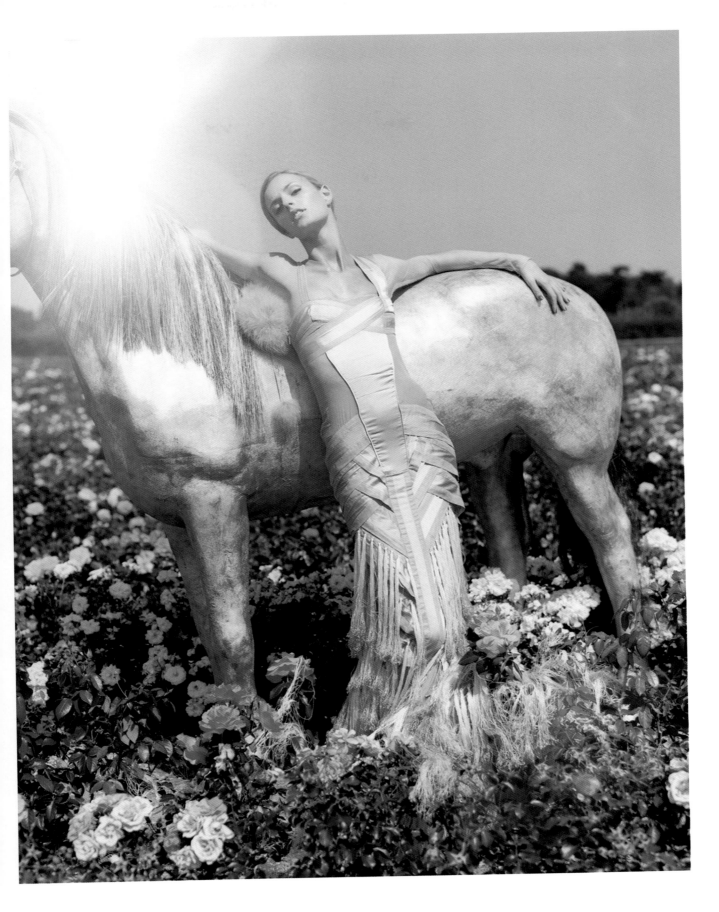

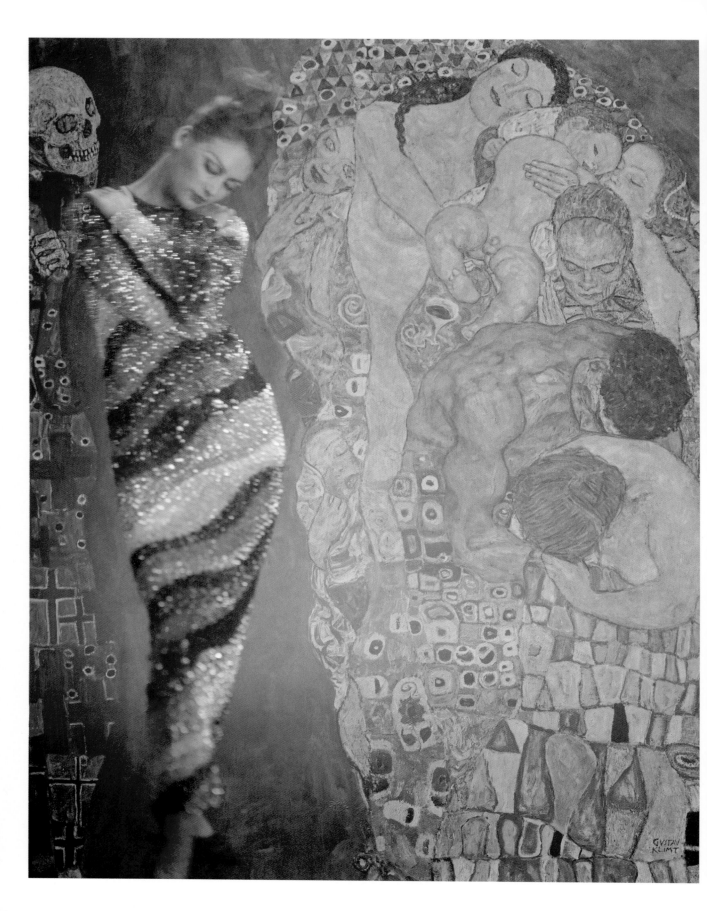

GVSTAV
KLIMT

← **Norman Parkinson, September 1965**

Fashion meets the canvas, as the fine art of sartorial decoration is here examined alongside the oil painting *Death and Life* by Gustav Klimt. The spiral of coloured sequins on Pierre Cardin's obelisk gown and the Austrian painter's masterpiece make an unlikely juxtaposition, but Parkinson's kaleidoscopic composition is both shockingly vibrant and surprisingly sympathetic.

↑ **Arthur Elgort, October 1999**

Like a character from F Scott Fitzgerald's novel *The Beautiful and Damned*, the American Maggie Rizer was among the most dazzling and successful models of the Nineties, amassing a huge personal fortune before discovering, in 2004, that her stepfather had gambled all her earnings away. She has subsequently taken on several charitable causes and occasionally dips her toe back into the fashion world. Here, she is captured in the aptly named story 'Golden Age', shimmering and heavenly in a gold floral lace gown, by Emanuel Ungaro Couture, and Christian Louboutin sandals.

↓ Paolo Roversi, March 2004

This beautiful septuplet in bias-cut ball gowns are so artfully decadent that they might have dropped straight from the imagination of F Scott Fitzgerald. But this is the Noughties, and our *Gatsby* heiresses are dressed instead by the modern masters – and mistresses – of flirty, feminine excess: (from left) Roberto Cavalli, Viktor & Rolf, Julien Macdonald, Jenny Packham, Dolce & Gabbana, Dior by John Galliano and Alexander McQueen.

→ Patrick Demarchelier, October 2007

Vogue travels to Rome to celebrate the 45th anniversary of the House of Valentino amid the showreels and sound stages of the Cinecittà Studios. In the birthplace of Frederico Fellini's *La Dolce Vita* and Joseph L Mankiewicz's *Cleopatra*, the mood is shamelessly nostalgic, all the better to enjoy this couture gown, 'handpainted in shades of grey and covered in a blanket of individual embroidered leaves'.

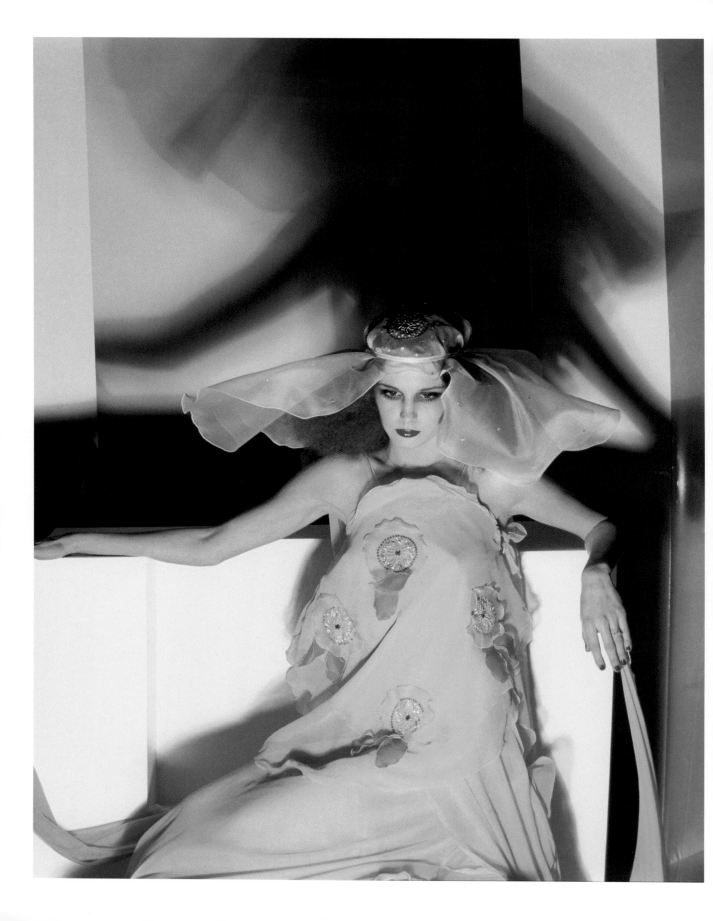

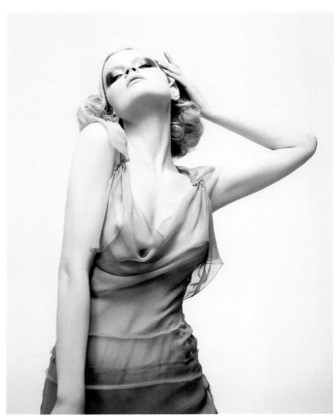

← **Guy Bourdin, April 1974**
The mid-Seventies, and fashion is once more obsessed with unrestricted movement and languid silhouettes. Here *Vogue* offers readers a taste of the new year's silks 'and the faces you'll wear with them'. In a gown that evokes Isadora Duncan, Pura's peach silk chiffon (with lime veil leaves) boasts two long trains which loop up to the fingers, and is worn with an organza mantilla and 'Riviera Red' nails.

↑ **Corinne Day, May 2004**
Blessed with Marilyn Monroe's curves and Dorothy Parker's raspy wit, Scarlett Johansson was always going to be a heavenly creature. Appearing in *Vogue* shortly after *Lost in Translation* and before *Match Point*, her bobbed blonde locks are artlessly dishevelled and her eyes direct. Here is one girl that even Alexander McQueen's embroidered-tulle corset dress can't upstage.

↑ **Willy Vanderperre, April 2012**
An oyster-pale chiffon dress, by Alberta Ferretti, is offset by a slick of shimmering eye-colour in 'Tender Is the Night', a homage to the Twenties revival on the catwalk. The flapper is back, but this time she wears her romantic bias cuts and barely-there slips with make-up that packs a dramatic punch. No one said nostalgia should be sweet.

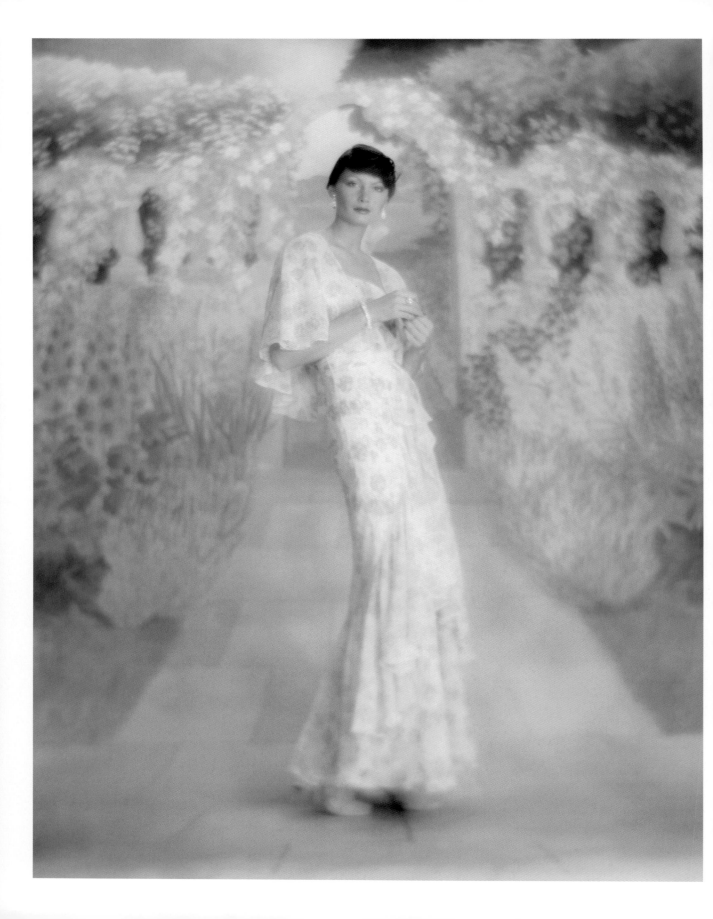

← Oliviero Toscani, February 1975

Months after the release of *The Great Gatsby* starring Robert Redford, the world is still enthralled with that film's hazy sensuality. Toscani brings the same gauzy sensuality to this image, part of a rhapsody on all things floral and a 'whole blooming garden' of new colours, and in which a tiered white georgette gown, by Salvador, is scattered with sweet peas.

↓ Eduardo Benito, December 1925

There is a hint of Josephine Baker about this tiered confection with the beaded neckline, but the dancing has yet to begin. Our young sophisticate faces the Roaring Twenties with an imperious air, a mouth that rivals actress Clara Bow's for sheer impudence, and a terribly dashing beau in tow.

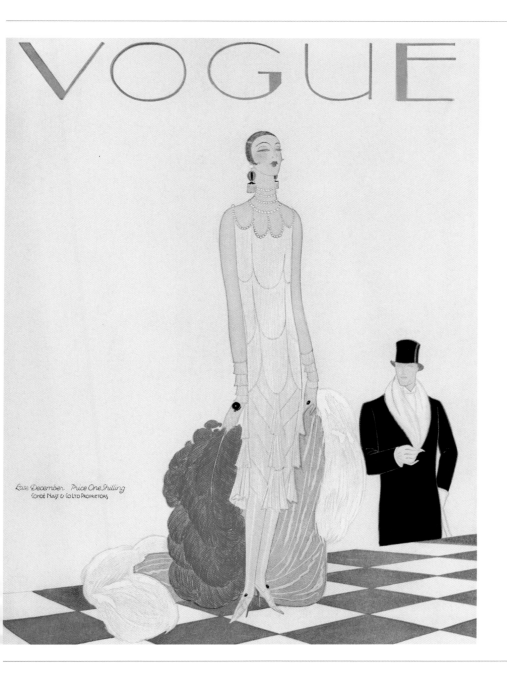

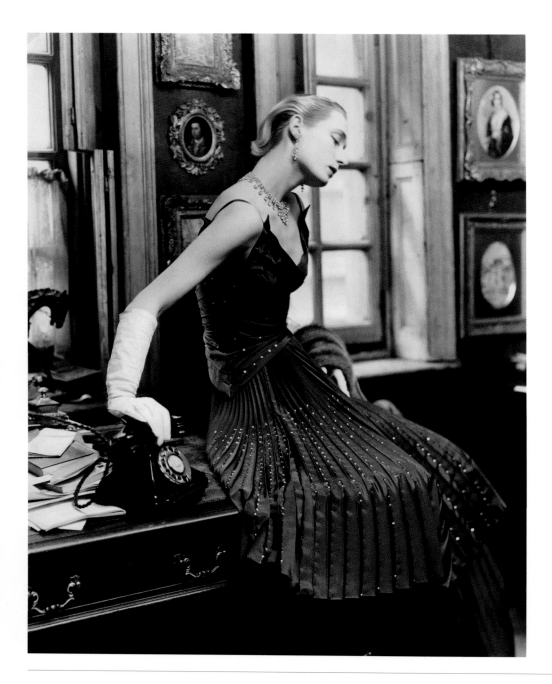

↑ Norman Parkinson, March 1951
'The most wearable clothes in the world,'
wrote *Vogue* of this sunray-pleated
dress with sequins, by Peter Russell.
'Their fabrics are perfection, their colours
sensitive, their lines pleasing to the eye
and flattering to the figure…Whatever
a woman's age, type, or way of living,
she could dress beautifully from these
collections.' She might, however, require
a little assistance with that telephone.

→ Carter Smith, December 2005
Lily Donaldson brings a blue-stocking's
intelligence to this study of haute
bohemia in an English country garden.
And Alberta Ferretti's silk event dress
is paired with a knitted gilet and vintage
bag, tempering any overt glamour with
a little dignified refinement. Evening
shoes are replaced with beaten
leather boots. Even Mrs Dalloway
would approve.

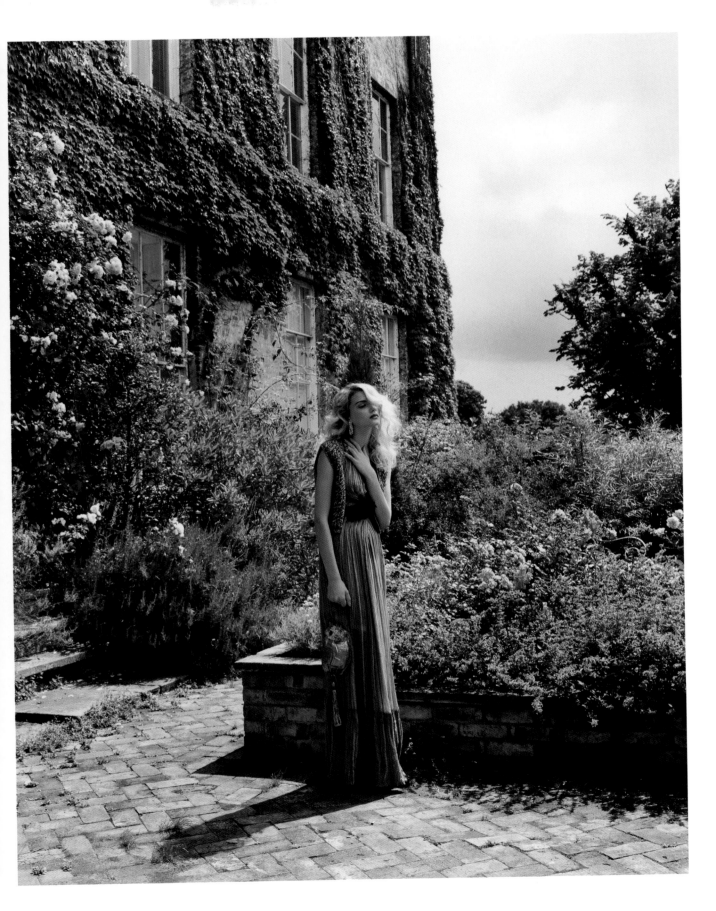

↓ Clifford Coffin, April 1948

A night at the opera. But is our muse arriving; in her embroidered bodice, white tulle skirts and pale blue evening coat by Dior – or is she making a reluctant retreat? Clifford Coffin captures a Cinderella-like suspense in this candle-lit sartorial romance at the Louvre in 1948.

→ David Bailey, March 1972

Photographed for *Vogue* shortly before the release of the duet 'La Décadanse' (a typically breathy piece of erotica recorded with her then partner, Serge Gainsbourg) the model, actress and singer Jane Birkin is here photographed in more modest repose.

With her dark hair tied back, mournful expression and balletic grace, she recalls the tristesse of Pierrot. This particular 'vulnerable beauty', however, is clothed in windblown layers of cotton organdie and 'fragile frills' from Dior.

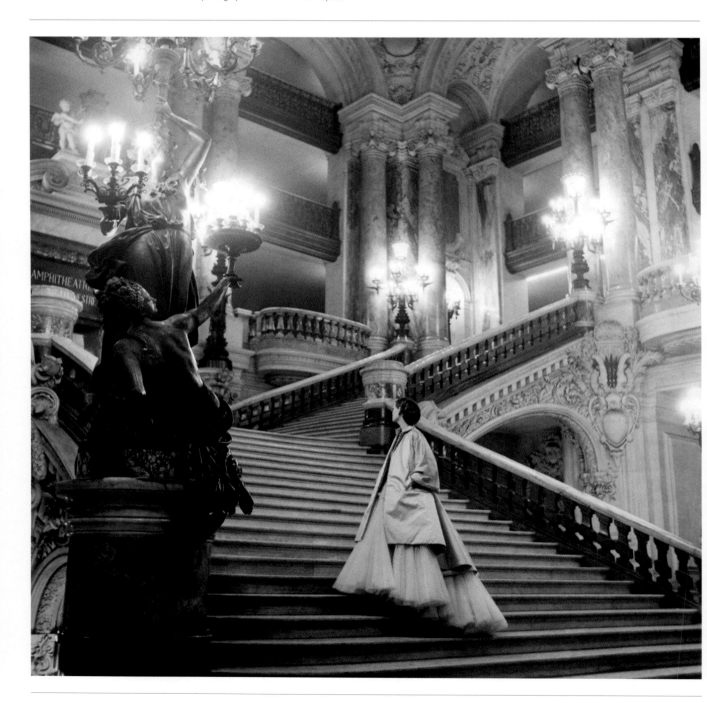

← **Mario Testino, December 2000**
A simple feathered headpiece
transforms Angela Lindvall's black
and grey pearl-embroidered gown
by Valentino Couture. Part Folies
Bergère, part *Vile Bodies*, the overall
impression is wickedly alluring.

↓ **Helmut Newton, October 1973**
The whisky is too warm, she has
smoked her last cigarette, and the
television's got no reception…
No matter: when you are dressed in
Pablo & Delia's black silk chiffon Spanish
gown, and are armed with a veil and a
sleeve of bangles, the party comes to you.

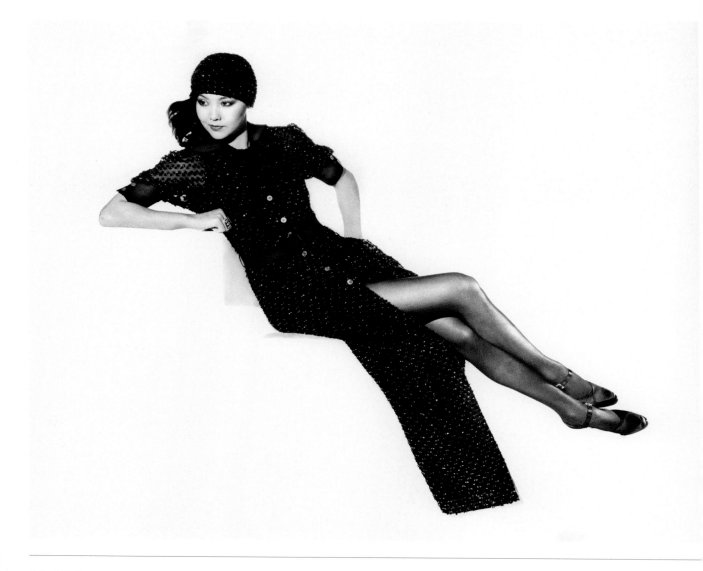

↑ **David Bailey, August 1974**
Jean Muir's button-through glitter
dress signifies a mood change in fashion.
Cuts are gently flared, hemlines are
mid-length and hats are *de rigueur*.
Marie Helvin makes an excellent case
for the modern – sparkly – cloche.

→ **Alex Chatelain, June 1986**
A flock-spotted net skirt, by Yves Saint
Laurent Couture, and a fitted cap bring
to mind the sinewy athleticism of the
Ballets Russes dancers, or the fashion
illustrations of Georges Lepape.
Saint Laurent was criticized for being
too obliging in meeting the traditionalist
demands of his couture clientele, but
the timelessness of this image may
convince us that his instincts were
right all along.

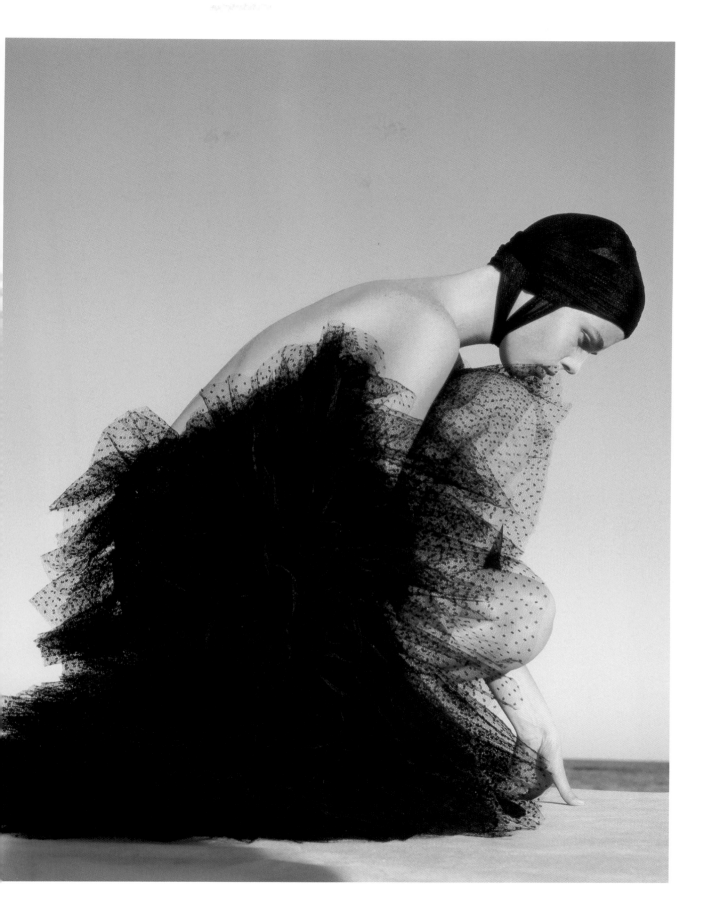

← Nick Knight, December 2000

The designer Adam Entwistle takes the deco theme quite literally. When tasked by *Vogue* to create a golden gown, he persuades Sally Turner to make an art nouveau face in gold leather to adorn his liquid lamé gown. And the age of decadence is born anew.

↓ Mario Testino, April 1999

Alexander McQueen's temporary residence at the House of Givenchy may not have been the happiest appointment. But in this sequined tango dress with handkerchief hem one can possibly see the kernel of his inspiration for a later, legendary show 'Deliverance', which he staged at his own house five years later, inspired by the Sydney Pollack film *They Shoot Horses, Don't They?*. McQueen's fascination with the denuded glamour of the Depression era serves only better to emphasize the gown's exquisite craftsmanship and beauty.

↓ Denis Piel, October 1983

This Eighties flapper speaks with her fists. In the fashion story 'Straight through to Midnight', the Australian-French photographer plays down the delicate bugle beading and diamanté accents on this navy shower by Chloé, and focuses instead on model Lynne Koester's natural power. As a study in twentieth-century feminism, this sure packs a punch.

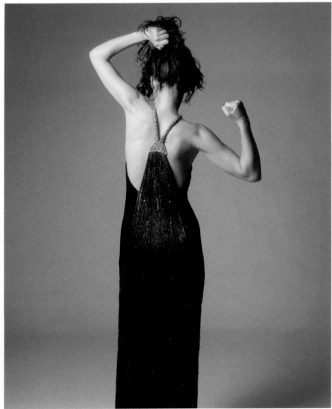

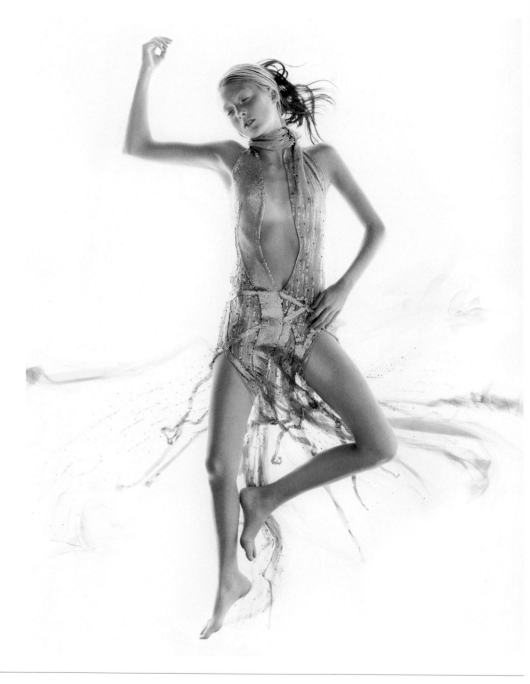

↑ Tom Munro, January 1999

At the end of the century, a new dawn awaits. In 'Light Future', Maggie Rizer dazzles in shades of white – well, silver in this instance – shimmering in barely-there Versace chiffon and chainmail, 'low cut, high voltage'. A sleeping time-traveller, she drifts seamlessly through the decades, from the Belle Époque to the bright new millennium.

→ Mario Testino, October 2008

Some images continue to ignite the imagination long after the issue has disappeared from the shelves; and none more so than this unique fashion marriage between Kate Moss's 'inimitable style' and 'the exquisite femininity of couture'. The louche elegance of a Twenties-inspired silver-beaded mermaid dress, by Armani Privé, is here perfectly balanced by the model's own faded army fatigues and badges.

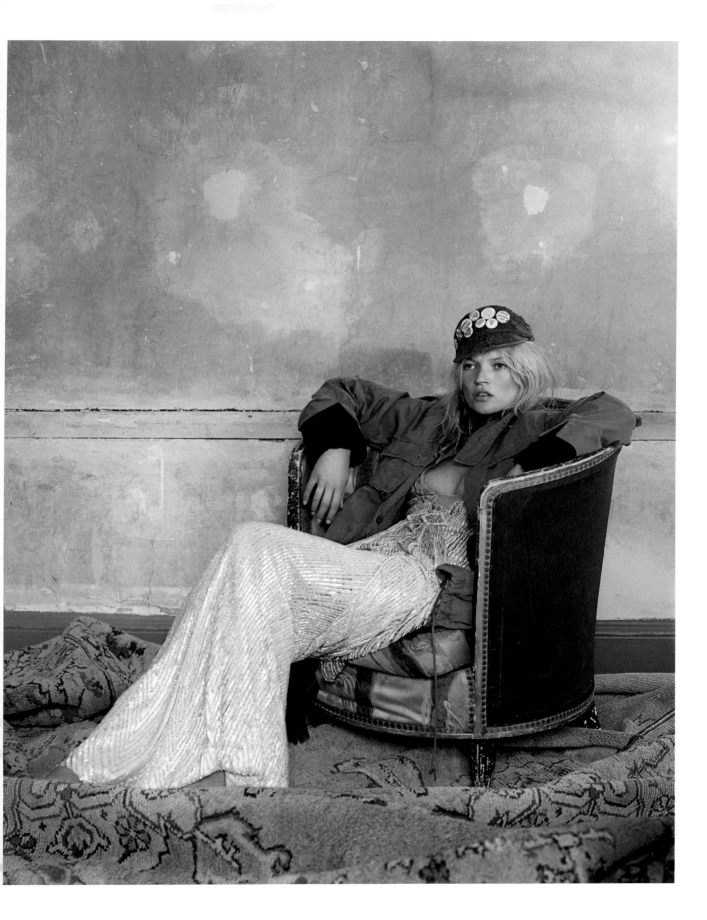

David Bailey, November 1973
For a commemorative issue celebrating the marriage of Princess Anne and Captain Mark Philips, Bailey photographed a portfolio of gowns representing the brides of different eras. Here Jean-Louis Scherrer's design bedecks the silver-screen bride in a 'sequin-spangled long dress, round high neck…and diamanté-studded veil'.

Benito, April 1928
Vogue weddings have always been an excellent gauge of the Zeitgeist, and the deco bride was a particularly magnificent creature, encapsulating that era's obsession with pared-down glamour, simplicity and youth. Here she is rendered, at the hand of a master illustrator, as though in alabaster, achingly elegant with elongated train, clutching a bouquet of calla lilies.

André Durst, March 1938
Ten years later, bridalwear still favoured clean lines and long sleeves. This regal gown, by the Court designer and leading London couturier Victor Stiebel, encapsulates the 'simplicity of sophistication…slender as a marble column and caught to the front with shirring'. The lilies, so adored by the deco artists, have here made way for wide white tulips, placed in the veil and faintly flushed, as they are also in the bouquet.

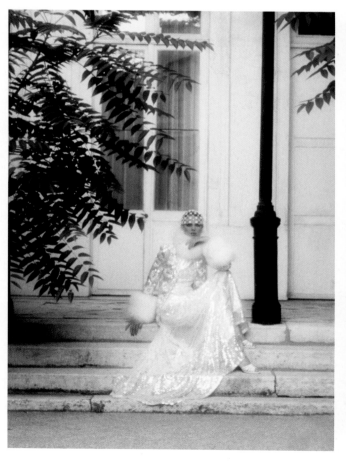

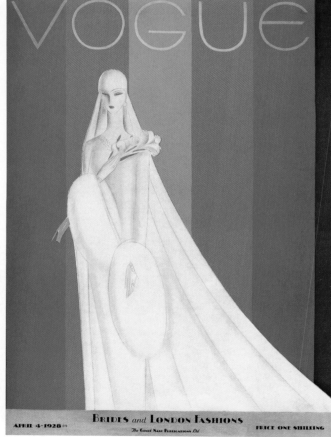

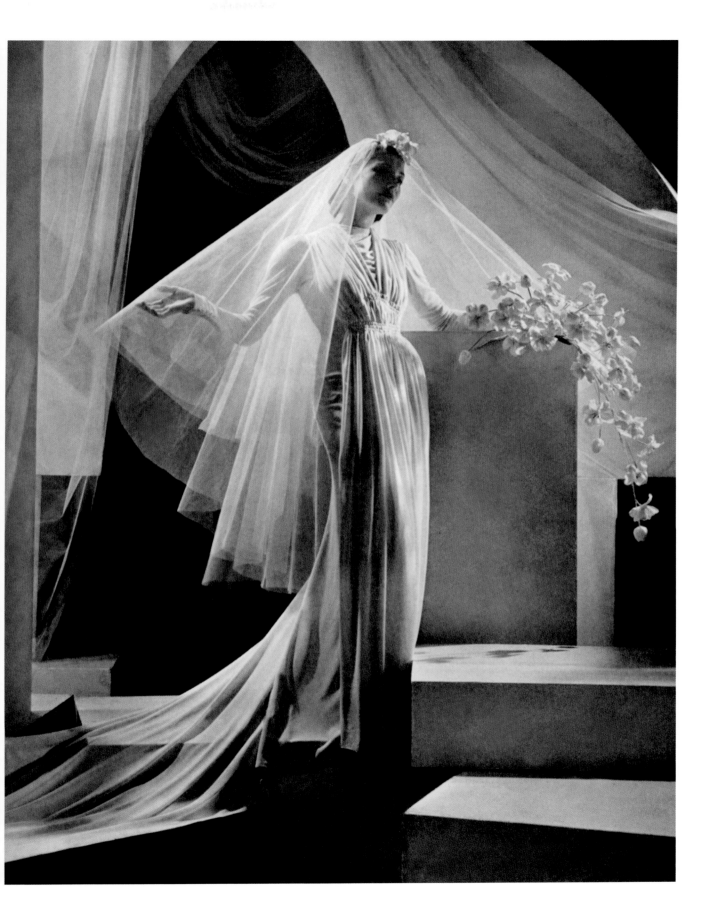

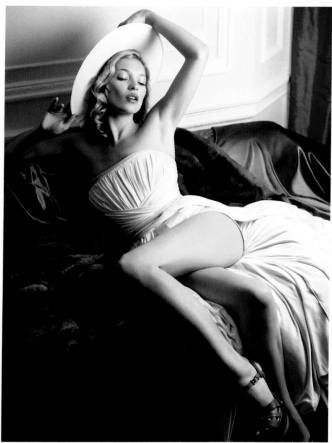

← **Nick Knight, December 2003**
The Polish art deco artist Tamara de Lempicka has long seduced fashion designers and photographers, entranced by her feel for 'lavish extravagance and curvaceous beauty'. Her artistic preferences for jewel-bright clothes and gloss remain a constant source of inspiration. *A Portrait of Ira P* (1930) acts as the reference here, with Bellville Sassoon's flowing gown in liquid silk satin giving new life to an iconic image.

↑ **Arthur Elgort, December 1991**
Christy Turlington channels Karen Blixen on an African adventure in Tarangire National Park, Tanzania. *Vogue* on safari means a retinue worthy of the earliest colonial adventurers – hairdressers, assistants, convoys of Jeeps, and trunks upon trunks of eveningwear; after all, one can't allow the leopards to upstage the clothes. A silver beaded dress by Louis Dell'Olio for Anne Klein serves as the perfect outfit for a spot of sightseeing – worn with Hermès leather driving gloves, of course.

↑ **Lachlan Bailey, December 2007**
Where better to stage an homage to Thirties glamour than that great edifice of deco architecture, Claridge's? Kate Moss is the hotel's most deeply glamorous guest, adorning its corridors in an ivory silk-plissé gown from Balmain and straw hat from Dior.

↑ Patrick Demarchelier, October 1987
'Saint Laurent's modern spirit embodied in all the fizz and feather of his funky Papagena dress,' enthuses *Vogue* of this cheekiest of yellow confections. And with Canadian supermodel Linda Evangelista ready to shake her tail feathers for us, what a swell party this is!

→ Nick Knight, December 2007
Star tattoos, a convertible Mustang and a California-yellow gown by Escada transform Sienna Miller into *Vogue*'s Christmas starlet, ready to hit the pedal and head for the Hollywood Hills. The truth is rather more prosaic: visiting her at home in West London, *Vogue* found her camping in an attic surrounded by boxes of shoes. Yet, Miller is very much the 'blithe spirit of the age': 'I'm 25,' she explains of her talent for exciting the tabloid press. 'I'm having a brilliant time. I like to party and I love to work.' But sometimes a wide-eyed girl just gets misunderstood: 'I don't want one-night stands,' she declares. 'I like loving someone.'

← **Tesh, February 2004**
'Foxtrot the night away in transparent pink by Tom Ford for Yves Saint Laurent Rive Gauche.' The dress has deco details, but at the hands of Ford, the master of seductive dressing, this drop-waisted jersey gown is slashed towards the navel, dangerously sheer, and shirred around a diamond at the crotch. It is a fast dance – better make sure you can keep up…

↓ **Mario Testino, December 2003**
Vogue plays 'divinely decadent dress-up' with a floor-length Dolce & Gabbana chiffon dress with Swarovski-crystal beading and a rabbit-fur cape. 'Fading tones, precious decoration and love-worn glamour' all add to the sense of nostalgia for a long-lost Gilded Age.

→→ **Corinne Day, October 2007**
In the year that post-war dressmaking is celebrated in a huge exhibition dedicated to 'The Golden Age of Couture' at the V&A, *Vogue* joins forces with the museum to showcase that season's most sumptuous creations. Shot around London landmarks, including the Underground, as well as in the museum's backrooms, here

Jessica Stam picks her way over the baby grands at G&R Removals – a piano removal specialist in Chiswick – dressed in a beaded siren gown by Atelier Versace.

modern

Modernist fashion is surely an oxymoron. For what is fashion if it does not have fresh ideas? Yet, often what is truly innovative can be appreciated only years later: what might seem scintillating at the time can look almost quaint with the benefit of hindsight.

So what is the modern gown?

Sometimes it presages a sea-change in fashion, an entirely different outlook and approach. Christian Dior's New Look, which cinched post-war Paris into nipped-in waists and extravagantly full skirts, transformed the fashion landscape, as did Cristóbal Balenciaga's balloon silhouettes that manipulated the very same proportions but inflated them or turned them into trapezes. These gowns represent the work of pioneering visionaries, men (and women) who have convinced the world to look at clothes – and the female form – anew.

Other times, it is the gown itself that is exceptional, a feat of tailoring or technique. In this category, we should include Junya Watanabe's superlative techno Origami gown from 2000 (see page 294), Hussein Chalayan's genius for the geometrical cut, or the paint-splattered audacity of McQueen's 1999 showstopper, a dress 'designed' by industrial robots (see page 271).

And yet, as Coco Chanel would surely have agreed, sometimes modernity is found in a gown's simplicity. While the most contemporary-looking designs are often the most technically accomplished, some of the boldest looks are also the sparest. When Princess Diana was photographed for *Vogue* in 1994, in a simple, red Valentino halterneck gown (and commemorated three years later with an image from the same shoot), the message was clear. Here was an entirely *modern* princess, unspoiled by the vicissitudes of royal privilege and unburdened by trappings (no tiaras or flashing diamonds here). As a portrait of modern royalty, it has become iconic. Similarly, in Cecil Beaton's examination of 'elegance' in 1950, he choose to illustrate his point with a black-and-white striped gown by Jeanne Paquin; more than 60 years later, the dress looks just as fresh and goes to prove that true modernity is timeless.

But contemporary style must be challenging, and *Vogue* has always embraced the new... and even the outlandish. Variously, the magazine has exhorted its readers to 'walk with swagger' à la Robin Hood, in velvets from Christian Lacroix, 'embrace the odd' in a conical bra-dress by Jean Paul Gaultier, and experiment with the 'wildly extravagant' cloud dresses by Lanvin Couture. Even when the gown represents no practical use at all, *Vogue* is first in line to salute the exploration and execution of an idea.

British *Vogue*, has always celebrated the more idiosyncratic elements of the nation's quixotic style, delighting in its eccentricities and turning fashion cheerleader for the myriad maverick talents that have graduated from the country's fashion colleges (not least, London's Central Saint Martins College of Art and Design, without which the global fashion industry might have collapsed). Such enthusiasm nurtures new talent and safeguards fashion's future – because, as only the most modern mind understands, the best is yet to come.

→ **Horst P Horst, November 1986**
To celebrate Horst's 80th birthday, and a near 50-year career at *Vogue* creating images with 'dramatic lighting and impeccable eye', the photographer is tasked with capturing 'The New Pillars of Society'. The silhouettes are strong, angular and sculptural, not least here in the shapes thrown by Versace's frilled black velvet column dress, with its silk taffeta and organza skirt. 'I prefer to regard elegance as a form of physical and mental grace that has nothing to do with pretension,' said the photographer.

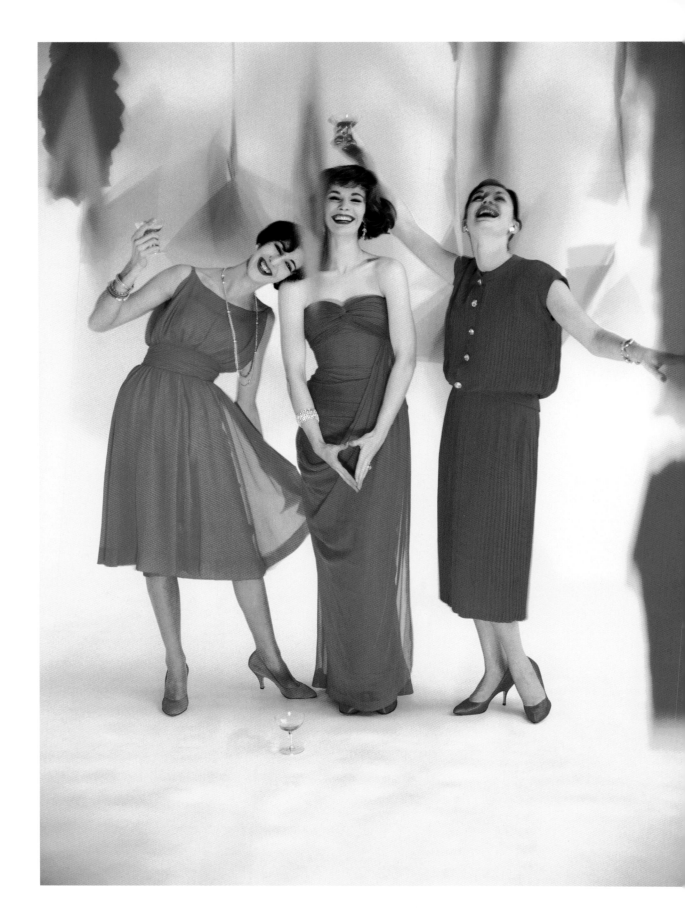

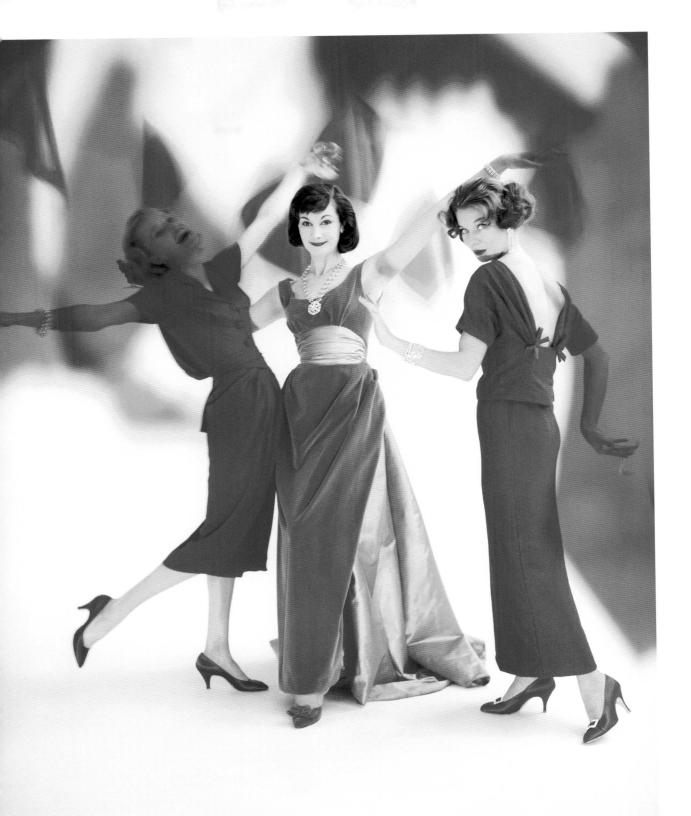

← ← Norman Parkinson, December 1957

The scarlet woman is a popular motif in fashion, and these saucy Christmas partygoers in geranium-red gowns, by (from left) Ronald Paterson, Victor Stiebel, Michael Sherard, Hardy Amies, Norman Hartnell and Michael, have an independent élan and sense of mischief in their vivid homogeneity. Matching pumps optional.

↓ Patrick Demarchelier, October 1997

Featured in a commemorative issue, printed just weeks after Diana, Princess of Wales' death in August 1997, this image was actually taken from a previous cover shoot in 1994. In the accompanying tribute, *Vogue* celebrated Diana's evolving style: 'Clothes were her vocabulary, and from faltering pidgin she gradually became one of the most fluent fashion speakers of her time.' Here, she is seen at her most gloriously chic, denuded of fussy accessories, in red, by Valentino.

↓ Emma Summerton, December 2009

'Where better to display winter's most daring hue than at the foot of the weather-beaten white cliffs of Dover?' asks *Vogue*. Red is the boldest colour in winter, and these vermillion evening gowns, by (from left) Jean Paul Gaultier, Chanel and Victoria Beckham, appear surreally Space Age against the stark white of their surroundings.

→ Peter Lindbergh, September 1989

The new season's mood is here marked with a nod to Robin Hood, principal boys and a certain piratical charm. Be in no doubt that Christian Lacroix's chivalric scarlet silk crepe dress, slit to the waist and worn with a gilt crucifix (encrusted with faux jewels) and thigh-high boots, will steal every scene.

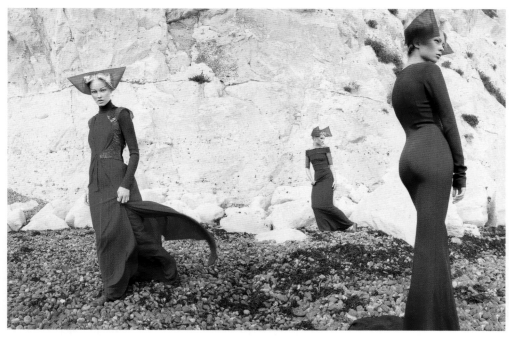

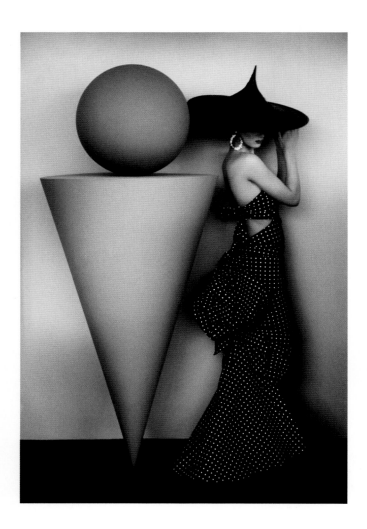

↑ **Sheila Metzner, March 1986**
Christian Lacroix, this time for the House of Patou, created this 'exuberantly bustled fantasy with polka-dots' in a couture season obsessed with shapeliness. Ruches, swags and bows were all part of the 'fireworks' the young designer brought to the fashion house, and while such pyrotechnics might make the addition of large diamanté hoop earrings and a pagoda hat seem a little *de trop,* the pieces in fact lend the look a perfect symmetry.

↑ **René Gruau, March 1955**
To Paris, and the line is either 'straight as an I, or triangular as an A'. Christian Dior, master of the New Look silhouette, was firmly of the latter camp. His style of dress, says *Vogue,* makes a 'powerful appeal to those many of us who like to have our fashion thinking done for us by experts: because we are busy, or a little uncertain, or know that we need "arranging". Here, he delivers a 'late-day dress in black faille', which falls full from the hips and is worn with a similarly broad, black cartwheel hat.

→ **Peter Lindbergh, September 1984**
'Just two cornetti,' observes *Vogue* wryly of Jean Paul Gaultier's wildly cheeky orange velvet corset dress, ruched, boned and 'whipped to impossible points'. Part of a new wave of design talent emerging in the mid-Eighties, Gaultier is praised for 'embracing the odd and sometimes startling'. Such an irresistibly provocative vision made him the perfect match for young pop newcomer Madonna Ciccone, who would wear a version of his conical bra to infamous acclaim on her Blonde Ambition tour nearly five years later.

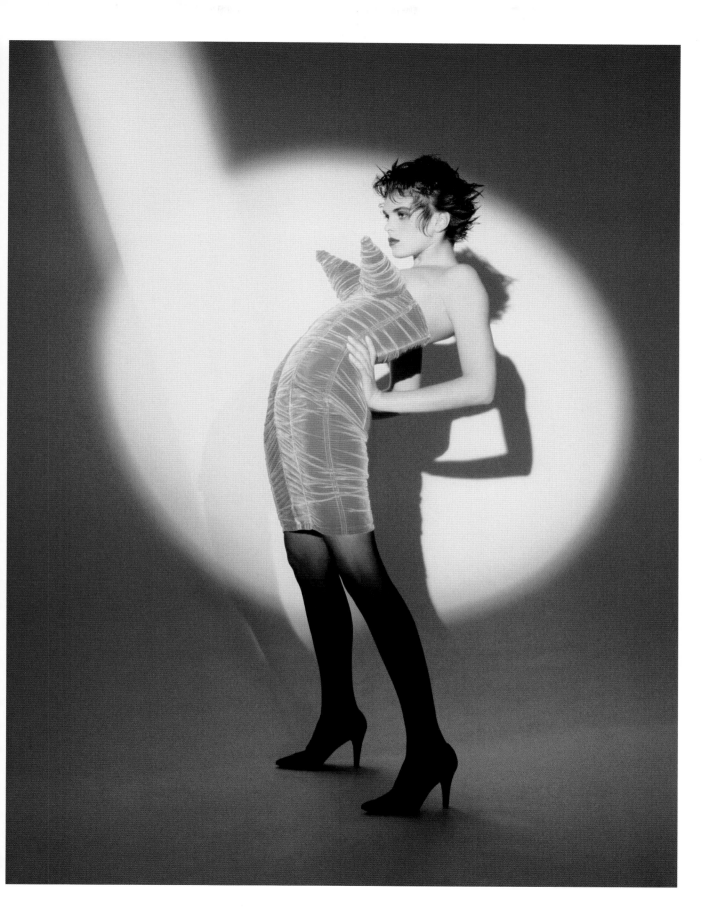

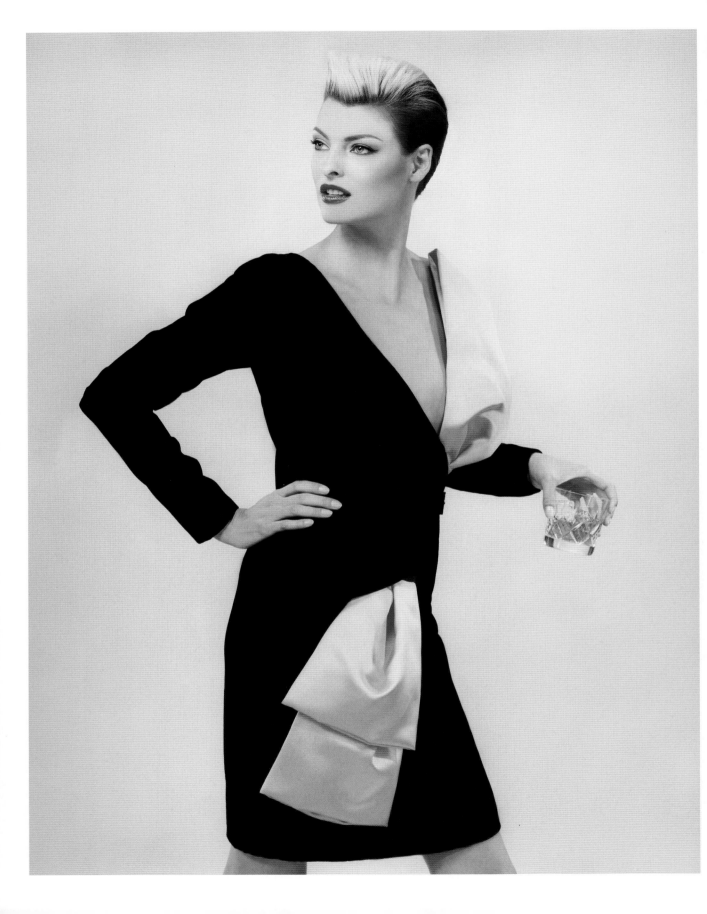

← David Sims, January 1996
What could be more modern than
Linda Evangelista 'à la moll' in a black
velvet wrap dress with pink satin sash,
by Yves Saint Laurent Rive Gauche.
The clothes may be classic but, with
her peroxide pompadour and frosted
lips, the effect is dazzlingly contemporary.
All this dame needs is someone to
freshen up that Scotch on the rocks.

↓ Photographer unknown, May 1927
It's all about the back. French designer
Jeanne Lanvin's black-and-white taffeta
picture dress simulates a butterfly with
a huge bow and ornamental detail
along the spine. As the summer
approaches, *Vogue* applauds such
originality and skill, which 'leaves one
breathless with admiration'.

↓ George Hoyningen-Huene, April 1931
One of the most inspirational
photographers and war reporters of the
twentieth century, Lee Miller is here
captured in her previous incarnation
as a *Vogue* model. It seems almost
inconceivable that such a figure of
feminist zeal and innovation should
have once have been associated with
debutante style and those 'charming
creatures' preparing to appear in society
in their presentation gowns. Perhaps
it is befitting, then, that she wears an
'unusual' black evening gown with
basket basque, by Jeanne Lanvin.

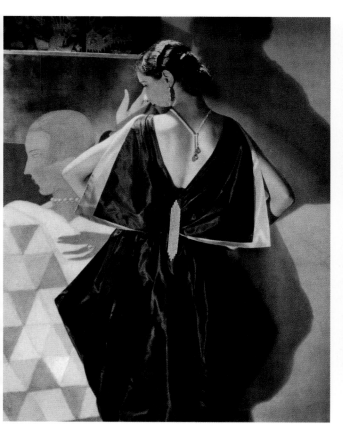

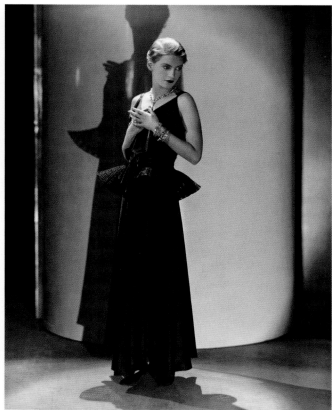

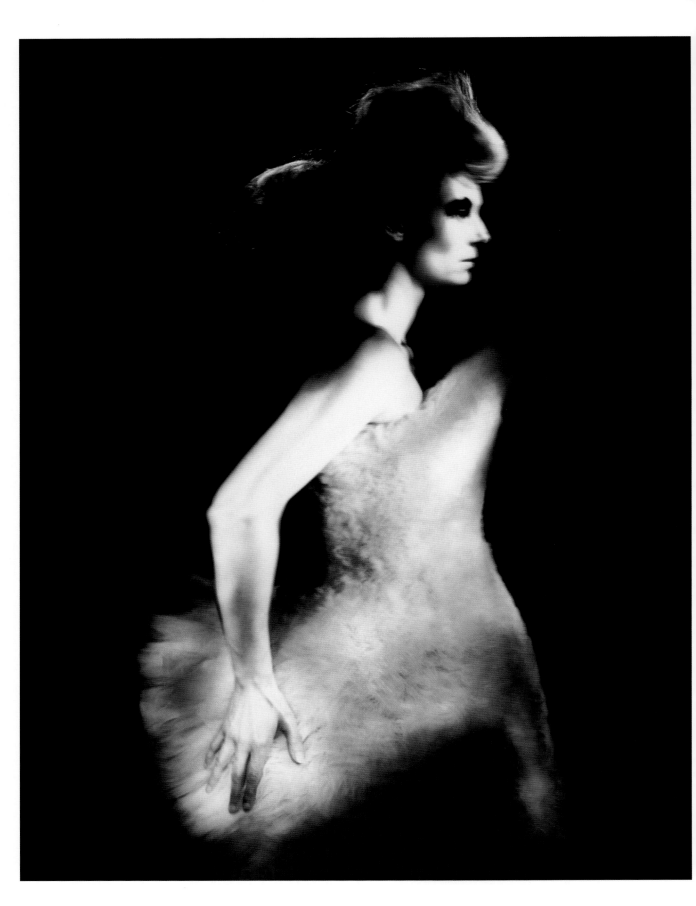

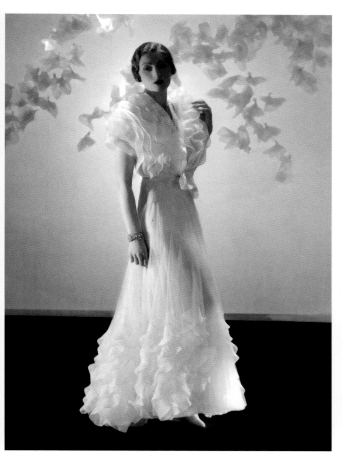

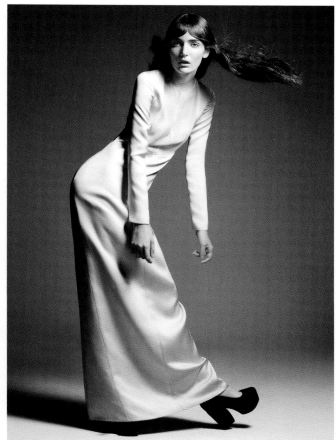

← Paolo Roversi, February 2000

In this union of avant-gardists, the actress Tilda Swinton brings a painterly stillness to Hussein Chalayan's sculpted ruffle dress. The Turkish Cypriot designer, who was forced to move to Britain in 1978, is famed for his singularly minimalist aesthetic. The Cambridge-educated cineaste is similarly lauded for her sense of experimentalism. Together, they are a perfect fit.

↑ George Hoyningen-Huene, June 1933

The gown, by Maggy Rouff, may combine crisp, airy white and a 'playful touch of romance', but before Hoyningen-Huene's lens these organdie folds and tulle pleats are strong, composed and anything but frilly.

↑ David Sims, March 2012

Lean lines, silk satin and extra-long sleeves ensure that this floor-sweeper by Calvin Klein remains effortlessly and breathtakingly simple. Polish model Zuzanna Bijoch's level gaze is enigmatic. The elegance is absolute.

↓ Artist unknown, October 1925
Hard to imagine, now, the sartorial revolution set in motion by Coco Chanel. A penniless convent girl, music-hall singer, mistress and milliner, the designer had only founded her couture house on rue Cambon six years prior to this feature in *Vogue*, but she was already igniting the fashion world with her emphasis on leisurewear, masculine detailing and louche élan. Here, she delivers what subsequently became a signature of the house style, a draped black dress in *mousseline de soie,* whose slimness is softened by its 'wind-like motion'. The anatomical cut is deemed of the utmost importance. 'Intricacy of cut has been increasingly manifest now for several seasons,' observes *Vogue*. 'Now, in the newest of the best dresses, it is employed to define the fluid lines of the body, adding grace to grace, line to line.'

→ Angelo Pennetta, May 2012
Nearly a century later and fittings at Chanel are still undertaken under Coco Chanel's watchful eye; her portrait hangs over Karl Lagerfeld's desk. Although many of the house's motifs have remained unchanged, Lagerfeld's genius has lain in his ability to reinterpret, rework and reimagine these classics – alongside more modern innovations – to huge commercial success. Here, Karlie Kloss turns up for a pre-couture show fitting in a white silk-tulle gown, with cap-sleeved top embroidered with the palest blue petal sequins.

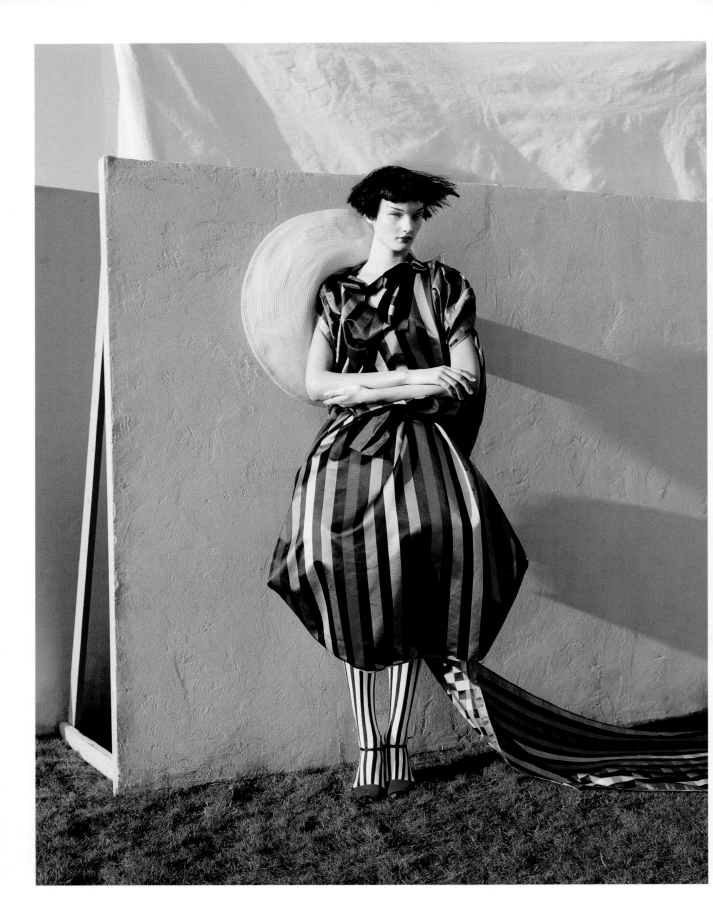

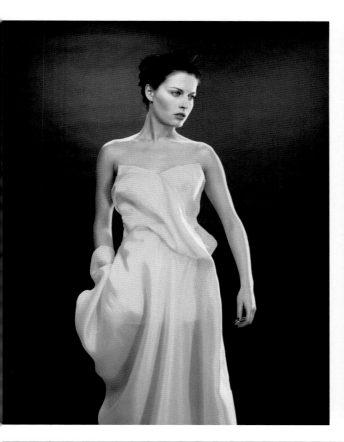

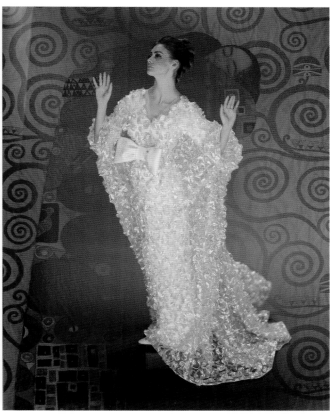

← **Tim Walker, April 2011**
As artists including Piet Mondrian or Bridget Riley have shown us, a graphic stripe can transform a thing into something at once bold, bright and contemporary. So too in fashion, stripes enliven the mood and sharpen the senses, whether banded on a Breton *marinière*, or gathered, as they are here, in the maypole-bright lines of Vivienne Westwood's puffball-skirted satin dress.

↑ **Wayne Maser, February 1997**
Vogue showcases the young designers exciting the fashion capitals with their 'strong, individual look' and sense of forward momentum. One of 1997's brightest stars was the reclusive Japanese designer Yohji Yamamoto, who has enthralled the fashion intelligentsia since launching his first collection in 1981. 'Yohji proved his brilliance with a striking, quirky collection devoted to the great couturiers of the twentieth century,' writes the magazine of this ravishing evening dress fashioned from a single bolt of buttercup-coloured silk. 'True to form, his version of couture's splendour isn't by the book…but a futuristic look at fashion's past.'

↑ **Norman Parkinson, September 1965**
Cloud control. Our model is the silver lining in Lanvin's 'burnous of white translucent net, sewn with doodles of silvered ribbon' and gathered with a yellow silk-gabardine bow. 'It's put together with rare panache and couture-sharp precision.' Just make sure that she doesn't float away.

↓ George Hoyningen-Huene, August 1928

A document of the aristocratic classes at their most flamboyant – Lady Abdy attends the 'Fond de la Mer' (Bottom of the Sea) Ball, in Paris: 'one of the most important events of the season', *Vogue* intones (as though we needed telling). Lady Abdy's costume represents sea-mist – 'large amber-coloured balloons shrouded in a cloud of grey and green tulle' – floating about a silver cockle-shell headdress. The gown is made of shimmering white satin.

↓ Helmut Newton, October 1966

In 1966, the sense of fevered optimism in *Vogue* is palpable: 'The Beatles are the biggest cult of all, Mary Quant wins an OBE, England the World Cup, Julie Christie wins an Oscar, Andy Warhol draws Brillo boxes and James Bond the queues…' Outside of London, the world was obsessed with the space race as man stepped ever closer to the moon, and fashion was inspired by all matters intergalactic. Paco Rabanne's cosmic dress in silvered chainmail speaks directly to the spirit of the times, and its passionate belief in the future: 'never before so much choice,' the magazine marvels, 'so many opportunities.'

→ Tim Walker, February 2007

Hussein Chalayan's sparkling bubble dress, made in conjunction with Swarovski, is as much a feat of engineering as any seamstress's skill. Walker shot the dress – and its model Coco Rocha – for a Magritte-inspired feature celebrating the V&A's 'Surreal Things' exhibition that year. 'Fashion once again finds itself colliding with art,' *Vogue* observes of the curios on display. 'Nothing is as it seems.'

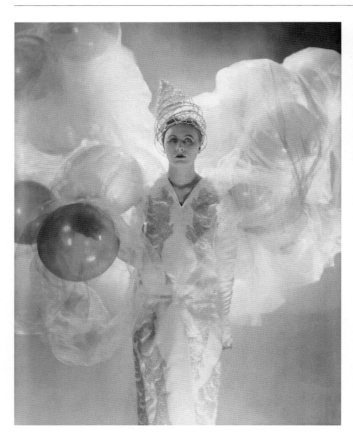

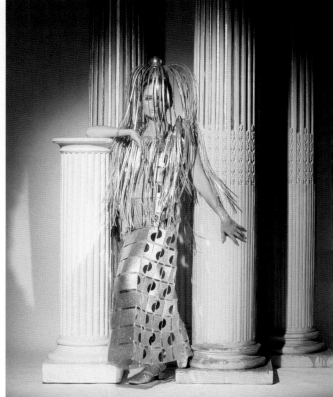

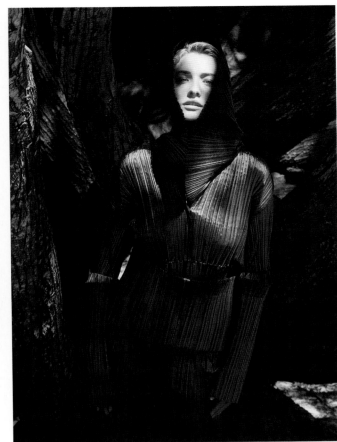

← **Nick Knight, November 2006**
In 2006 Moët & Chandon threw a masked ball to pay tribute to the photographer Nick Knight and *Vogue* asked designers to create a suitably thrilling ball gown to wear to the party. Stella McCartney's contribution in silver lamé is a study in intergalactic chic. When the look is complemented by make-up artist Val Garland's gold-leaf mask – and Kate Moss – the results are bound to be universally appreciated.

↑ **Herb Ritts,**
December 1988 and October 1989
Ritts's masterly control of light and motion is brilliantly illustrated in these images. In the first (left), a waterfall allows the light to cascade across a mercury silk gown from The Emanuel Shop, rendering his muse as interplanetary goddess. In the second (right), a single beam spotlights Tatjana Patitz as a modern-day Joan of Arc, heroic and serene in metallic pleats by Issey Miyake.

↓ Arthur Elgort, August 1996
In 'Optic Verve', a sinuous striped
evening dress by Gianfranco Ferré
is graphically glamorous against a
bright Grecian setting. Black and
white is deemed the boldest sartorial
solution for the summer heat: the
new length is 'cut straight and
tailored with painstaking precision…
This look does not permit sloppiness.'

→ Tim Walker, November 2005
The angular aristocratic model
Stella Tennant is here declared the
'picture of English glamour'; on
the cover of *Vogue*. The bias-cut,
panelled silk-shantung dress, by
Neil Cunningham, is paired with
matching show-jumping poles
for this modish version of
equestrian elegance.

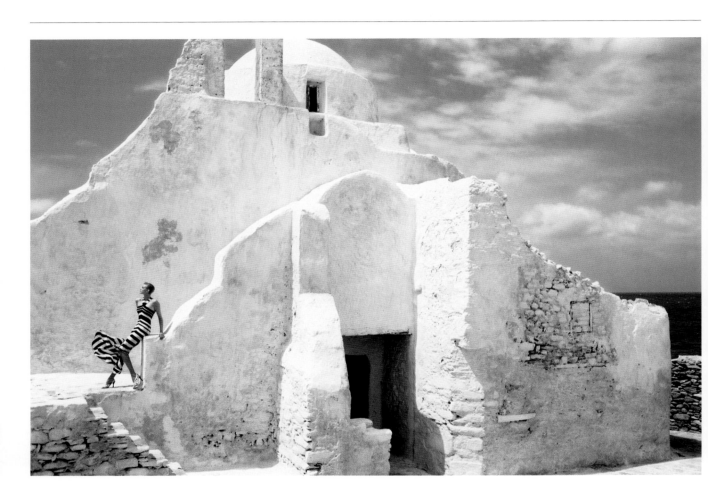

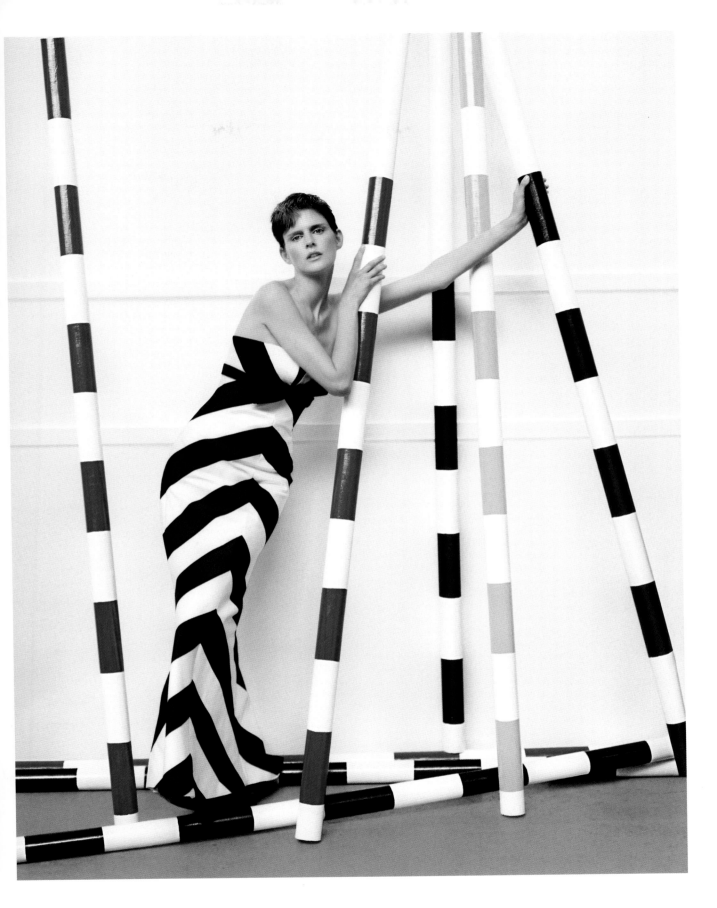

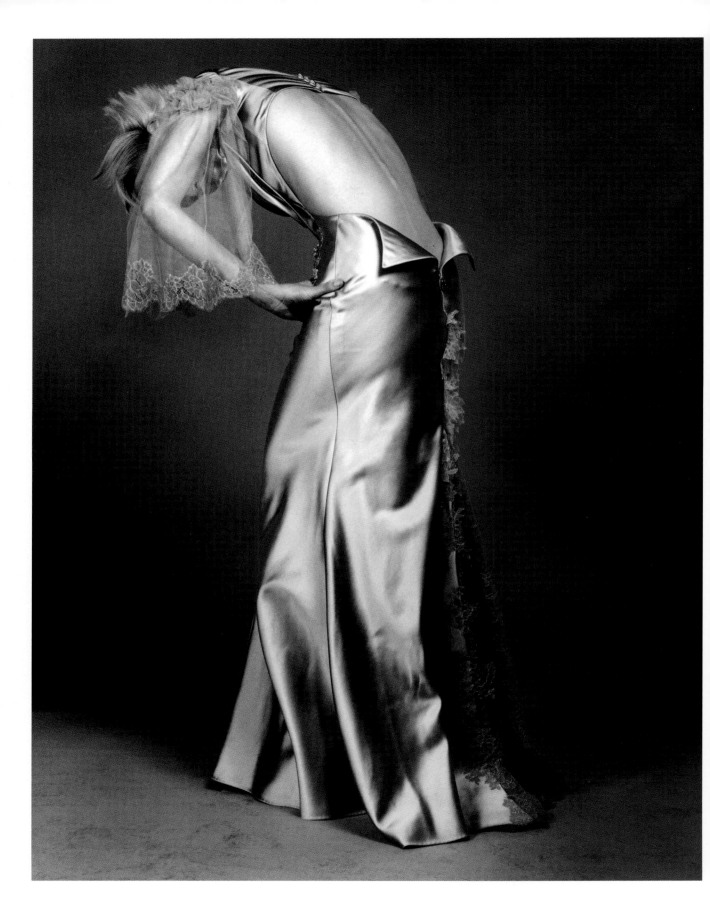

← Craig McDean, October 1996

The sculptural rigidity of Christian Lacroix's satin gown focuses our minds on the couturier's expertise. Despite such traditional craftsmanship, the modernity here is found in the gown's provocatively exposed back, skimming around the ribcage and plunging down the spine, to pool at the feet.

↑ Helmut Newton, August 1957

Forty years prior, and the 'new backless dress', by Fredrica, may dip less deeply, but is no less alluring. Awaiting the autumn, amid the Italian terraced garden of Rose Hill, Cumberland, this wool dinner dress is demure, with a high, straight neckline in front, and stick slim.

↑ Carl Erickson, March 1934

For this issue, the illustrator was commissioned to capture 'the last rush hours before the Collections' at the great Paris dressmakers: 'At breakneck speed he sketched the masters, feverishly at work in their ateliers, putting the final touches to their models.' Here, Jean Patou sits crossed-legged on the floor to observe final adjustments to a long sapphire-blue crepe dress.

'I like women to look, not like Juno, but like Diana,' observed Patou, 'moving, spirited, with shoulders thrust back.' The designer is also mindful of an exciting new client. 'For the first time, I'm showing dresses for cinema actresses,' he continues, 'a step towards the future, for the cinema is a great medium of clothes expression and the French couture houses are not indifferent to it.'

↑ Brian Duffy, June 1961

There is a change of mood in the air, and *Vogue* insists that one's summer wardrobe be 'as free-swinging' as the new era's attitude. In an image entitled 'Getting Home with the Milk', Duffy (one of the young, radical photographers dubbed the 'Black Trinity' by Norman Parkinson, alongside David Bailey and Terence Donovan) finds our early-morning revellers perched outside the *Vogue* offices in Hanover Square, still wearing last night's gowns by (from left) Victor Stiebel, Frank Usher and Jean Allen: 'Three dawn enchantments, so breathtaking that if parking metres could talk these here would be breathless.'

→ Horst Diekgerdes, May 2007

This evening dress, from the house founded by the German minimalist Jil Sander (the 'Queen of Less'), was actually made during the creative tenure of that other exponent of spare design, Raf Simons. In keeping with the label's adherence to clean silhouettes and elegant simplicity, the designer instead uses vivid colour – a shot of bright apple green, 'fresh and delicious' – for maximum impact.

← ← Mario Testino, June 2007

To celebrate the diversity and dynamism of talent at the London collections, and mark London Fashion Week's quarter-century of existence, *Vogue* embarks on an odyssey through the capital's far-flung ateliers – from the 'mean streets of Dalston' to the gilded squares of Mayfair. East London was an abundant source of new talent, with Jonathan Saunders, Christopher Kane and Giles Deacon among its brightest stars. Here, Sunderland's own Gareth Pugh makes alterations to a cyber-style Little Black Dress at his studio. The designer, then a waifish 25-year-old, is described as conjuring 'a cyber-gothic fantasy world in a huge, dank, concrete space with only two working sockets – and no heat'.

↓ Nick Knight, September 2004

Gemma Ward wears Alexander McQueen's reptilian dress in printed chiffon with leather inserts, all set against an electro-luminescent blind by Rachel Winfield. The effect is riotous, ironic, perhaps, for a designer whose intentions that season were 'to strip away all theatrics and focus purely on design'.

→ Craig McDean, December 2006

It's the stuff of fashion legend: Alexander McQueen's groundbreaking 1999 Spring/Summer show climaxed with the model Shalom Harlow spinning on a turntable as two industrial robots spray-painted her white column dress neon yellow and black. As with so many of his ideas, the show raised questions about fashion, art, commerce and manufacture, and yet did so within the parameters of an exquisitely staged performance. Here, the dress is revisited in *Vogue*, still paint-spattered, and worn by Gemma Ward.

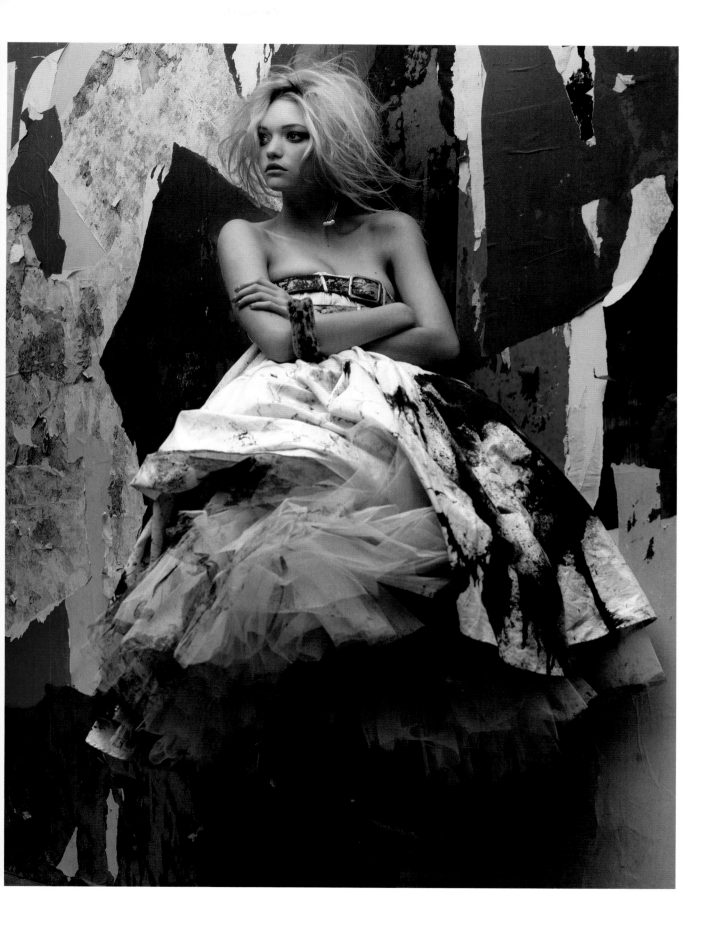

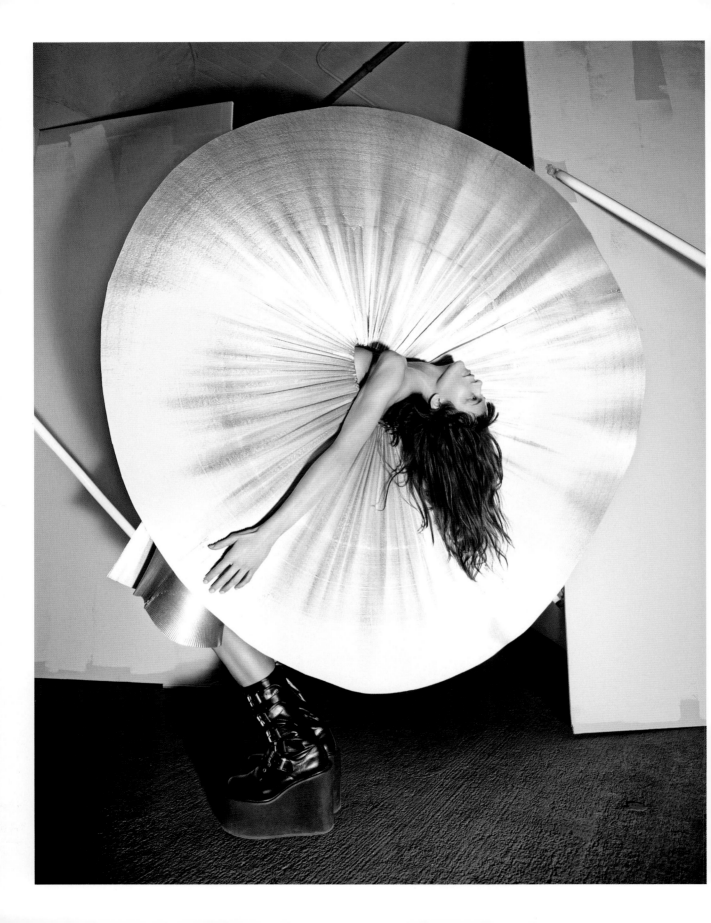

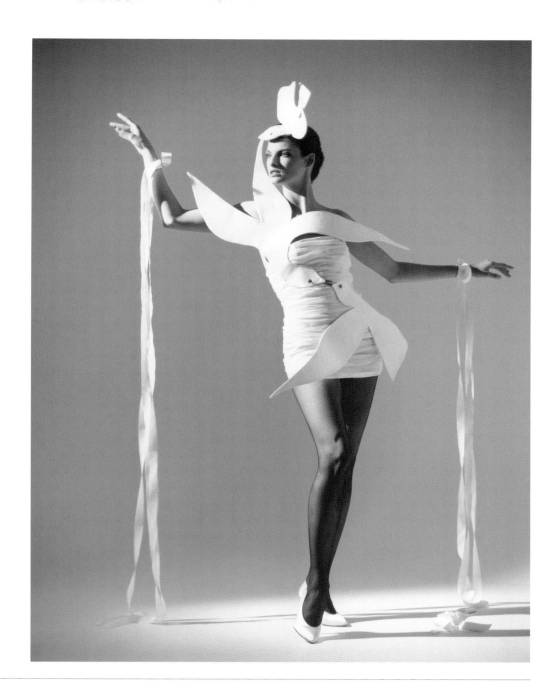

← **Mario Sorrenti, March 2012**

Is it a dress or a flying saucer? Clothes become objects in this highly experimental shoot that delights in the return of avant-garde design. Manish Arora's debut collection for Paco Rabanne featured his paper-silk dress that got everyone in a spin: 'concepts fly high, lines are asymmetric and designs beautify both mind and body,' said *Vogue*.

↑ **Arthur Elgort, April 1988**

The theme of experimentalism is no less pronounced here. Yves Saint Laurent is inspired by the French father of Cubist painting, Georges Braque, to create a pair of cut-out doves to adorn an otherwise minimal white silk wedding dress. The modern bride is urged to balance 'inspirational colour and theatre' with romance and 'a triumphant purity of style'.

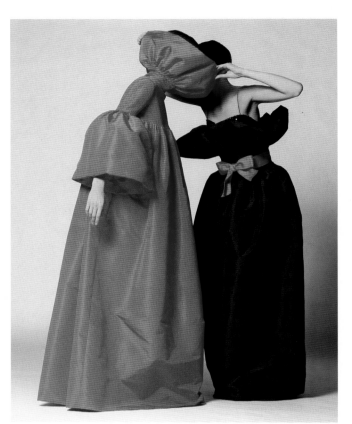

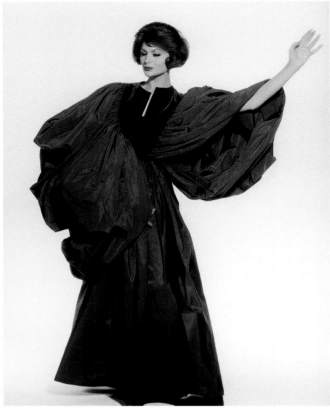

↑ **Peter Knapp, September 1971**
Fashion turns voluminous.
Pierre Cardin's taffeta flower gowns
feature 'tiny tucked tops, and grand
puffs of skirt to billow about it.
The cerise one's petal collar peels
off, in case you want to see who's
sitting next to you at dinner.'

↑ **Irving Penn, December 1959**
'A magnificent arrival', announces *Vogue*
of this cloak dress by Grès. Madame
Grès, always uncomfortable within the
commercial confines of the industry
and a long-time prêt-à-porter refusnik,
was awarded the Légion d'honneur for
her patriotic actions during World War II.
Her singular attitude and independent
spirit (even the scent she launched for
the house, Cabochard, translates as
'pig-headed') is much in evidence here:
turning her back on the clean tailored
lines popularized elsewhere during the
Fifties, she adopts an oversized balloon-
style silhouette instead.

→ **Henry Clarke, November 1951**
Creator of the bubble skirt, the balloon
jacket and the sack dress, Spanish
designer Cristóbal Balenciaga totally
revolutionized the look of womenswear,
and his radical approach to design has
remained a constant inspiration. In 1951
he transformed the female silhouette by
broadening shoulder widths and placing
less emphasis on the waist, creating a
dramatic new 'blown up' shape – and
a challenge for women seeking clothes
that merely flattered. This balloon-
hemmed black taffeta dress – worn with
a wide-collared, wide-cuffed velvet coat –
is a perfect example.

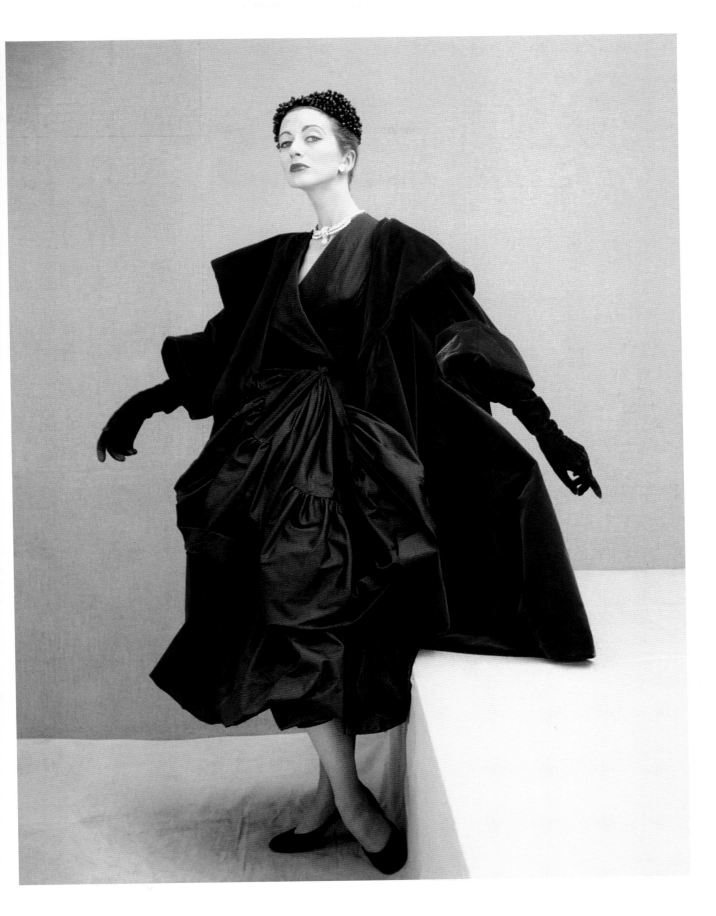

← **Bruce Weber, September, 1982**
'There is a lot to be said for the power of positive slinking,' says *Vogue* of Saint Laurent's black velvet sheath with billowing blue satin sleeves. 'Dressing with flourish and finish is here,' the magazine continues. And yet: 'It is not prerequisite that you go over the top. Style, and life, may be simpler than that.'

↓ **Patrick Demarchelier, October 2005**
The Paris couture collections mid-decade at the beginning of the twenty-first century were rich in sumptuous fabrics and shapes. Christian Lacroix's gown and cloak in poison-green duchesse satin, with jewelled bodice and shoes, has a 'regal air', although one wonders whether our muse here might have Irish sympathies.

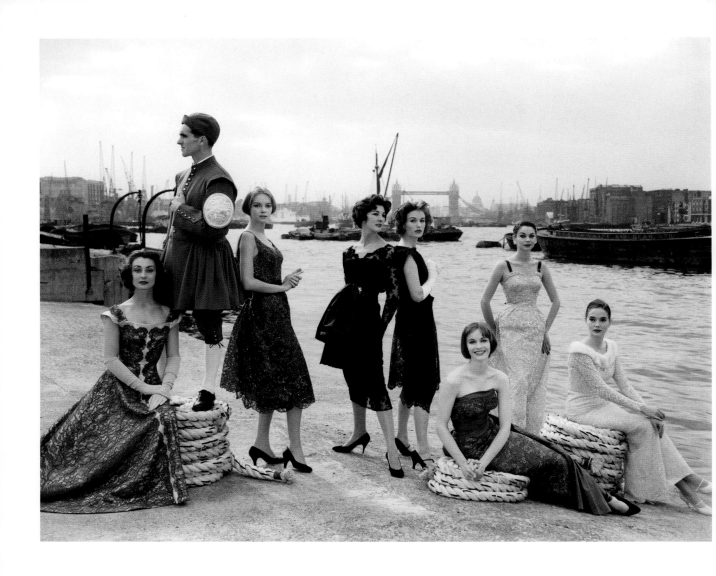

↑ **Norman Parkinson, September 1957**
At the end of the Fifties, London came
into its own as an authoritative design
capital, 'owing little or nothing to outside
influences'. Here late-day wear is
focused on lacy, pillar-slim ball dresses
in beautiful textures, by (from left)
Worth, John Cavanagh, Ronald Paterson,
Hardy Amies, Victor Stiebel, John
Cavanagh and Norman Hartnell. Where
better to showcase quintessentially
British designs than against a classic
London landscape, looking down
the river towards Tower Bridge from
Rotherhithe Wall.

→ **Bill Silano, June 1963**
It should come as no surprise to
discover that this image coincided
with the release of Alfred Hitchcock's
avian thriller *The Birds*. The world had
fallen for the director's enthralling
female leads, and Tippi Hedren was
the new poster girl for elegant
déshabillé. Silano's heroine faces
no less menace, but our girl here has
eschewed the skirt suits and high-
neck sweaters so beloved of Hedren's
character and opted instead for a 'long
streak of bronze linen with an Empire
bust', by Clive Evans.

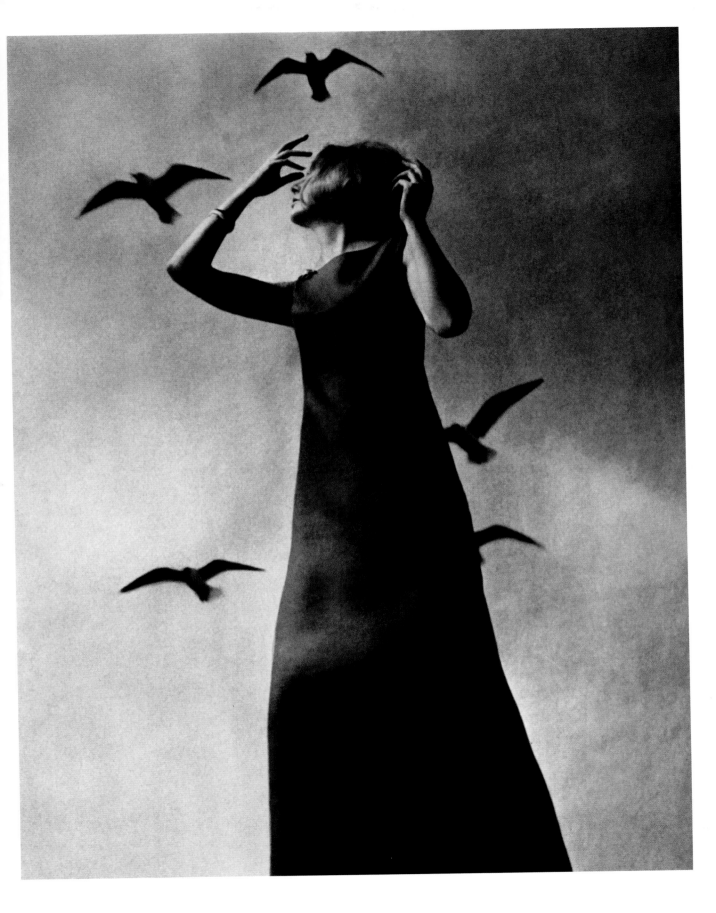

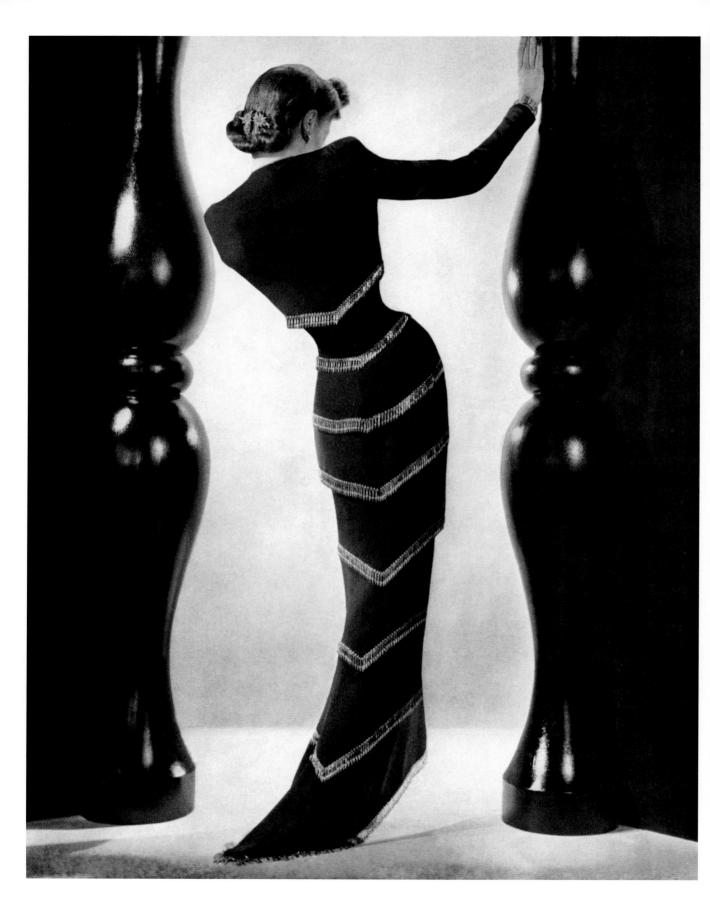

← **André Durst, August 1939**
A clinging dress with mermaid hem needs a strict posture and an even stricter dietary regimen – the waist measures a teeny-tiny 20 inches (51cm). According to *Vogue*, when working on this collection the designer, Jean Patou, was inspired by the drapery used on ancient Tanagra figurines, and follows a new fashion for a 'completely covered look' in eveningwear.

↓ **Adolph de Meyer, November 1917**
The first official fashion photographer to be appointed by *Vogue*, in 1913, de Meyer captured celebrity, royalty and artists alike for the magazine, and was described by Cecil Beaton as the 'Debussy of photographers'. He was also one of the highest paid. Few of his prints survived World War II, but this one, depicting sartorial japes 'in a New York shop when a well-known artist decided to design some gowns', illustrates how an 'uninspiring waistcoat' can become the 'leading spirit in a black velvet dress'.

↓ **Cecil Beaton, February 1936**
Preparations for New York's Lace Ball have sent the workrooms of London and Paris into a froth of activity, with each house working tirelessly to satisfy clients desperate to outdo each other. Mrs Heneage will no doubt get things spinning in this frock, by Yda Irvine, featuring rows of appliqué black lace circles around the hem.

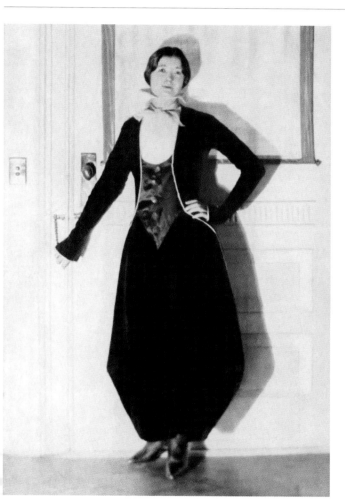

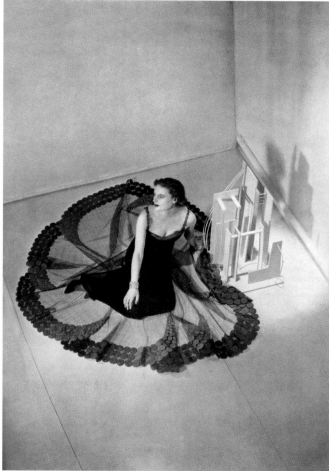

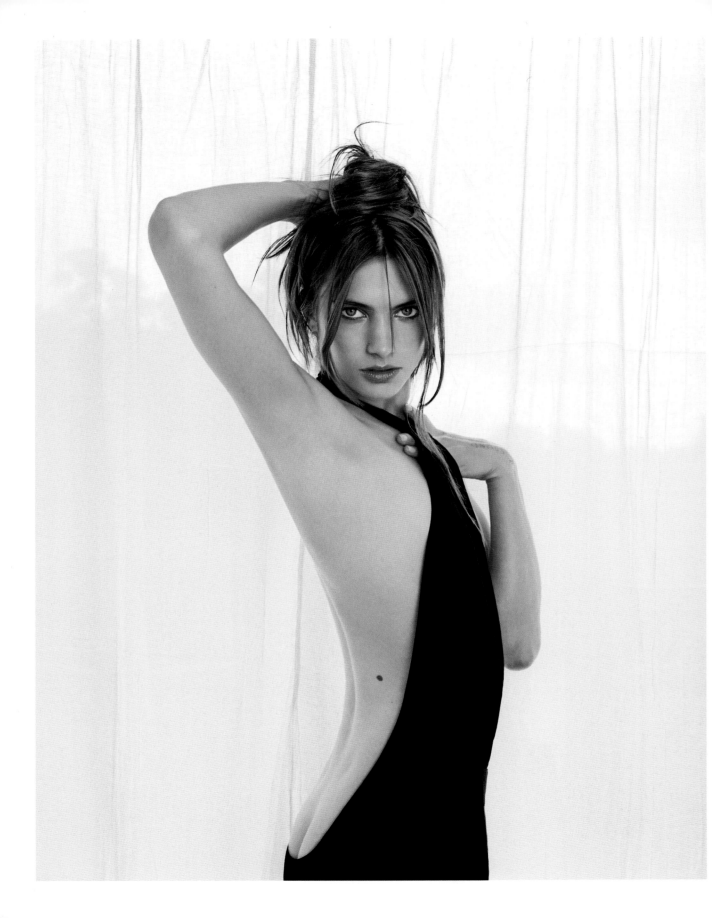

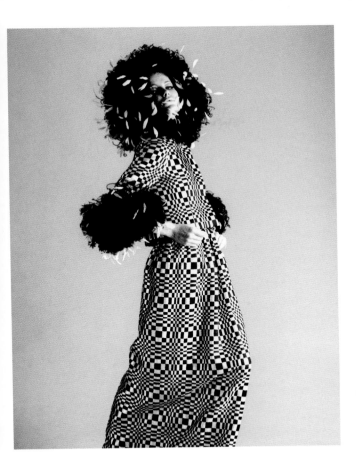

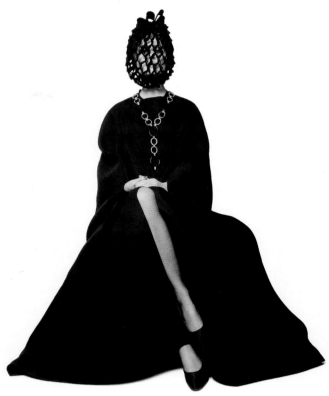

← Corinne Day, January 2003

A study in minimalism: Hugo Boss's simple black halterneck is dangerously low cut and 'fit for a siren' in this typically understated portrait by Corinne Day. Forget jewels, or underwear for that matter – even the Biro hand-scrawls remain untouched. All that's been added is 'an air of nonchalance'.

↑ Norman Parkinson, September 1965

Sometimes, a girl wants it all: optically mesmerizing black-and-white ribbons woven to create oscillating circles, fronded ostrich feathers, and a dirndl skirt. And if this 'wild new ribbon work' comes courtesy of Italian designer and experimentalist Roberto Capucci, who are we to argue?

↑ David Bailey, March 1968

Vogue takes a magical mystery tour through the Paris collections to demonstrate how 'folklore, fairytale, ancient and not so very old' have been translated into the fashion language of spring 1968. Political revolution is in the air, and huge social upheaval awaits, but fashion prefers to explore the new set of rules via more phantasmagorical sources. Here, Bailey conjures a Japanese kabuki player, in Lanvin – 'dark as secrets, wide as a bat' – masked with bewitching black ribbon gazar, by Swiss textile company Abraham.

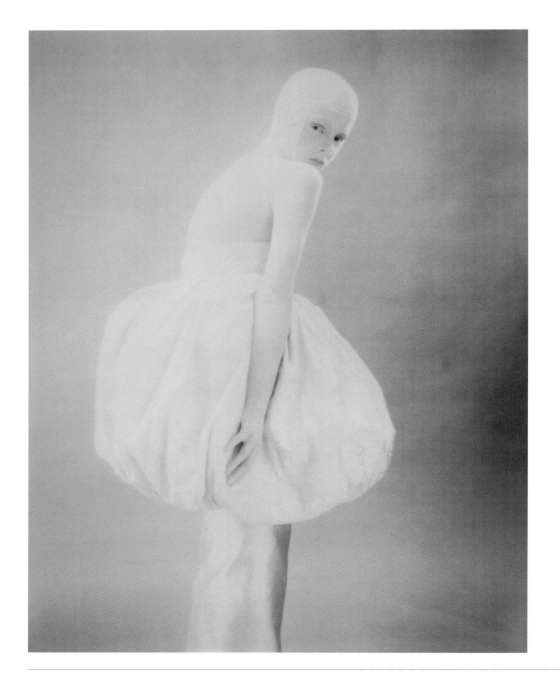

↑ Paolo Roversi, April 1986
The girl who fell to earth: *Vogue* heralds
a new luminary, dressed in pure white,
and in skirts that puff and billow. *Vogue*
holds that this ivory duchesse satin,
strapless, ankle-length dress with moiré
skirt will translate marvellously well for
summer parties, although guests might
possibly want to dispense with the
muslin head bandaging.

→ Mario Testino, May 2007
Dutch model Lara Stone becomes
Jean Paul Gaultier's latest muse –
'the Madonna dressed in celestial
chiffon'. The gathered silk-tulle
Empire-line gown is traditional in
every way, although the addition of
silver shoulder pads saves it from too
much nostalgia. This couture collection
is razor sharp and white hot.

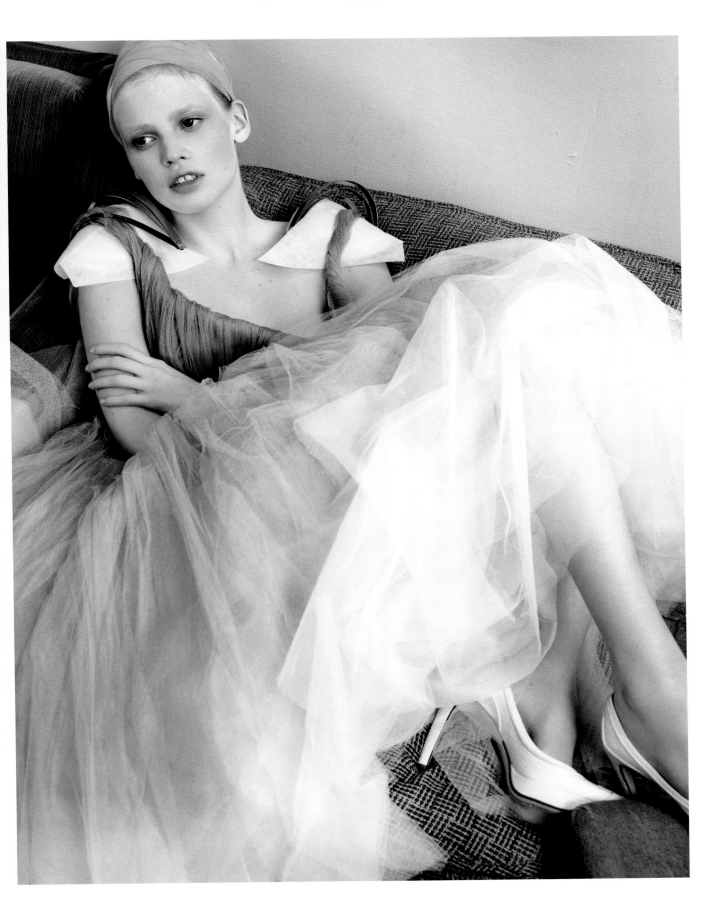

← **Lachlan Bailey, April 2007**

A paper apron dress, designed and made especially for *Vogue* by stylist Charlotte Stockdale, her assistant Katie Lyall, Lyall's mother, a pattern-cutter, and eight Central Saint Martins' students. Stockdale wanted to hand-make her paper props to showcase the season's new accessories, and this design features a papier-mâché bustle over which sits a circular skirt made from 27 sheets of paper, topped with a bib inspired by Twenties workwear. 'I liked the thought of doing something cartoony and exaggerated,' explained Stockdale of her painstaking endeavour, 'but had no idea of the hours of labour involved.' So what essentials does the contemporary toolkit contain? A card-holder, scissors, screwdriver, spanner and a silver key-chain, of course.

↓ **Mario Testino, October, 2009**

Naomi Campbell is among those brilliant individuals celebrated in Testino's tributes to the 'eccentrics, traditions and subcultural tribes' that typify British style. And when she summons the spirit of Boudica, in a smoke-coloured gown, with silver breastplate and studded-felt detail, by Giles, it's the stuff of schoolboy dreams.

↑ Cecil Beaton, February 1928

A relative novice at the magazine in 1928 when these illustrations were made; Beaton had joined the staff only a year previously, but his witty observation and inarguable artistic talent were already winning him admirers – not least among the society he documented so ardently. Here, Beaton peers into fashion's crystal ball to imagine futuristic looks for a fancy-dress ball – a positive obsession among the Bright Young Things of the day. Miss May Vickers is urged to dress as a bather of 1970, while Miss Faith Celli is told that 'she will' wear the costume of a nun, encased in chiffon, in 1950.

→ René Bouché, December 1949

Elsa Schiaparelli's gleaming blade of a green satin evening dress, 'with a giant jungle leaf', is reduced to just a few spare lines by the social portraitist and *Vogue* illustrator. The gown is selected as one of 'six exhilarating dresses for every form of festive evening', yet this is the only design to be presented as an illustration. Schiaparelli, herself a huge admirer of the Surrealist artists, would surely approve.

← **Cecil Beaton, January 1950**
In a study of contemporary 'Elegance', *Vogue* examines its predominant characteristics with an assiduous eye. 'It postulates a rightness, a correctness, a certain fastidious formality,' warns the accompanying text, before gracefully conceding: 'Elegance is witty, is good company… and can be as contagious as love.' The comtesse Alain de La Falaise is selected as one of four women to represent this most elusive of virtues: 'She likes big earrings, striking clothes: such as this Paquin black-and-white striped fishtail taffeta. She takes some time to learn how to wear a dress.'

↓ **Cédric Buchet, November 2007**
A great blast of sea air sweeps through the winter collections, and sweater dressing gets a fresh spin with oversized yarns and streamlined cashmere. A striped wool dress, by Tommy Hilfiger, joins the knit parade – and takes off.

↓ Henry R Sutter, May 1923
An anonymous young woman with seductive sloping shoulders and a shimmering satin gown reels in a male admirer. *Vogue* readers in the early Twenties are urged to find inspiration in the English modifications of French styles, while being mindful of the new passion for all things Egyptian: 'No modern designer could afford to ignore events of such world-wide topical interest as the opening of an Egyptian tomb and the discovery of the marvellous treasure it contained.' Tutankhamun, notwithstanding, this little scene suggests the reader might be inspired by rather more quotidian excitements.

↓ Carl Erickson, October 1938
'Out of Paris reel dance dresses that are whirling pinwheels of colour – and who can wear them better than the tall young of England?' The gown (left) by Alix (later Madame Grès) is a 'burst of satin ribbons below a hugging sheath of jersey,' while Lanvin's offering (right) is a 'subtle splurge of lamé stripes' worn with a black fox cape. (British *Vogue* in the Thirties had a more tolerant view of the fur industry than today's.)

→ Tim Walker, April 2011
Marc Jacobs's silk trapeze bumblebee dress may not sting, but it sure makes for a mighty powerful fashion statement, especially when worn with matching stripy tights.

Early May 1923 Condé Nast & Co Ltd London *Price Eighteenpence*

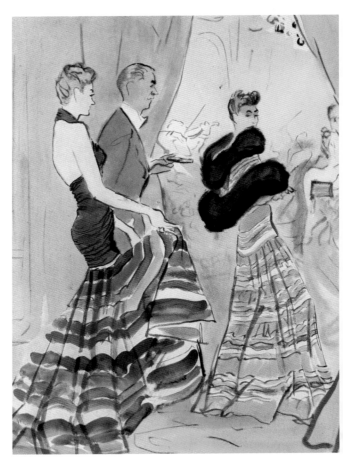

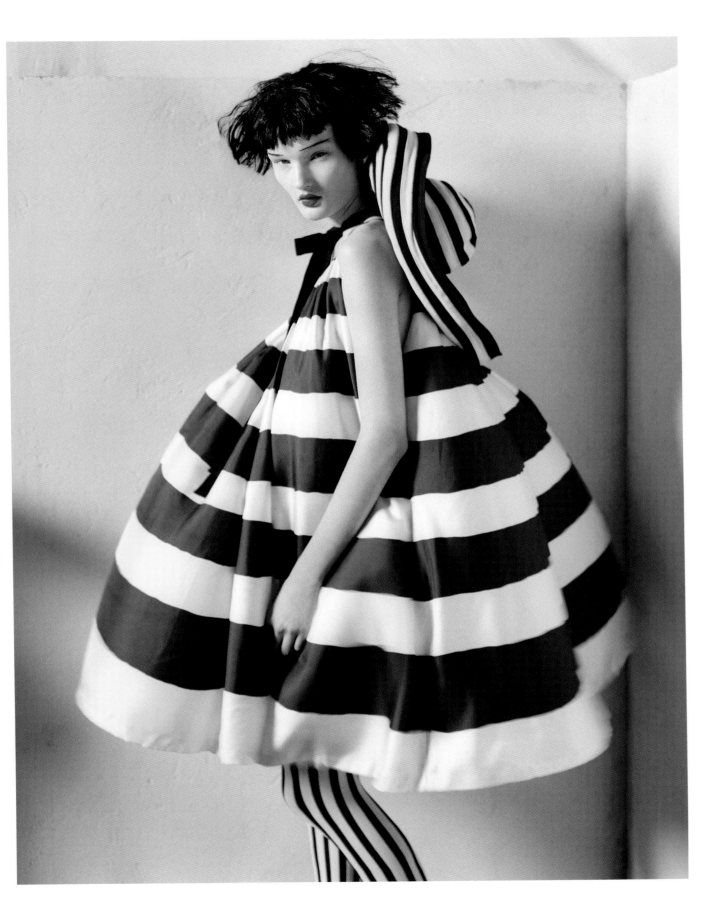

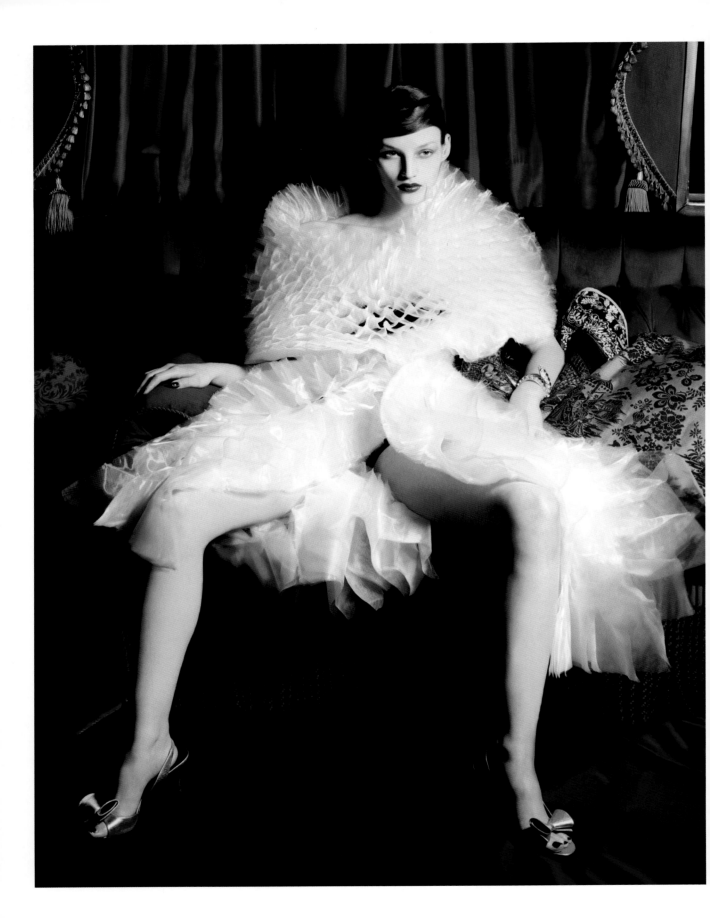

← John Akehurst, October 2000

In 'Night Clubbing', classics are presented with a twist. The star of the night is this stunning 'techno couture' ball dress in polyester organza by the Japanese designer and former Comme des Garçons protégé, Junya Watanabe. The dress's intricate honeycomb structure was created with the help of a computer program that followed the principles of origami to aid its construction. Watanabe has described his passion for the past as being tempered only by an obsession with the new technological means by which 'you can reveal beauty'. How you interpret it, though, is up to you.

↑ Mario Testino, December 2006

To celebrate those people who work behind the scenes to shape our cultural landscape, *Vogue* here casts Richard Rogers as the architect in charge of refashioning Bekonscot Model Village. A tiny figure in the corner, he waves his blueprints for a new world order before model Erin O'Connor, the 'spirit of architecture', dressed in Hussein Chalayan's fabulous yet vice-tight fibreglass Airplane dress.

Vogue heads to Madrid to admire and explore the fast-emerging European fashion centre. At Las Cuevas de Luis Candelas, the 'colourful tavern hideout of the eighteenth-century Spanish Robin Hood', *Vogue* discovers Manuel Pertegaz's black taffeta evening dress with bubble-puffed rumba skirt. Olé!

→ **Nick Knight, November, 2001**
When British designer John Galliano was awarded a CBE (and an honorary professorship at Central Saint Martins), *Vogue* asked his friends and family to describe the fashion magus (then the creative head of Dior as well as of his own label), while Knight was commissioned to capture some of his seminal looks. The couture season of 2000, in which this dress featured, was so dense in references, influences and eras – encompassing everything from Versailles, to vandals, to vaudeville – that to try to surmise its meanings would be impossible. As an illustration of a chaotically brilliant creative mind, however, it is a case in point.

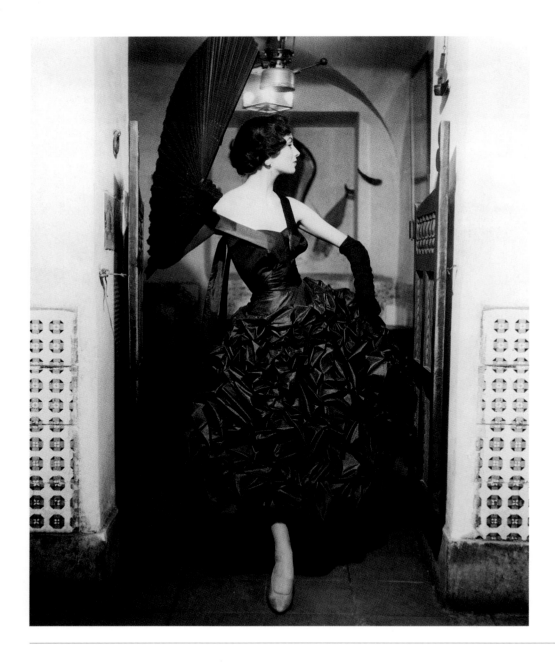

index

picture credits

acknowledgements

First published in Great Britain in 2014 by Conran Octopus, an imprint of Octopus Publishing Group Ltd, Carmelite House, 50 Victoria Embankment, London EC4Y 0DZ
www.octopusbooks.co.uk
www.octopusbooksusa.com

An Hachette UK Company
www.hachette.co.uk

The authorized representative in the EEA is Hachette Ireland, 8 Castlecourt Centre, Dublin 15, D15 XTP3, Ireland (email: info@hbgi.ie)

This edition published in 2017.

Distributed in the US by Hachette Book Group 1290 Avenue of the Americas, 4th and 5th Floors New York, NY 10104

Distributed in Canada by Canadian Manda Group 664 Annette St., Toronto, Ontario, Canada M6S 2C8

ISBN 978 1 84091 764 2

A CIP catalogue record for this book is available from the British Library.

Printed and bound in China

10 9 8 7 6 5 4 3 2

Publisher: Alison Starling
Art Director: Jonathan Christie
Senior Editor: Sybella Stephens
Editor: Robert Anderson
Proofreader: Zia Mattocks
Senior Production Manager: Katherine Hockley

Special thanks to Alexandra Shulman, Harriet Wilson, Brett Croft and Ben Evans at The Condé Nast Publications Ltd.

Every effort has been made to reproduce the colours in this book accurately; however, the printing process can lead to some discrepancies.

Jo Ellison was *Vogue*'s Features Director between 2005 and 2014, where her writing covered fashion, culture, art and photography, and she wrote many of the magazine's cover interviews. She took a particular interest in *Vogue*'s 100-year history and profiled or interviewed many of the magazine's great names, from Norman Parkinson and Grace Coddington, to David Bailey and Juergen Teller. *Vogue: The Gown* is her first book. Jo is now the fashion editor at the *Financial Times*.

Alexandra Shulman was Editor-in-Chief of British *Vogue* between 1992 and 2017.